W9-AFW-624

ANDRÉ BIÉLER

AN ARTIST'S LIFE AND TIMES

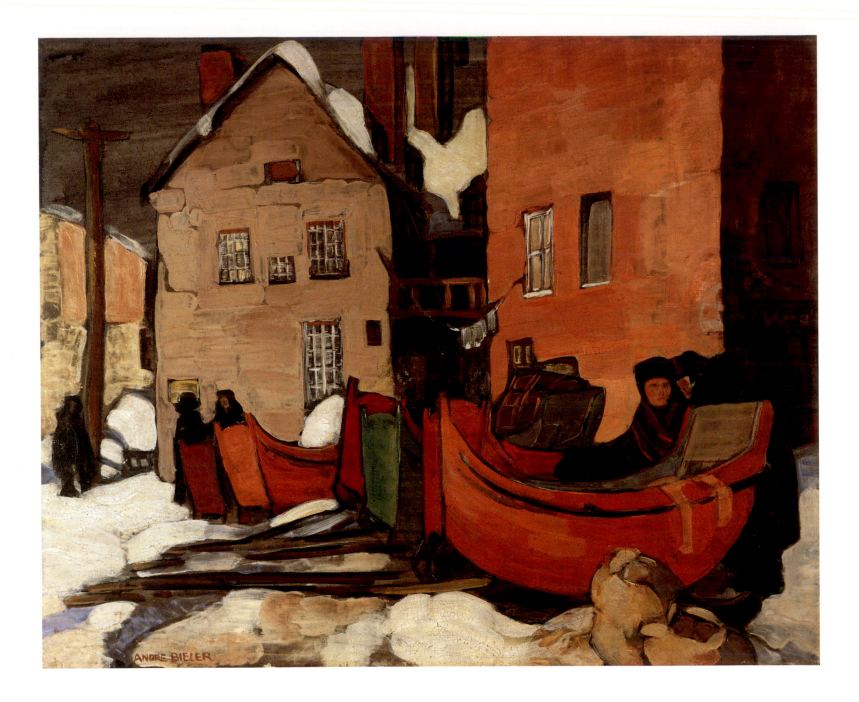

FRANCES K. SMITH

Introduction by David Karel

Epilogue by Ted Biéler

ANDRÉ BIÉLER

AN ARTIST'S LIFE AND TIMES

Edited by Philippe Baylaucq

FIREFLY BOOKS

A FIREFLY BOOK

Published by Firefly Books Ltd. 2006

Copyright © 2006 Les Presses de l'Université Laval

All rights reserved. No part of this publication may be reproduced, stored in a retrieval system, or transmitted in any form or by any means, electronic, mechanical, photocopying, recording or otherwise, without the prior written permission of the Publisher.

First printing

Publisher Cataloging-in-Publication Data (U.S.) available

Library and Archives Canada Cataloguing in Publication
Smith, Frances K.
André Biéler: an artist's life and times / by Frances K. Smith; introduction by David Karel; epilogue by Ted Biéler. — New ed. / edited by Philippe Baylaucq. Includes bibliographical references.
ISBN-13: 978-1-55407-232-3 ISBN-10: 1-55407-232-8
1. Biéler, André Charles, 1896-1989. 2. Painters-Canada-Biography.
I. Baylaucq, Philippe
ND249.B53S64 2006 759.11 C2006-902602-5

Published in the United States by Firefly Books (U.S.) Inc.
P.O. Box 1338, Ellicott Station
Buffalo, New York 14205

Published in Canada by Firefly Books Ltd.
66 Leek Crescent
Richmond Hill, Ontario L4B 1H1

Editor	Philippe Baylaucq
Direction in Paris	Jacques Baylaucq
Editor at PUL	Léo Jacques
Production coordination at PUL	Jocelyne Naud
Design and setting in Paris	Nathalie Baylaucq Baylaucq & Co.
Design and setting in Montreal	Marie-Eve Nadeau M.E.N. Design
Translation of the Introduction (D. Karel) and Preface (J. Porter)	Marcia Couelle
Proof reading	Jane Jackel

Conseil des Arts du Canada Canada Council for the Arts

The publisher gratefully acknowledges the financial support for our publishing program by the Canada Council for the Arts, the Ontario Arts Council and the Government of Canada through the Book Publishing Industry Development Program.

Printed in Canada

PHOTOGRAPHIC SOURCES

Patrick Altman (Québec) 63, 68, 75, 78, 116

Jacques Baylaucq (Paris) 291

Philippe Baylaucq (Montréal) XXV, 85, 90, 99, 103, 121, 122, 134, 143, 148, 149, 167, 175, 186, 206, 230, 235, 240, 241, 253, 278, 280, 290, 317

Tom Bochsler (Hamilton) 161

Jean-François Brière (Montréal) 220

Martin Bühler (Basel) 13

Bertrand Carrière (Montréal) IX, X, XV, XX, XXV, XXVIII, XXXI, XXXII, 10, 11, 18, 19, 37, 44, 51, 58, 71, 76, 77, 86, 87, 90, 93, 94, 98, 104, 110, 115, 117, 118, 120, 123, 124, 125, 132, 133, 148, 149, 151, 157, 162, 172, 179, 183, 186, 188, 189, 199, 200, 202, 203, 204, 207, 219, 224, 225, 228, 232, 234, 239, 243, 245, 254, 257, 264, 265, 268, 269, 271, 273, 274, 282, 283, 284, 288, 289, 290, 297, 298, 306, 318, 321, 322, 323, 324, 330, 331, 333, 335

Carlos Catenazzi (Toronto) XII

Paul Cimon (Saguenay) 215

Agnès Chaumat (Paris) XIX

Bernard Clark (Kingston) XVIII

J-C. Ducret (Lausanne) 96

Denis Farley (Montréal) 149

Christine Guest (Montréal) 97

Claude Huber (Lausanne) 72-73

Tom Jenkins (Dallas) 158

Jean-Guy Kérouac (Québec) XVII, 128, 129, 164, 165, 182, 191, 194, 195, 196, 197, 211

Patrick Lacasse (Ottawa) XXII

Ernie Leemook (Toronto) 181, 244, 285

George Lilley (Kingston) 242, 261, 262, 291, 292

Gerry Locklin (Kingston) IV, VII, 75, 84, 106, 107, 109, 110, 118, 119, 161, 170, 171, 218, 221, 226, 227, 229, 231, 233, 236, 237, 251, 260, 271, 281, 294, 295, 299, 305, 308, 309, 312, 313, 314, 315

Robert McCallum (Kingston) 326-327

Ralph Mercer (Boston) XXIV

Brian Merrett (Montréal) 113, 120

Ernest Meyer (Winnipeg) 137, 189

Guillaume Millet (Montréal) 20, 21

Larry Ostrom (Toronto) 131

Denis Rainville (MontréalL)121, 154, 190-191, 310

Normand Rajotte (Montréal) XXIX, 25, 68, 74, 77, 87, 111, 167, 175, 178, 192, 193, 209, 255

Bernard Saint-Genès (Paris) 54, 55, 67, 81, 102, 140, 263, 302

Dana Salvo (Boston) 42, 46, 47

F.K. Smith (Kingston) 79, 145, 207, 220, 261, 280, 288, 296, 297

Endpaper
Base for a composition prepared circa 1980
Acrylic on canvassed panel
A.B. Archives

Page IV
Les Berlines, Québec, 1928
Casein on canvas
41 x 51 cm
Collection of the Musée national
des beaux-arts du Québec

This book is published with the financial assistance of the following Foundations, Public Institutions, firms and individual donors. Others have requested to remain anonymous. The authors and publisher thank everyone who has generously contributed to the creation of this book.

Canada Council for the Arts
Dr. Albert and Mrs. Christa Fell
The estate of André and Jeannette Biéler
Alcan Inc. of Canada
Power Corporation of Canada
Phil and Sue Cowperthwaite
Baylaucq & Co.
Canneberges Atocas Cranberries
Peter Biéler
Le Groupe CGI
Zeller Family Foundation
Jacqueline Biéler (In memoriam Guy Biéler)
Passerelle Production
The Davies Foundation
Pacart
Musée national des beaux-arts du Québec
Agnes Etherington Art Centre
Rick and Carol Brettell (In memoriam Jacques Biéler)
Galerie Valentin
Alexandre Taillefer
Louis-Marie Gagné
Les Encadrements Marcel Pelletier
Anne Baxter
Françoise Montgomery
Nicholas Kasirer
Hélène et Jean-Marie Roy

Monos, Mexico, 1964
Acrylic on paper
23.5 x 15.5 cm
Private collection

ANDRÉ BIÉLER

TABLE OF CONTENTS

Étude d'une main tenant une pomme, 1929
(Study of a Hand Holding an Apple)
Lead pencil on paper
19.5 x 13.5 cm
Private collection

AN ARTIST'S LIFE AND TIMES

Le Semeur zen, 1950
(The Zen sower)
Ink on paper
15 x 12 cm
Collection of the Musée national
des beaux-arts du Québec
Gift of the estate of
André and Jeannette Biéler

THE LEGACY OF ANDRÉ BIÉLER (1896-1989)

All too rarely do we see new editions of monographs on Canadian artists, such as this one coming a quarter-century after the publication of Frances K. Smith's essay entitled *André Biéler. An Artist's Life and Times.* The reissue of this classic of our art history stands as a tribute to both the painter-printmaker and to his historian, whose 1980 text has lost nothing of its original freshness and pertinence. At the individual and collective level, this endeavour further attests attachment, continuity and maturity.

André Biéler was an authentic, sensitive artist open to diverse national and international artistic currents. Reflecting an uncommon duality, he was a modern who cared about tradition, a creator who sought to immortalize ephemeral harmonies through the (sometimes bold) exploration of varied techniques. Insatiably curious, he ceaselessly expanded his visual universe, ever in quest of original subjects and innovative stylistic approaches. In the realm of human relations, he showed himself to be a man of balance, striving to reconcile and unify the protagonists of conflicting movements around shared objectives. In short, he shared great gifts with those who were privileged to know him, both in Quebec and in English Canada, contributing to the country's artistic evolution and fostering its public understanding at home and abroad, and still today.

This book has the merit of recounting the singular journey of a multitalented artist while delivering a lively portrait of the changes that marked a bygone century. Boasting an enriched selection of artworks and truly exceptional photographic iconography, it features fresh graphics and 376 pages, twice as many as the original edition. Also new is the timely discussion of the socio-historical context by Professor David Karel, a respected art historian with a long-standing interest in regionalisms. In keeping with the artist's deep attachment to the Francophone world, and to Quebec in particular, the book is appearing simultaneously in French with, at long last, a faithful, nuanced translation of the 1980 English text. The entirely new layout makes it a very handsome work that speaks to an undeniable maturity in art-related publishing.

Not content to have spent several years on a remarkable film commemorating his grandfather, Philippe Baylaucq assumed the dual functions of designer and director for the revised edition of Frances K. Smith's account. With the enthusiastic support of other members of the Biéler family, he has demonstrated the vital role that descendants can play in the conservation, transmission and appropriation of an artist's legacy. Let us hope that the patrimonial interest and care shown by Philippe and his relatives prove to be a source of inspiration for the families of other contemporary artists.

For its part, the Musée national des beaux-arts du Québec is most pleased to have been able to contribute to this publication, especially as we hold the largest collection of works by André Biéler in Canada. The first of our 174 pieces was acquired in 1941. Other acquisitions in 1951, 1969, and 1987 were followed in 1990 by the Biéler family's outstandingly generous gift of 160 works from the artist's estate. That same year it was our honour to present the fine exhibition *André Biéler in Rural Québec/André Biéler et le Québec rural* mounted by the Agnes Etherington Art Centre in Kingston.

Some years later, having shown only parts of our collection, we in turn paid major tribute with the monographic presentation *André Biéler. Dessinateur et graveur/André Biéler. Draftsman and Printmaker*, which opened in Québec City in April 2003. This show later toured to Kingston, the Pulperie de Chicoutimi in the Saguenay region and the Beaverbrook Art Gallery in Fredericton. On a final note, I am pleased to say that in 2004 the Musée national des beaux-arts du Québec proudly acquired the 1928 *Les Berlines, Québec/Saloon Cars,* Québec City, the emblematic Biéler work that illustrates the cover of this book just as its striking composition and bright hues graced the cover of the original edition of the Smith essay in 1980.

John R. Porter, CQ, FRSC
Executive Director
Musée national des beaux-arts du Québec

Primera comunión, San Miguel, 1966
(First Communion, San Miguel)
Mexico
Ink on card
15 x 10.3 cm
Private collection

Mirroring the twentieth century, my grandfather André Biéler lived his 93 years in a state of effervescent creativity, endlessly reinventing himself, torn between the traditions of a rich past and the dynamic currents of modernity. Shortly after his death in 1989, our family had the privilege of sorting the contents of his painting studio. As we examined hundreds of unexpected photos, artworks and documents, the twists and turns of his amazing career emerged. For me, this overview raised countless questions that, sadly, he was no longer there to answer. My search for understanding led to the idea of a film.

Reading the many documents that came to light over the course of the thirteen years it took to produce *The Art of Time,*[1] I realized that Frances K. Smith's 1980 biography *André Biéler, An Artist's Life and Times* merited a French translation and an updated version of the original English, long out of print. While remaining faithful to Ms. Smith's account, the new book would be enhanced with a fresh layout, entirely in colour and richly illustrated with works and photographs discovered during my film research.

I undertook this project with the blessing and active participation of the ever-keen and enthusiastic author, and with the support of numerous others to whom I owe thanks.

First, my publisher Léo Jacques, at Les Presses de l'Université Laval, for believing in this project from the outset and for his steadfast, enriching collaboration. Rachèle Martinez, for preserving the subtleties of a great life story in her French translation. And my friend and translator Michel Tanguay, for his valuable input in revising the French.

To design the new layout I called on the skills of my sister Nathalie Baylaucq, a graphic artist well known in Paris. The book could not have been redone without her. Jacques Baylaucq, our father, then produced the initial mock-up, a long, painstaking job in which he was supported by the Baylaucq et co. studio team.

I took over from there, working in Montréal with Marie-Eve Nadeau, a young graphic artist as efficient as she is dedicated. We completed and refined the initial proposal for nearly a year before submitting it to Jocelyne Naud at Les Presses de l'Université Laval, who, with her team, oversaw the final steps prior to printing.

Long before that others had provided a variety of services vital to the project. With customary diligence, my photographer friend Bertrand Carrière recorded the entire family collection. My cousin Torben Sorensen assembled the images on CD, giving us a

tool that fast proved to be indispensable. My cousins Rick and Carol Brettell, Jacqueline Biéler, my aunt Nathalie Sorensen and my uncle Ted Biéler were always there, quick to respond when I needed information or visuals. And my mother, Sylvie Biéler Baylaucq, helped us recognize details and nuances that needed attention in the text, the design and the choice of images.

My gratitude also goes to the many people at private and public archives and Canadian and other museums who supplied me with documents or suggested ways to find them. The list is long and space is short, but I must mention the assistance of Janet M. Brooke and Dorothy Farr at the Agnes Etherington Art Centre, George Henderson at Queen's University Archives, Rosalind Pepall at the Montreal Museum of Fine Arts, Pierre l'Allier at the Musée national des beaux-arts du Québec, Guy Tessier at Library and Archives Canada, Charles C. Hill at the National Gallery of Canada, Éric Bungener, and finally Sylvie Wuhrmann at the Fondation de l'Hermitage in Lausanne, Switzerland.

A special thanks to my uncle Ted Biéler for having written the epilogue that deals with the last decade of his father's life, and many thanks also to his wife Marina. From the onset of this project, their support and enthusiasm have been crucial. Heartfelt thanks are due as well to my friend and art historian David Karel for his fascinating introduction. Taking up where Frances Smith left off, he has written two texts[2] that open new avenues for exploring the artist's oeuvre.

Lastly, I want to acknowledge the invaluable contribution of my father Jacques Baylaucq, whose commitment to this complex endeavour stands as a tribute to his father-in-law and friend. The countless hours he has invested reflect his conviction that André Biéler's work deserves to be better known. This new edition is dedicated to him.

Philippe Baylaucq
Editor

Untitled (Renaissance tree), 1941
Linocut on rice paper
14 x 10 cm
Portion of a Christmas card
Private collection

1. The initial shooting took place in June 1986, before the artist's death. There followed a ten-year hiatus during which the iconographic research continued. The documentary film project was relaunched in 1996 and *The Art of Time / Les Couleurs du sang* was released in 2000.

2. David Karel is also the author of *André Biéler ou le choc des cultures / André Biéler at the Crossroads of Canadian Art*, published in 2003 by Les Presses de l'Université Laval in conjunction with the touring exhibition *André Biéler: Draftsman and Printmaker*, which debuted at the Musée national des beaux-arts du Québec in April 2003.

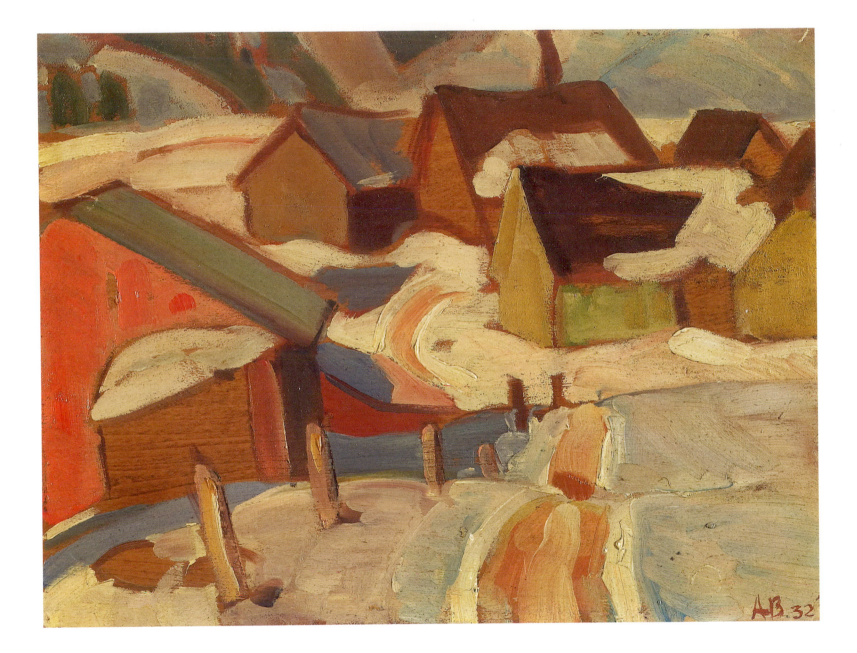

Soir d'hiver, Saint-Sauveur-des-Monts, Québec, 1932
(Winter evening, Saint-Sauveur-des-Monts, Québec)
Oil on board
25 x 35.5 cm
Collection of the Art Gallery of Ontario
Gift of A.Y. Jackson, 1951

BIÉLER IN BALANCE

BY DAVID KAREL

*Identity is local and regional,
rooted in the imagination and
in works of culture*

Northrop Frye[1]

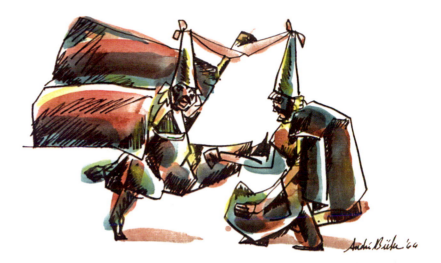

Dancing clown, Mexico, 1964
Ink on paper
15.5 x 24 cm
Private collection

Shortly after André Biéler's death in December 1989, Joyce Zemans, chair of the Canada Council for the Arts, paid him eloquent tribute, recalling his role as organizer of the 1941 Conference of Canadian Artists in Kingston, Ontario, and his paternity of "the concept of a national arts funding organization, the prototype for the Canada Council,"[2] created some years later. Despite such attention to his accomplishments, Biéler remained little known as a painter in 1990, as if his brilliant service record had eclipsed or diminished the importance of his artistic contribution. The purpose here, from the perspective of the still-dawning twenty-first century, is to consider a paramount principle that guided his endeavours as both activist and artist – that of equilibrium. Conceived for inclusion in the new edition of Frances K. Smith's exhaustive biography of André Biéler, this essay aims to point up the pertinence of his oeuvre for our day and age.[3]

AT THE CROSSROADS OF CANADIAN PAINTING

The year 1941, when the Kingston Conference took place, is the departure point for this holistic exploration, which goes on to look at the decade André Biéler spent in Québec. It was then, between 1926 and 1936, that he first affirmed the need for equilibrium.

1. "Identity is local and regional, rooted in the imagination and in works of culture; unity is national in reference, international in perspective, and rooted in a political feeling," Northrop Frye, *The Bush Garden. Essays on the Canadian Imagination* (Toronto: Anansi Press, 1971), p. ii.

2. Joyce Zemans, "One Year Later...," *The Canada Council,* no. 28 (winter 1989-1990), p. 3.

3. Much of the inspiration for this essay was drawn from my 2003 book *André Biéler ou le choc des cultures,* published in English as *André Biéler at the Crossroads of Canadian Art* (Québec City: Les Presses de l'Université Laval, 2003). For the sake of brevity, some of the book's notes have been omitted here.

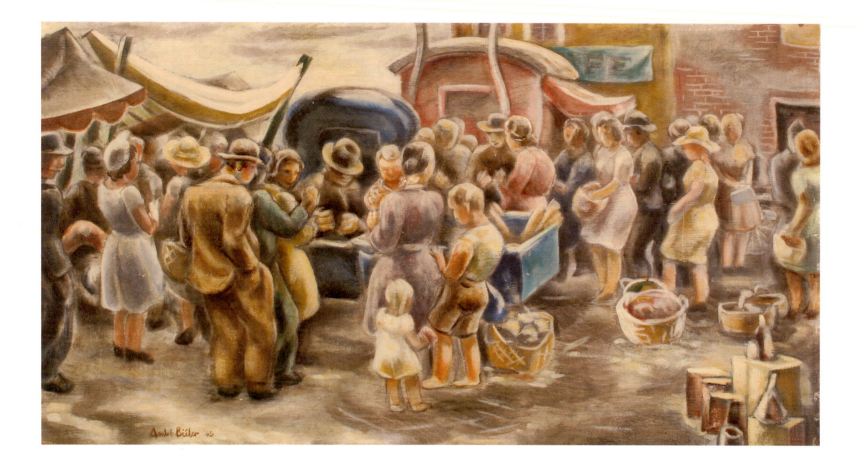

Wartime Market, Kingston, 1943
Mixed technique on pressed board
45.7 x 85.1 cm
Collection of the Agnes Etherington Art Centre
Kingston, Ontario
Gift of Dr. W.E. McNeil, 1959

The locational change was strategic. Biéler was living in Kingston when, in 1939, he declined an invitation to join the Société de l'art contemporain de Montréal, thus cutting his ties with the modernist milieu. His complaint was not with modernism itself but with the disequilibrium that came in its wake. Incapable of combating the problem from within, he refocused his action in 1940-41. His riposte to the discord in Montréal came in the form of a structured, inclusive community, giving artists the power to marginalize infighting of any sort, in any place. The "dynamic meeting of opposites" figure was achieved by incorporating local (or "regional") conflicts into an expanded federative framework. In geographic and military terms, this also meant that opponents of the unity cause[14] were completely outflanked.

14. John Lyman was the main target of this assault. Paradoxically, Lyman later defended the equilibrium argument against the "liberating" audacities of Paul-Émile Borduas, who broke with him just before issuing the *Refus global* (1948).

PERSONAL SYMMETRIES

There I was living in my little house just between two extremes yet, I must say, related to both.

André Biéler, "The Painting in the Centre," ca 1980.[15]

Withdrawal from Montréal and its troubling adversarial disputes allowed André Biéler to reflect more serenely on possible forms of equilibrium: collective, personal, stylistic, geographic, cultural, etc. Applied to Canadian art, they come in pairs, as in abstraction and figuration, East and West, English and French, urban and rural, traditional and modern. Biéler came face to face with these twosomes everywhere, as if his world were governed by the yin and yang of Taoist duality.[16] He felt the need to admit them into his work, to conciliate and perpetuate them.[17]

In turn, these antinomic duos are manifestations of vaster dualities. For instance, the contrast between figuration and abstraction is underlain by a tension between past and future. The cardinal points refer to similar primordialities, to the ancientness of immemorial civilizations in the East and the Edenic awakening of Aboriginal peoples in the West. Consider Romanticism's yearning for the Orient, for origin. Viewed in this sense, the strategic value of Biéler's geographic position in Kingston takes on metaphoric significance.

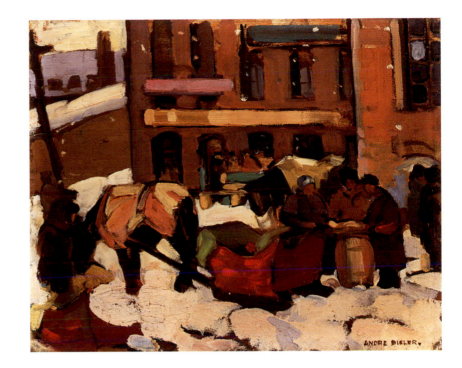

Marché de Québec, circa 1928
(Québec Market)
Oil on wood panel
22 x 27 cm
Private collection

15. The text continues: "On the one hand, I had chosen the island for its regional qualities, man in his environment. Yet I had studied in Paris and had come in contact with the latest expression by colour. The two opposites had been separated by time leaving in the centre a break: that was my challenge; what would I do with it? Would I succeed in bringing my sympathy with man and my new expression through colour together?" Unpublished manuscript in the artist's archives.

16. The bilateral symmetry discussed here is to be distinguished from the radial symmetry of the crossroads examined earlier. Bilateral stability suggests equilibrium, whereas radial stability implies harmony, as noted.

17. A key element of Biéler's aesthetic lay in the distinction between handcrafting and industrial manufacturing. The conclusion of this essay will show how, after long favouring the former and deliberately shunning the latter, he came to reconcile the two.

ÎLE D'ORLÉANS

The "in-between" figure emerges frequently in Biéler's words and life story. His first studio after returning to Canada from Europe was located in the village of Sainte-Famille on Île d'Orléans.[18] While living there from 1927 to 1929, he liked to imagine the little town as a point of equilibrium, not only because of its midpoint situation on the island, but also because it drew on the opposing values of the insular population – somewhat suburbanite at the western end, near the provincial capital, while clinging to tradition at the eastern end.

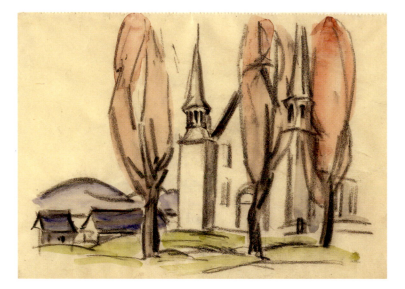

L'Église de Sainte-Famille, 1927
(The Church at Sainte-Famille)
Charcoal and watercolour on paper
14.2 x 22.8 cm
Private collection

This sociological figure overlay another, in which the traditional aesthetic of Horatio Walker, firmly rooted in Sainte-Pétronille (to the west), stood in opposition to that of one Dr. Rousseau, a collector with a taste for the modern who had known Matisse and now lived in the hamlet of Argentenay (to the east).[19] Biéler, well ensconced in centrally sited Sainte-Famille, saw himself as the island's third sensibility and the moderator of its extremes.

His unexpected way of associating modernism with the homespun portion of the island and traditionalism with its semi-urbanized area is significant. Since Gauguin, the primitive way of life had been seen as salvation and even the essence of modernism. This linkage appeared as well in the "Neo-Traditionist" doctrine of Maurice Denis, who had known Gauguin during the Nabi period and had taught André Biéler at the Académie Ranson in Paris. Hence, the modernist sensibility on Île d'Orléans naturally gravitated to the archaic western tip, where life resembled another time or place, light-years from urban modernity.

To achieve the symmetrical principle required a counterpart, an obstinately traditionalist rustic art, at the "civilized" end of the island. Old Horatio Walker fit this need to a T. Biéler disapproved the resolutely backwards focus of his work, both the bucolic subject matter and the outmoded realism of its painterly language. But like Walker he was sensitive to the gradual suffocation of the old way of life, swallowed up by rapid urban expansion.[20]

18. Île d'Orléans lies in the Saint Lawrence River, its western tip facing Québec City and its eastern tip across from Sainte-Anne-de-Beaupré.

19. The document consulted identifies this collector as "Dr. Brousseau," either a transcription error or the result of confusion between the island's two collectors. One also wonders to what extent the symmetrical vision of the island expressed by Biéler around 1980 was actually formulated in his mind fifty years earlier.

20. The decline of traditional ways on Île d'Orléans accelerated after the island bridge was built in 1936.

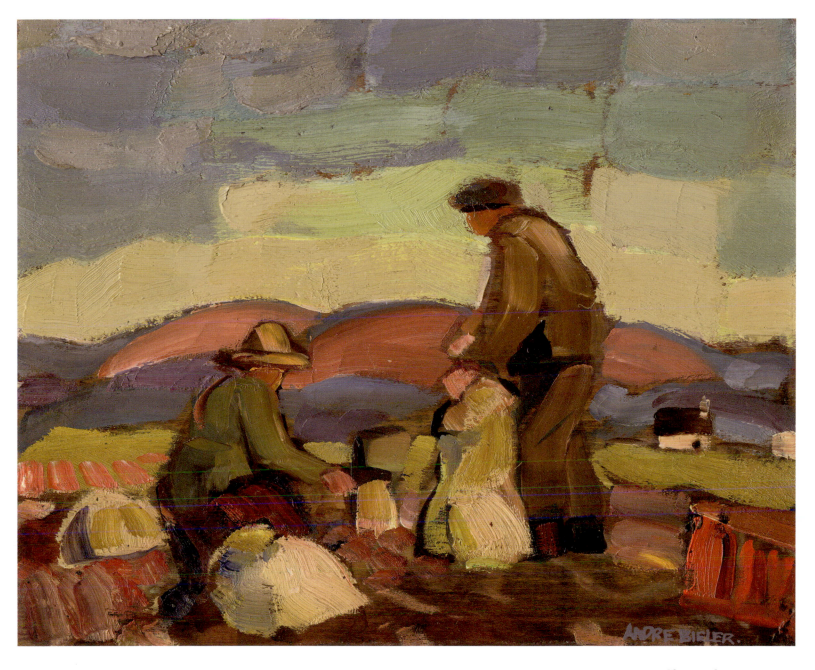

Champs de patates, 1927
(Potato Fields)
Oil on panel
23.6 x 25.4 cm
Private collection

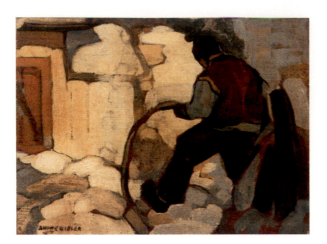

Mon voisin, Sainte-Famille, 1928
(My Neighbour, Sainte-Famille)
Oil on panel
20.3 x 26.7 cm
Collection of the Carleton University Art Gallery
Gift of Frances K. Smith

Thus it was that he came to discern urban art (modernism) deep in the country and rural art (regionalism) in town.[21] And to see excess on both sides. Rather than choosing between them, however, he sought to moderate each extreme with its opposite. Like his studio midmost on the island and his mixed heritage within the extended family of artists, he would be a "modernist regionalist."

I AND THOU

Living on the island fulfilled Biéler's desire to live with the Other, but this attraction never became a wish to assimilate: difference was the driving force of his form of regionalism.[22] Each work renewed and perpetuated the contrast of cultures. And the best of them rendered both the subject (seeing) and the object (seen), momentarily united and in equilibrium.

Over time, the artist found Québec to be straying from the purity of its traditions. This impression was reinforced by the conclusions of his ethnologist friend, Marius Barbeau. Unable to feel the inspirational spark of difference in a semi-modernized Québec, he gradually withdrew, occasionally searching his sketchbooks for an old drawing apt to rekindle emotion. Now and then he returned for brief visits, which, although agreeable, were of no particular consequence to his art. During this period of weaning, of detaching himself from the other, he evolved towards abstract painting, more attuned to the sensation of otherness than to its source. But once he discovered Mexico, the figurative component of his style regained its rightful place.

AESTHETIC SYMMETRIES

The experience of opposites on Île d'Orléans speaks to the depth of symmetry's influence on André Biéler. His painting reveals a striving for harmony and balance, yet it is not always confined to harmonious or balanced forms. At most it can be said that his overall aesthetic was one of duality.

FORM AND SUBSTANCE

Biéler's creative effort was largely guided by the quest for parity between visual language and subject matter, the perpetual opposites of artistic creation. But awareness of this prin-

21. The symmetry Biéler perceived is fractal; in other words, the elements in symmetrical opposition are themselves composed of elements in symmetrical opposition, and so on to infinity.

22. In regard to the Québec of those days, there is a distinction to be made between "regionalism of difference," inflected by post-colonialism and often tourism, and "collective affirmation regionalism," sometimes called clerical nationalism.

ciple, he claimed, came only in 1963,[23] after some forty years of gestation. He compared it to "two vehicles running on the same road," one fuelled by "love of people," the other by the creation of "arrangements of shapes and forms."[24] At no point could he declare a winner. But the race was always uneven, he said, except for a brief moment in 1946 when form finally overtook substance. This would seem to be an allusion to his mural for the Shipshaw power station at Arvida, in the Saguenay region of Québec.

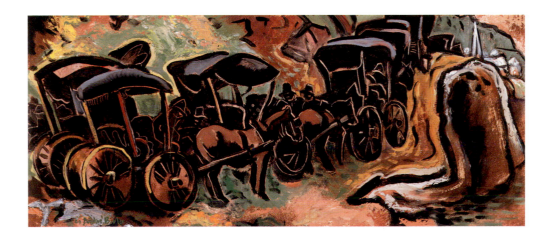

Voitures, Tadoussac, 1947
(Carriages, Tadoussac)
Oil on masonite
30 x 71 cm
Provenance: Maurice Gagnon Coll., Montréal
Power Corporation of Canada Collection

Up until that point, Biéler had been a "modernist regionalist," gradually embracing formal considerations after long exploration of the mysteries of otherness. Inversely, during those same years, certain modernists, such as John Lyman, had progressively blended cultural values with their initial pure formalism, becoming "regionalist modernists."

Biéler and Lyman were fast friends early on[25] and briefly (1931-1933) followed the same path as instructors at the short-lived Montréal art school *The Atelier,* which promoted a new classicism. They parted ways not over the "modern vs. traditional" argument but because of the clash between equilibrium, advocated by Biéler, and radicalism, endorsed by the Automatiste movement in which Lyman was active for a time.

23. The occasion of this awakening was an undocumented retrospective mentioned several times by Biéler in recorded interviews.
24. "Love of people" is the regionalist principle, whereas "arrangements of shapes and forms" is the modernist principle.
25. Lyman's wife Corinne was the godmother of Nathalie Biéler, the first child of André and Jeannette Biéler.

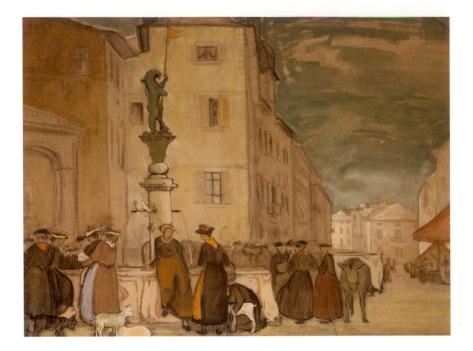

The Kid Market, Sion, Valais, 1925
Charcoal and tempera on card
44.4 x 59.4 cm
Private collection

MAURICE DENIS VS. CLIVE BELL

The division of artistic forces in the Montréal melee was exacerbated by linguistic difference, which in turn reflected an important aesthetic difference. Although bilingualism was common in the milieu and French modernism was well regarded, a profound divide separated the followers of Maurice Denis and his North American disciples, including Father Marie-Alain Couturier (1897-1954), from those who espoused the "significant form" concept[26] of Clive Bell (1881-1964) and Roger Fry (1866-1934). Bell and Fry's central notion, which boils down to a theory of abstraction in painting, in fact represents the British reading of French modernism, and a certain distortion of it.

Biéler championed the Fry-Bell aesthetic and did not mix with the Denis disciples. But he had trained with their master in Paris and his approach stemmed from Denis's "Neo-Traditionism," particularly its core concept of "decoration." The way in which he explained his painting, along with the facts of his career since the early days in Europe, shows that he came to abstract art through exploration of the decorative. This path was very different from that of the anglophone painters he knew in Montréal. Indeed, he was the only member of the group whose modernist aesthetic spanned the two theoretical bases.[27]

THE LEGACY OF ERNEST BIÉLER

The beginnings of André Biéler's quest for equilibrium antedate the influence of Maurice Denis. Ernest Biéler (1863-1948), his uncle and first mentor, had already made his mark as a modernist painter in Switzerland and Paris when his heart was captured by the picturesque Valais canton, specifically the commune of Savièse. He installed his studio there in 1900, and over the years the formalism of his younger days subsided, allowing for greater emphasis on mountainous landscapes and typical crafts motifs. Long before his nephew, who lived with him from 1922 to 1926, Ernest Biéler reconciled the dual heritage of universal modernism and local tradition.

26. Bell laid out his theory of abstraction in the 1914 book *Art*.

27. Denis's theory was also a defence and illustration of Catholicism. For Bell and Fry's Protestant partisans, this was another obstacle to embracing his tenets.

André Biéler returned to Canada in 1926, bringing with him an ambition already realized in Switzerland. In an essentially regionalist spirit, he set out to translate the relationship between the people and the land. During those rural years he opened up to modernism as a result of contact with Edwin Holgate and A.Y. Jackson.[28] His evolution towards a synthesis of new and old thus proceeded along a path contrary to that of his uncle, who began as a modernist.

Among the different figures of equilibrium attributable to the teachings of Ernest Biéler, and the Helvetian example more generally, are those of language and religion. Linguistic equality and religious tolerance, inherent to Swiss multiculturalism, remained imprinted in the artist's mind as an ideal to be pursued in the New World. Like his Protestant uncle in Catholic Valais, he put his spiritual and cultural heritage in the balance on the equally papal Île d'Orléans.

CULTURAL SYMMETRIES

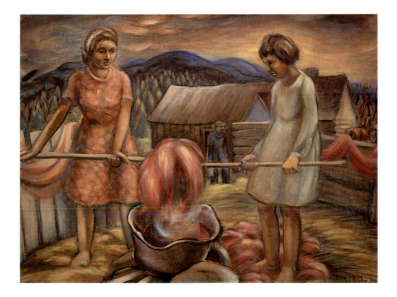

Girls Dyeing Wool, Péribonka, circa 1946
Mixed techniques and tempera on masonite
46 x 61 cm
Private collection

Culture is the common denominator of regionalism. It governs the different forms of equilibrium in question here – notably that of "self and other" – because they are implicitly cultural. When explicitly targeted by Biéler's thinking, culture, like the rest, took the form of balanced counterparts.

NORDICITY AND FUSIONISM

References to nationalism or culture in discussions of modernist art were commonplace in Biéler's day, between the Great Wars. But in later decades this became awkward, since the very notions of art and modernism demanded that loyalties and differences be put aside in pursuit of the universal. Today, with the advent of the postmodern era, frank discussion of this long-occulted aspect of his work has once again become possible.

André Biéler, John Lyman and the ethnologist Marius Barbeau shared a curious sympathy for the Nordic peoples, all the while finding a special, salutary Northernness in Québec, each in his own way. *Gatineau Madonna* (1940) is perhaps the best expression of this interest by Biéler, who had little time for the convoluted theories of

28. It should be noted that Biéler's training, both in the United States and in France, was to some degree modernist.

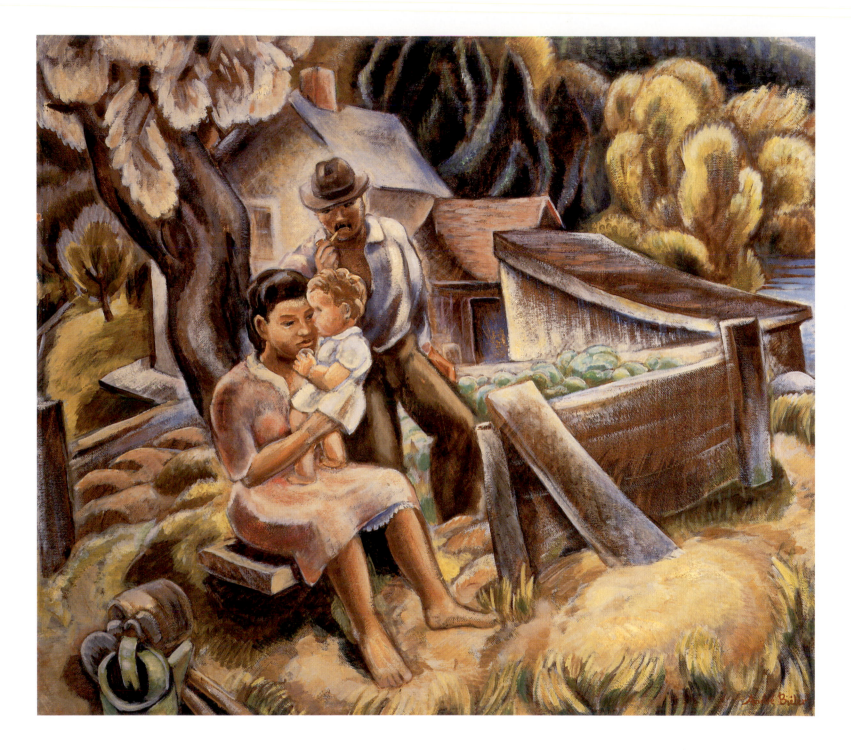

Gatineau Madonna, 1940
Oil on board
91.4 x 105.4 cm
Collection of the National Gallery of Canada

the other two.[29] These facts would be of no more than anecdotal interest were it not for a similar debate then raging in France and the involvement of the poet Charles Vildrac, one of Lyman's friends.

The crux of this debate was whether France was essentially Nordic or Latin, the Left leaning northwards and the Right inclined to the south. Barbeau went so far as to posit that Medieval and pre-Latin – hence Nordic – France was still alive and well and living in rural Quebec, sheltered from the corrupting influence of writing and rationality![30]

The precise idea behind Biéler's *Madonna* is unknown, but one can surmise that his intent was to celebrate the union of two northerly peoples – the French in Canada and the Aboriginals – in which he may have seen the birth of a people closer to nature.[31] This fusionism evoked and revitalized a notion recurrent among English-speaking regionalists, as expressed by one of the "first wave" painters on Île d'Orléans and the Beaupré Coast.[32] Horatio Walker saw Canada as a country blessed by the gods, formed by the merging of the spiritual heirs of the great civilizations of Antiquity: the French, inheriting from Greece, and the English, from Rome.

Lyman attributed similar virtues to the Celtic "race," a sort of Franco-British people endowed, in his mind, with French sensibility and English pragmatism. This belief was the basis of his praise for the Canadian painter James Wilson Morrice, to whom he ascribed quintessential "Canadianness" owed to the fusion of cultures.

These different personal ideologies, however fanciful, are based on a single figure, that of the meeting of two contrasting cultures, one of which, at least, is "Nordic." All three painters saw Canada as a place where Old World flaws faded and vanished as a new humanity emerged.

Le Reposoir, 1937
(Roadside Shrine)
Watercolour and pochoir technique on paper
35.5 x 24.5 cm
Private collection

29. Barbeau developed this notion in the introduction to his *Folk Songs of French Canada* (New Haven, Conn.: Yale University Press, 1925. 216 p.), p. xvii.

30. Shortly before leaving France to return to Canada, Lyman adopted a neoclassical modernism based on the theory of French Latinness and strongly influenced by the writings of Eugenio d'Ors. He does not appear to have considered the fundamental contradiction between the essayist's ideas and those of Charles Vildrac.

31. He frequently portrayed people of the First Nations: in Quebec at Kahnawake (Mohawk) and Mashteuiatsh (Montagnais), in Ontario near Deseronto (Mohawk) and in the Canadian West, chiefly in British Columbia's Skeena Valley (Gitxsan and Tsimshian) and in Alberta (Blackfoot and Stoney).

32. Anglophone regionalists came to Quebec in three waves. The first included Horatio Walker (mid-1880s); the second comprised the painters of Toronto's Canadian Art Club (1890s); and the third was characterized by the modernist regionalism of the Group of Seven (1920s and 1930s). Biéler was of the third wave by virtue of his close ties with the Group of Seven's A.Y. Jackson and Edwin Holgate.

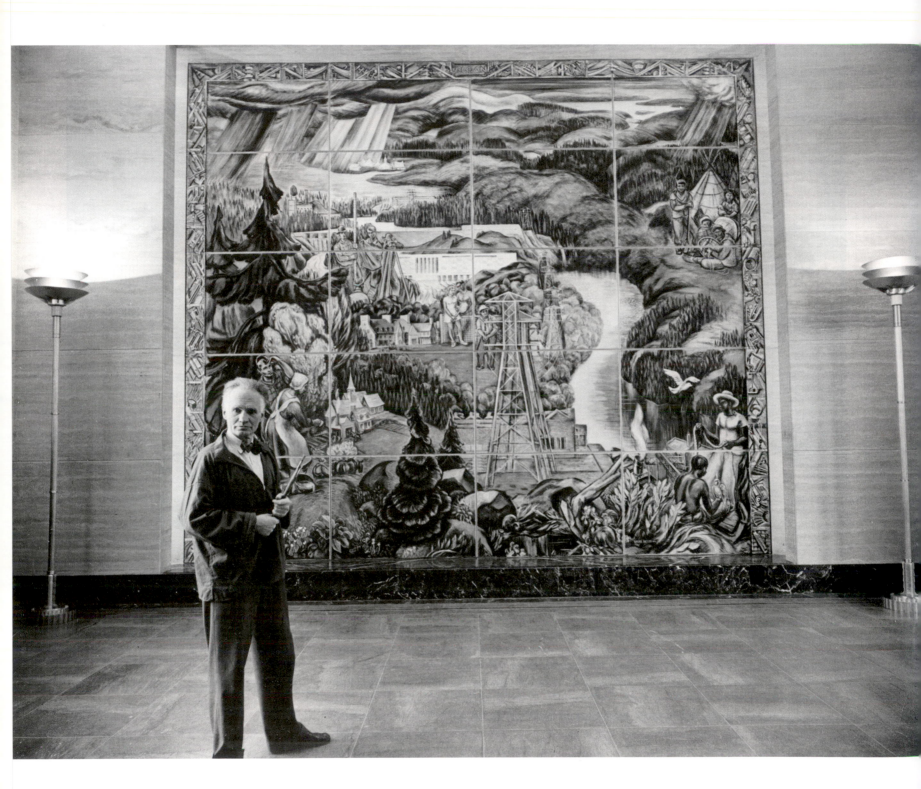

André Biéler in front of *The Shipshaw Mural*
Shipshaw, Québec, 1947
Painted aluminum panels
4.9 x 5.8 m
Collection of Alcan Inc

Lastly among the antinomic variations on culture in Biéler's life is the contrast between the Old World and the New. His Continental reflexes shielded him from a certain asymmetry, a certain neocolonial imbalance that placed English above French in the founding peoples' dialogue. This can be largely credited to his Swiss origins. In his own way, he achieved the regionalist ideal of living two cultures at once.

ETERNAL BEGINNING, OR THE ART OF SELF-REINVENTION

But does the culture of the Other actually exist? In the last analysis, is the Other not simply the imaginary complement of oneself? In the years spent living in generations-old houses in Sainte-Famille and Saint-Sauveur – which he furnished *à l'ancienne* – and exploring the back roads of the Charlevoix hills, the artist found emotion. He drew nourishment from Québec's "primitive" society until it fell apart before his eyes, as if the whole thing had been a mirage. While pleasant, his return visits to Québec after 1936 proved disappointing in this regard. Tradition had faded. These (translated) lines by the poet Charles Vildrac eloquently express the dilemma:

– You say that you love us, But you're going away...[36]

Study for Shipshaw, 1945
Ink and watercolour on paper
22 x 30 cm
Private collection

André Biéler's symbolic adieu to Québec, a mural completed in 1948 for Alcan's hydroelectric power station at Arvida, in the Saguenay region, is also his most consciously symmetrical and explicitly cultural project dedicated to La Belle Province. Aluminum and electricity promise the couple at the centre of the composition a new society of leisure, a bright future enabled by the technological advances spurred by World War II. The twenty component panels are unified by the arabesque of the Saguenay River. This work reconciles two visions of Quebec, that of its past and that of its future. It also references the peoples of the Greater Americas, including the Caribbean.

36. "Tu dis que tu nous aimes, Mais tu vas t'en aller..." Charles Vildrac, "Autre Paysage," *Livre d'amour* (1910).

In the margins, three groups – humble settlers, Natives and Blacks – practice their modest way of life, sustained by the bounty of the land. Far in the distance, the brimming Lac Saint-Jean underscores the river's abundance and eternal renewal. In the centre, near the modern-day couple, amid a landscape bristling with pylons, a dam and industrial structures, builders are hard at work.

From the infernal crucible of war has come a world of technology useful to Good, the artist seems to be saying. He had been deeply discouraged by the resurgence of global conflict and its incomparable violence. Now he was marvelling at the alchemy that transforms technological Evil into Good. In it he found reason to hope, and his optimism echoed the positive outlook that brought him to the middle of Île d'Orléans after the previous war.

Rougeoiements, 1985
(After-glow)
Oil on canvassed board
39 x 49 cm
Private collection

André Biéler's work is rich in lessons for postmodern times and art. He implicitly condemned the dogma of progress and artistic perfectibility, seeing there a breach of balance and a rift in the creative community. His humanist aesthetic was naturally opposed to formalist solipsism, and to anything that, in its exclusiveness and elitism, resembled the old doctrine of art for art's sake. Biéler moralized only against moralizers. And excluded only sectarians from the ecumenical cenacle.

His philosophy of art and life evokes the circle of continuity characteristic of First Nations thinking. The past and the future do not exist, for each opens onto the other. Biéler aspired to stability of the past in the present, to the permanent duality of this essential cohabitation. His works are marked by the distinctive rhythm – slow, serene breathing – that he urged upon the Kingston Conference delegates. Adept at repairing old clocks, he set his daily routine to the cadence of their antique mechanisms. His ability to infuse stilled timepieces with new life opened the doors to many homes on Île d'Orléans, and to the hearts of his neighbours. The moving pendulum recalls the indolent, inexorable oscillation of contrary principles. Like the extended cycle, the eternal beginning, his painting is in harmony with the passing of time.

David Karel

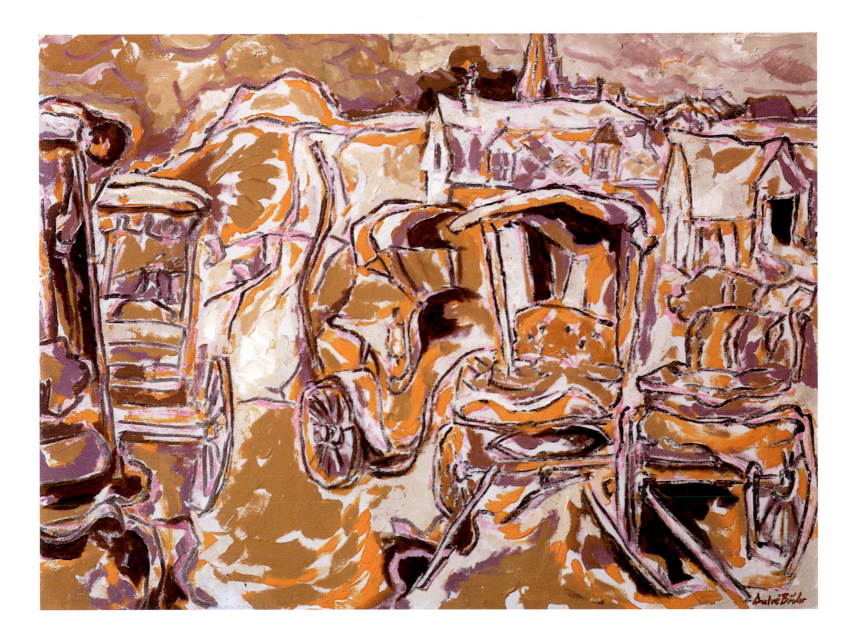

Les Voitures, 1970
(Carriages)
Acrylic on board
50 x 67.5 cm
Private collection

Page XXXV
Premières pousses, 1936
(First Sprouts)
Watercolour and pochoir technique
42 x 25 cm
Private collection

Page 1
André Biéler painting in the Laurentians
with his wife, Jeannette Meunier-Biéler, 1932.
A.B. Archives

ACKNOWLEDGEMENTS

The initial research for this book was supported by two Canada Council grants, in 1969 and 1970. These grants enabled me to examine, record and photograph over two thousand sketches, paintings, sculptures and prints by André Biéler, and for that I am most grateful.

Many people have helped my research in a variety of ways. Foremost among them are Jeannette and André Biéler, who generously put at my disposal a very extensive collection of family memoirs and diaries and hundreds of personal letters. They and their four children also patiently answered my many questions over the years and allowed me to record on tape their reminiscences. Friends of André Biéler who have shared with me their recollections of earlier years include Rita Grcer Allen, Thelma and Robert Ayre, Florence and John Bird, Charles Comfort, Allan Harrison, Elizabeth Harrison, Frances and Edwin Holgate, George Holt, H. G. Kettle, Carl Schaefer, Jack Shadbolt, Hazen Sise, George Swinton and Fred Taylor; to all of them, and to others too numerous to mention, I am greatly indebted. I am grateful also for the support of many colleagues in the university community and for access to the Queen's University Archives. Charles C. Hill, Curator of Post-Confederation Art of the National Gallery of Canada, has been consistently generous in sharing information.

My warm thanks go to the editor, Katherine Koller, for her skillful and patient work on the text and to Helen Wooldridge for helping the book through the production process.

My husband, Walter, has unfailingly shown much patience and culinary expertise during my preoccupation with the book and I am very grateful to him.

Frances K. Smith
Kingston, 1980

PROLOGUE

The foremost intention of this book is to present the art of André Biéler, in all its continuing variety, influenced by the cultures of Europe and Canada during a long and productive life. It is also intended to provide, through the focus of a dedicated artist and teacher, a close look at the vicissitudes that faced the artist in the Canadian society of the twentieth century, particularly through two world wars and the years of depression between them.

It is inherent in André Biéler's character that his energy and vision should be reflected, not only in his considerable creative output as an artist, but also in his lasting contribution to the cultural life of Canada. Europe had given him an insight into the honoured place that art and the artist could achieve in an older culture; in Canada he was concerned to find that the artist was virtually ignored in a society preoccupied with materialistic rather than cultural development. Communication between the artists themselves, in the east and west of the country, was almost nonexistent in the thirties.

An important aspect of this book is to examine the actions taken by André Biéler to alleviate this situation. On the national level, with the help of the Carnegie Corporation, he organized the first conference of Canadian artists, the Kingston Conference, held in 1941 at Queen's University. Its purpose was twofold: to bring artists from east and west together to get acquainted with each other; and to study the function of art in a democracy. The conference initiated national movements towards the understanding and appreciation of the role of the artist in the culture of a democracy – still relevant issues today. On the community level, his work as a teacher, both of art history and of painting and drawing in the studio, has been outstanding. An added dimension has been the establishment of the Agnes Etherington Art Centre as a public art gallery in Kingston, resulting from the vision and determination of two people, André Biéler and Agnes Etherington, and the support of Queen's University.

Some of the achievements of a life rich in human qualities unfold in this book, I believe; I am deeply conscious, however, that at best it is only a substitute for the privilege of friendship with the man himself.

Frances K. Smith
Kingston, 1980

Page 5
André Biéler, in his late eighties, in his studio
Harbour Place, Kingston, Ontario.
Photograph by Jacques Baylaucq

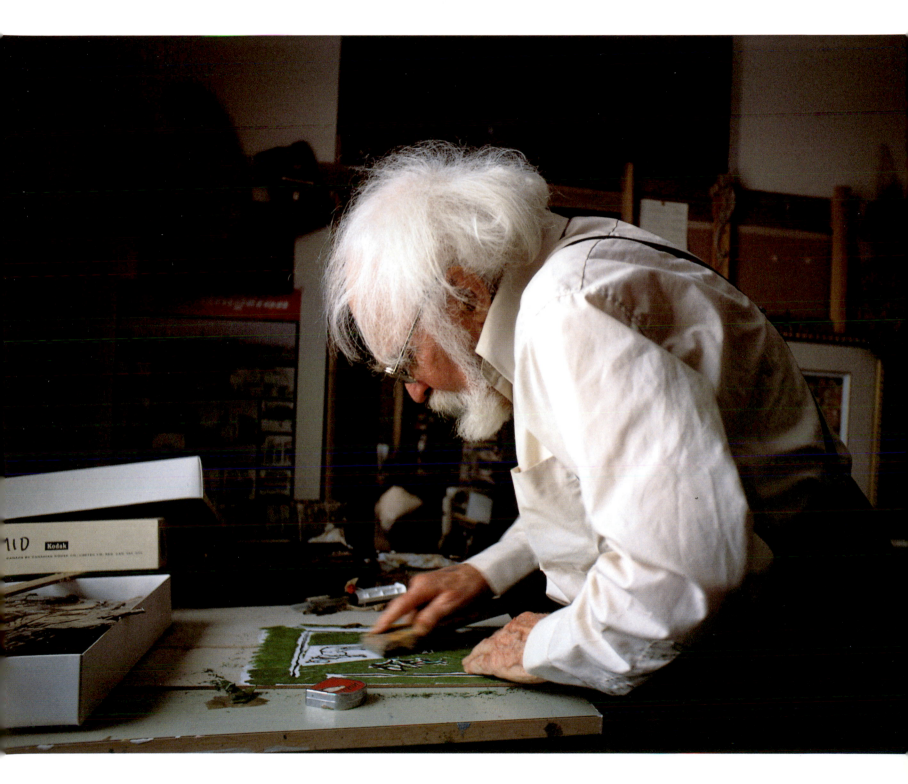

A PERFECT ATMOSPHERE FOR

Not that I am a man to think of the past entirely; I live in the present very much, but ... you can indulge yourself, because it was a very rich past, so that I can indulge in it and appreciate all its various aspects...

ANDRÉ BIÉLER

A CHILD 1896 - 1914

THE DE BUTZOWS

Nathalie de Butzow "brought into the family not the fortune which was wanting, but a rich heritage, Slavic and Nordic; the courage of the Philanders (her father was the son of a doctor, a Counselor of State of Viborg), the art and charm of the Poles (her mother was from Warsaw) and the perfect manners of Russian diplomacy, which was the sphere of action of her father."[3]

Charles de Butzow, Nathalie's father, was born in 1790 in Viborg, Finland, which was annexed by Russia in 1809. His uncle, Comte David d'Alopeus, insisted that he study the French language and helped him enter the Russian diplomatic service. In succession, Charles served in Constantinople; in Poland as secretary to the Grand Duke Constantine, then viceroy; in Danzig as consul general; and also in Berlin and Genoa as consul general. The journey from Berlin to Genoa at that time was a very complicated enterprise for a family with five small children; travelling by stagecoach, it took at least fifteen days to reach Genoa.

While in Warsaw in 1828, Charles de Butzow, a Protestant, had married Hélène Jezioranski, a member of the rural Polish nobility. This connection may have protected him during the 1830 revolution. Life in Poland under the Grand Duke Constantine was relatively liberal but not entirely satisfactory from the point of view of the Russian Czar Nicholas, brother of Constantine, when help from the Polish army was not forthcoming in the 1829 war with Turkey. The memoirs record, with humour: "Constantine refused to let his army leave; he needed it for his own very sumptuous and peaceful parades; for the rest, he declared to anyone who wanted to listen that a war is the ruin of an army, an opinion which has an element of truth."[4]

Nathalie, the grandmother of André Biéler, was born in Danzig in 1834 in the princely residence of the Russian consulate. The most influential period of her development, however, was during the twelve years she spent in Genoa, where the Russian consulate was a gathering place for Genoese society, foreigners and visitors. The abundant artistic resources of that prosperous city encouraged her interest in art and in painting, and in turn she passed her talents on to her family.

The year 1852 was a sad turning point for the de Butzow family. On a visit to Warsaw, Poland, to see relatives and friends, Charles de Butzow, aged sixty-two, succumbed within a period of twenty-four hours to a cholera epidemic. Hélène, leaving two sons at school in Saint Petersburg, returned to Genoa with her daughters, their means extremely reduced. For economic reasons, and through the contact they had made with the Swiss-French church in Genoa which they attended, they moved to Switzerland, first to Geneva and then to Rolle and the meeting with Samuel Biéler.

Samuel's veterinary profession at Rolle did not provide adequately for his growing family and they moved to Lausanne in 1865. As a professor of zoology, he resumed his personal studies and research, and became a pioneer in the early use of the microscope. He was a champion of scientific agriculture, which he popularized through lectures around the countryside and through his writing. Later, Samuel Biéler became director of the Institut agricole du Canton de Vaud and remained there for sixteen years. Among the recognition and honours that came in later life, an honorary doctorate from the University of Lausanne gave him particular joy.

There were years of poverty for the family, the early deaths of two children and, in 1879, the serious illness of both parents. Amidst these difficulties, the parents remained warm and devoted to their children. The character and intellect of each parent was remarkable. Nathalie had been called to bear a life of considerable hardship in comparison with the luxury of her youth, but she had the support of Samuel, "an exacting but kind father and an indulgent grandfather." They passed on many of their combined personal characteristics and interests to their children.

THE MERLE D'AUBIGNÉ

Largely because of the popularity of *L'Histoire de la Réformation* by Jean-Henri Merle d'Aubigné, the Merle d'Aubigné family name was internationally known at the time of the marriage of Charles Biéler and Blanche Merle d'Aubigné. In 1930, Blanche Biéler, André's mother, published *Une Famille du Refuge,* which traced the origin and family connections of her father – a subject that was frequently discussed among the Biéler family. The ancestors of Jean-Henri's father, Aimé Robert Merle, were French Protestant refugees, descended on one side from the Huguenot leader Agrippa d'Aubigné (1552-1630), poet and historian, who served Henry IV as soldier, friend and counselor. Forced to leave France under Louis XIII's persecution of the Protestants, Agrippa crossed the country on horseback with his son Nathan and took refuge in Geneva, where he spent the last ten years of his life. Another son of Agrippa, the adventurer Constant, was the father of Françoise d'Aubigné, who, as the consort of Louis XIV, was known as Madame de Maintenon.

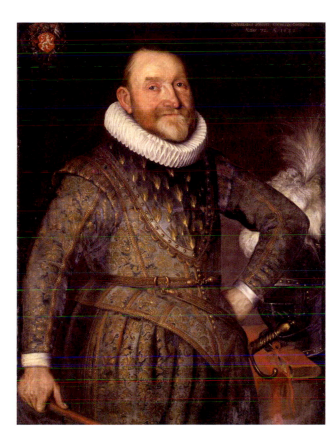

Agrippa d'Aubigné as Maréchal des logis
Ancestor of André Biéler
Portrait by Bartholomäus Sarburgh
109.5 x 77.5 cm
Collection of the Kunstmuseum, Basel

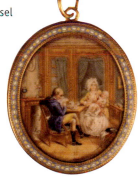

Miniature portrait of
Aimé Robert Merle d'Aubigné,
Elisabeth Barbezat and their son
Guillaume in 1790
Unknown artist
M. Merle d'Aubigné Archives, Paris

Portrait of
Aimé Robert Merle d'Aubigné
Unknown artist
M. Merle d'Aubigné Archives, Paris

In Switzerland, the d'Aubigné line descended from Nathan to his grandson Georges Louis (1680-1732) and then through Elizabeth, daughter of Georges Louis, who married François Merle in 1743. The sons of François and Elizabeth, in the latter part of the eighteenth century, adopted the double name of Merle d'Aubigné, finding that there were altogether too many Merles.

The father of François Merle, Jean Louis, was also a Huguenot. He fled from his home in Nîmes, France, following the *Revocation de l'Edit de Nantes* in 1685, walking by night and hiding by day. Crossing the Alps to find refuge with the Huguenot colony at Lausanne, he thus made the acquaintance of the d'Aubigné family.

Aimé Robert Merle d'Aubigné (1755-1799), father of Jean-Henri, was the second son of François and Elizabeth. As a youth, he was trained in the honourable Swiss profession of watchmaking, although it was against his inclinations. At the age of twenty-one, he broke away and traveled throughout Europe, very much a disciple of Rousseau. On his return to Geneva he married Elisabeth Barbezat, who was also descended from a Huguenot refugee family. They settled at a house called La Graveline in the district of Eaux-Vives, Geneva. This beloved home remained in the Merle d'Aubigné family until 1912. It satisfied, in many ways, Aimé Robert's Rousseau-inspired plans for his family and fellow citizens; there was sun, fresh air and few constraints. He succeeded in establishing a public swimming school on the shores of Lac Léman near his property. An active and imaginative individual, he established an international postal and courier service operating from neutral Geneva in about 1789. The system was accepted by the Committee for Public Safety of the Republic and for a number of years, important and confidential dispatches from all directions passed through his hands. The irony of this operation was observed by Blanche Biéler: "A curious anomaly that this Genevan should be directing a confidential service of the French Republic, that this so-called aristocrat should be carrying out the affairs of the Jacobins and that those *sans-culottes* should accord their correspondent, without flinching, the detested particle."[5]

An amusing story exists in the family about an event that occurred in Marseilles in March 1796. The brothers Jean Louis and Aimé Robert Merle d'Aubigné were friends and business acquaintances of the banking family Clary. Eugenie Désirée Clary, their younger daughter, had captured the heart of Napoleon Bonaparte about two years earlier, and the couple had been officially engaged. To Désirée's distress, the news of Bonaparte's pending marriage to Josephine de Beauharnais in the spring of 1796 reached the Clary family. In March, when the brothers Merle d'Aubigné were visiting the Clary family, they witnessed the unexpected arrival of the general. Animated discussion followed,

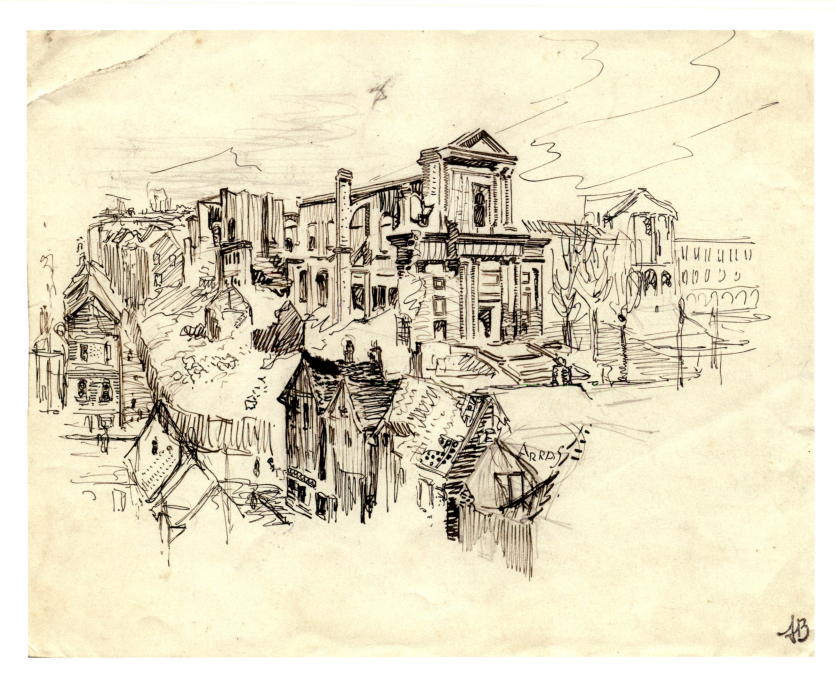

Arras Ruins, 1917
Ink on paper
17 x 22 cm
Collection of the Canadian War Museum
Gift of Sylvie Biéler Baylaucq

Pages 26-27
André Biéler and his regimental companions
A.B. Archives

A NEED TO DRAW, DRAW, DRAW

2

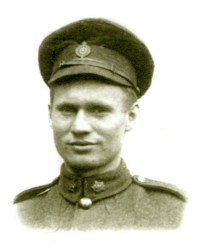

T he war years can be seen now as a period during which the casualties of the artist and the humanist developed in André Biéler's character. It was a point of maturity for him, young as he was; his mother recorded that "he left an adolescent and now his brothers declare that he has become a man. He had experienced all the hardships, the responsibilities, the trials and the joys which go to form a character and give it its distinctive stamp."[1]

André enlisted in the First University Company of the Princess Patricia's Canadian Light Infantry (PPCLI) in May 1915, following the example of his brothers Jean and Etienne: his brother Philippe followed in 1916. About eighty-five of the letters he wrote from the Front to his parents and brothers have survived. They were written in French, in courtesy to his parents, although in 1916 André observed that he would find it easier to write in English; his comrades were English-speaking. Together with his mother's chronicle, these letters reveal the shaping nature of his war experiences on his character and his personal interests.

Writing to his mother in August 1915, he treated the misery and privations of the trenches with a youthful humour:

> We have had a lot of rain these last days and naturally we enjoy the inevitable mud in the holes where we sleep, but we do not lie down very often, having had only two hours rest last night (and those two hours not consecutive) you can imagine that I was in a great good humour to cook my breakfast with damp wood on my knees in the mud![2]

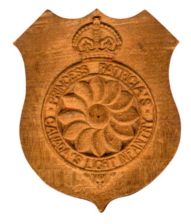

André Biéler in uniform; at base, a shoulder pin of the Canadian Infantry
A.B. Archives

Crest of the Princess Patricia Regimental Canadian Light Infantry, 1915
Sculpted in England by André and Etienne Biéler
Windsor Forest oak
17 x 13 cm
Collection of the Canadian War Museum
Gift of the estate of André and Jeannette Biéler

Jacques, Philippe and parents at La Clairière, 1916. A.B. Archives.

Battlefield at Passchendaele, 1917. A.B. Archives.

He enjoyed the touch of drama it required to be able to portray life in the trenches with colour and wit. This was a notable characteristic of his letters to Blanche, and strengthened the sense of rapport between mother and son. In the word picture he painted of the trenches in September of that year, he was aware of the contrast between the two different worlds he and his family lived in:

Mother sent me a fine description of your salon, which must be very pleasant and comfortable, but it's not a patch on our life in our little sheds. It's true that we can't stand upright, and that there are more holes than canvas at one end, but in the evenings it's not too bad lying on the beaten earth or when it rains in the mud, with a candle on your box of rations to read by, or when an old soldier tells us stories of different wars...³

André would disclaim the suggestion that he was a writer; paint was to become his medium – colour and line. But he had one of the essential qualities of the born letter writer: the style and content of his prose changed with the person to whom he was writing. This was an extension of his natural human sympathy. Thus he writes to his two younger brothers, Philippe and Jacques, who had made photographs of the Biéler farmhouse for his birthday:

When I am on sentry duty and when I look into the periscope (which has just about the same dimensions as a photograph) I see the two lines of the Huns, cut into the chalk, and on the first plane our barbed wire barriers ... seemingly impenetrable, and all to the accompaniment of the thunder of the terrible bombardment of Arras, then I glance for a few moments at those marvellous photographs of La Clairière, and especially of the dining room with cups, and linen, and the comforting smile on all the faces, and that makes me feel very good.⁴

His innate visual sense, the eye of the artist, was developed and heightened by the verbal expression called for in the human communication of letters, so necessary to him during the war.

This young soldier, a member of a family with a strong protestant and evangelical tradition by profession and inclination, was not weighted down by the dangers and sufferings of war but instead found within himself the strength and outlook of mind with which to accept them. The war letters show this throughout. He did not write in terms of religious imagery; rather he described in human and realistic terms the aspect of a situation which made it supportable. The severest test of his faith in these years came with the sudden death of his brother Philippe in France in October 1917. During the short time Philippe had been at the Front the meetings between the brothers were highlights for André in the seemingly endless duration of this unnatural life. They had shared closely the first months of their arrival in America, struggling with the English language together in Vermont, and the news of Philippe's death "made a terrible gap" in André's life. A letter to his parents shortly afterwards, searching for some consolation for them and perhaps for himself, ended with "take courage, he has done his duty."⁵ But the deep sense of loss remained.

André had been preparing to study architecture at the outbreak of war, a career which he had felt might involve both his drawing ability and his love of making things. In the army, therefore, he took the opportunity to visit cathedrals and museums in the cities of Europe. His opinion of Canterbury Cathedral was that it had "too great a mixture of styles and proportions to be very beautiful." An escapade with a friend took him to Amiens, and the raconteur took over:

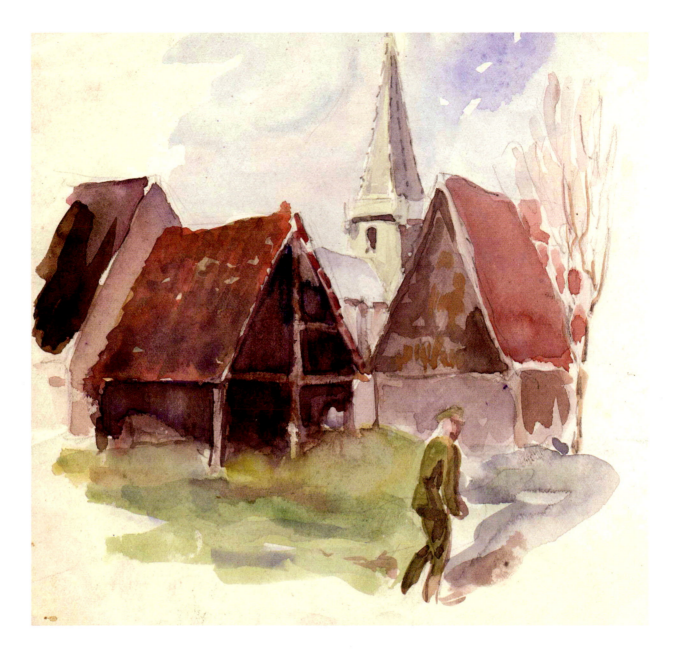

Canadian Soldier in a Wartime Landscape, 1917
Watercolour on paper
17 x 17 cm
Collection of the
Canadian War Museum
Gift of Sylvie Biéler Baylaucq

Two hours crossing through woods, fields and paths brought us to the end of the electric tramway, with conductors who were either men with white beards or boys of fourteen or fifteen years. Twenty minutes of zigzagging through the tortuous little streets and fine modern squares brought us in front of what I believe to be the most beautiful thing I have ever seen in my life! The cathedral, after Notre Dame, Montréal, and several other fine specimens of French-Canadian architecture, it gave us a shock ... the interior was still better than the exterior – the great height is what most impressed me.[6]

The two friends returned to their base after a memorable meal in a restaurant – their first seated at a table in four months – resigned to face the following day not a battle with the Boches but the jealous ire of the battalion!

Sanctuary Wood, that fierce bombardment of 1 to 3 June 1916, was a traumatic experience; André was buried twice but was extricated by his comrades. A leg wound sent him to hospital in France and his convalescence there gave him unexpected opportunities of

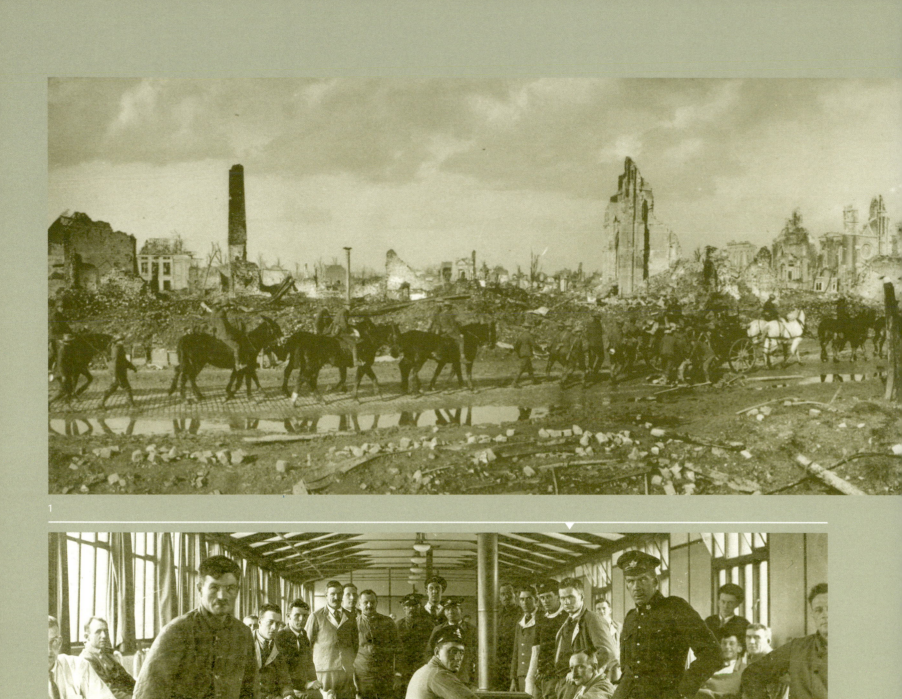

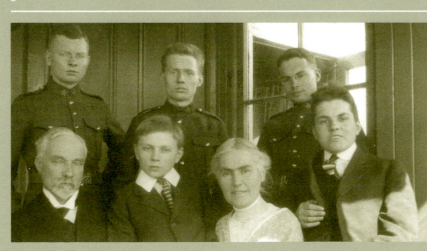

All images A.B. Archives (except for 1 & 4)

1. Canadian troops passing in front of the ruins of "la Halle-aux-Draps" at Ypres in Flanders. Imperial War Museum, London, U.K. (CO-3881)

2. André Biéler, fourth to the right of the stovepipe, convalescing in a military hospital in 1917, following the battle for Vimy Ridge.

3. The Biéler family, from left to right; Etienne, André, Jean, Philippe and, between his parents, younger brother Jacques.

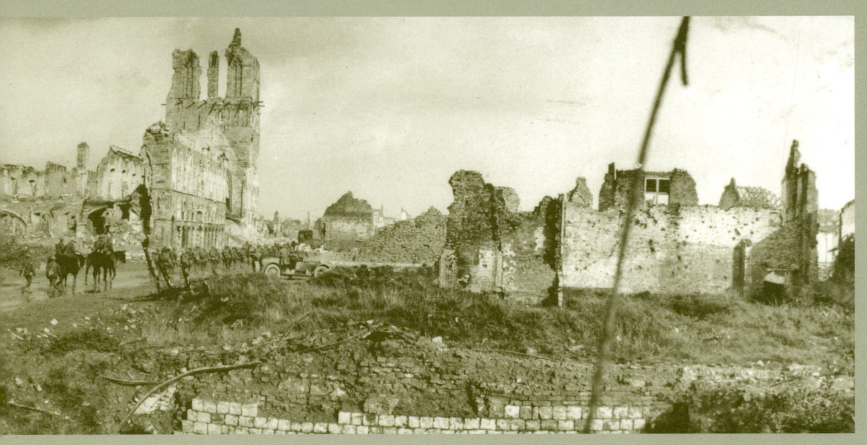

4

5

4. Canadian Commandment inspecting large-scale Canadian army crests reproduced on the grounds of a Canadian field hospital, in France. National Archives of Canada (PA-2730)

5. Canadian Corps Headquarters, at Camblain-l'Abbé, in France.

6. Philippe Biéler, in uniform, 25 January 1917.

7. The Commonwealth Military Cemetery at Aubigny-sur-Artois, Philippe Biéler's burial place.

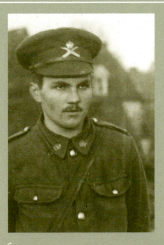

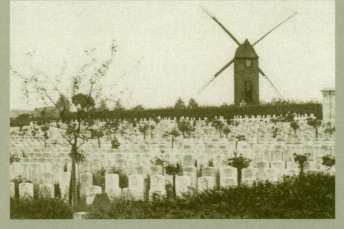

6

7

Place Vendôme and *View of Sacré-Coeur,* Paris, August 1917
Ink sketches on a letter written home while on leave
Queen's University Archives

a very different order. He passed the time by sketching his fellow patients and the environment of the hospital. In response to an appeal for *dessinateurs*, he made an application to Army Head-quarters, hoping to find an outlet for his skills and imagination. In August 1916, he began to make a series of mosaics of regimental emblems on the lawns of the hospital garden (repr. p. 33 #4). With characteristic resourcefulness, he found the materials for the mosaics in the environment: sand and shells from the beach for whites; pulverized charcoal for black; powdered bricks for red; broken glass bottles for green. Interest in these designs spread and an officer remarked that he should be employed in "un service artistique de l'armée." His mother recorded in her journal that "this appreciation brought to life in André hopes that had been put off for a very long time. Meanwhile, his chiefs, who had the same ideas, did not rush to send him back to the Front but entrusted him with some of the peaceful duties of a quartermaster."[7]

But this did not last. At the end of the year he was sent back to the Front. He anticipated this with some chagrin:

> I am really afraid that it has all fallen through. I was told to make an application some time ago already, giving a great deal of importance to the number of years working in a studio which in my case is natu-rally none, so that I am waiting to be sent back to the battalion.[8]

The year 1917 brought a cold winter of waiting in the trenches as preparations were made for the attack on Vimy Ridge in April. André's letters about Vimy Ridge were visually oriented and showed his appreciation of the beauty of the military tactics. The raconteur emerged once again as he wrote of coming face to face with the Germans, of finding the luxury of the enemy trenches, complete with electricity, furniture taken from nearby French châteaux and an abundance of food and champagne. But there was the other side, the terrible loss or wounds of his comrades, endurable only as that which is necessary to bring the war closer to its end.

Another slight wound and a brief period in hospital was followed by leave and permission to visit Paris in August 1917. There André felt at home and experienced a new excitement and sense of purpose as he explored the city. Architecture still domi-nated his interests and a long letter to his mother is illustrated with vignettes of the Eiffel Tower, Place Vendôme and Sacré-Coeur. Two of them are shown here. He also saw some of the war paintings at the Hôtel des Invalides, and commented that they were "not bad but too small." He was particularly impressed by some of the fine works by Rodin in the sculpture galleries of the Louvre. Sculpture had been of little interest to him before.

André Biéler on leave, Neuilly, Paris, August 1917.
Photographed with his cousin Robert Merle-d'Aubigné
A.B. Archives

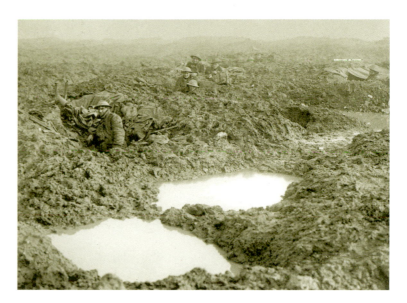

Soldiers of the 16th Canadian Machine Gun Company
in the mud fields of Passchendaele, Flanders.
Collection of the Imperial War Museum, London, U.K. (CO-2246)

The horror and heroism of the three days and nights of the battle of Passchendaele and the preliminary bombardment of the Princess Pats among the ruins of Ypres from 23 to 27 October 1917 is recorded in visual terms in the family chronicle: "André has un souvenir dantesque of these midnight hours among the decapitated pillars and broken arches of the Halle aux Draps (repr. p. 32-33). The night, the gigantic ruins illuminated by the uncertain glimmerings of camp fires, etching against the night sky the profiles, the shadows, the fantastic lighting effects which would have been the delight of Rembrandt or of Gustave Doré."[9] This nineteenth-century romantic description expresses Blanche Biéler's love of drama, a heritage from the family's evangelical tradition. At a critical point of the battle, separated from his company with a few comrades, André was called on to act as a "runner" – to take an important message to General Headquarters – and had to cross through the bombardment to do so. There he was called on to act as a guide in the final relief of the Princess Pats, who had sustained ninety-five hours of combat, and he found himself leading three hundred men across swamps and craters. He was just twenty-one years of age. Almost asleep on their feet, the troops were attacked by gas. Set against the drama of the situation recalled in retrospect, André presented a touch of reality in a letter of November 1917:

We had to cross miles and miles of seas of mud ... on leaving, the *Boches* sent gas after us and it looked rather black; we wore our masks, naturally, but it was extremely difficult to see through the glass; I took a false step and two men were needed to pull me out of the mud.[10]

The gassing had serious and lasting effects on André's health.

He was transferred to the topographical section of the Canadian Corps Headquarters shortly afterwards and worked as a draftsman until the end of the war. He became a sergeant in charge of a section at the age of twenty-two. The environment at Headquarters was most agreeable to him – "la différence avec le bataillon est comme le noir et blanc" – and André was able to learn from the mixed group of commercial artists and cartographers with whom he worked. Sketching and painting were pursued by everyone whenever time permitted and, for André, it became a self-training period. Visits from Cullen, Varley and other war artists from time to time further stimulated his interest in art and perhaps helped to signal the direction of his life.

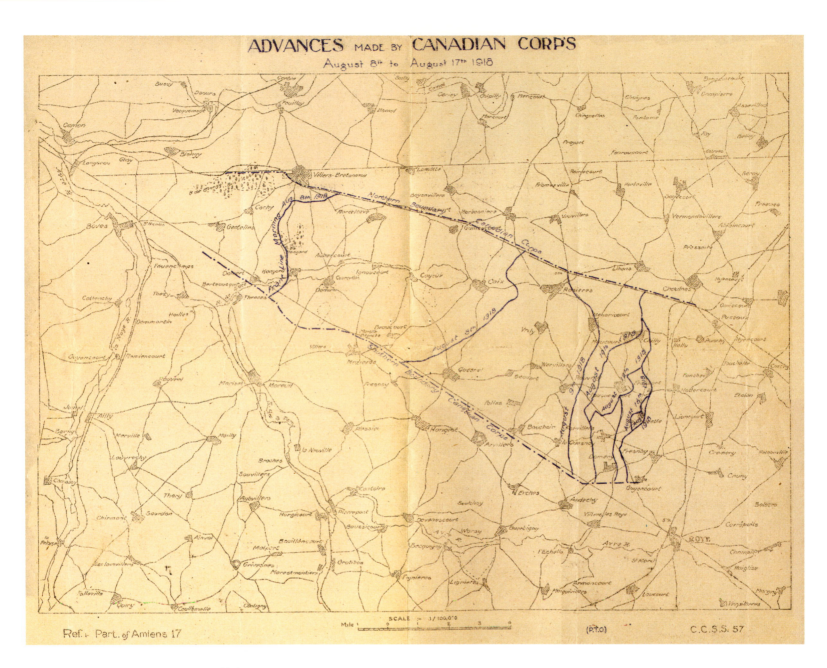

ADVANCES MADE BY CANADIAN CORPS
August 8th to August 17th 1918

WW1 map found in the artist's personal belongings.
Collection of the Canadian War Museum
Gift of the estate of André and Jeannette Biéler

But although he had found a congenial milieu in the topographical section, and had made new artist friends, life was still uncertain. The general war-weariness of the spring of 1918 was emphasized by contact with French civilians in towns and villages where life was far from easy and food was scarce. His bilingual ability brought him close to the people and made him acutely conscious of the aftermath of war. His concern for the future was a very practical one and he wrote to his parents, asking them to seek advice about architecture – he feared it might be a "dead profession" for some years. But perhaps he should consider naval architecture and reviving an offer of an apprenticeship he had had before the war? He realized the problem of finding a position when everyone returned to Canada at once – but he had no thoughts of making a living as an artist in Canadian society at that

time. His immediate concern was training and study, which he knew he would need for whatever avenue he followed.

The autumn of 1918, with victory and an armistice in sight, was a period of renewed excitement and anticipation of returning home. An attack of *grippe espagnole*, bronchitis and asthma, aggravated by the gassing at Passchendaele, hastened his move to hospital at Birmingham University, followed by convalescent camps in the south of England. The cold and humidity of an English winter tried his health still more and a medical board finally ordered him to be "invalided to Canada" with instructions for three months of treatment in the open air. He arrived back in Montreal on 11 April 1919, broken in health, after almost four years' absence from his family.

Historian Arthur Lower, writing of this war which had encroached on four years of André's life, commented that although "Canada entered the war a colony, she emerged from it close to an independent state."[11] The Canadian response to the outbreak of war was, he found, conditioned by several factors: war required the vigorous execution of physical tasks, the qualities the pioneer had needed and developed in coping with the wilderness or building a railroad through forests and mountains. But outlets for this sort of individualism were restricted by economic problems during the summer of 1914 and the war called forth primarily men with close links to Great Britain – England was threatened. The French Canadians, however, the people of the New World, had little knowledge of European conditions. The fusion of emotions between the English and French inspired by the idealism of the call, "this was a great world conflict for existence and for freedom itself," was short-lived and waned quickly for French Canadians, and the old hostile attitudes between the two cultures returned. The "near independent state" was still a house divided, in spite of a very definite movement towards nationalism.

The historian must generalize on this issue. To the individual soldier, the perspective was different – much more so to André Biéler, a young man with a European background (but not an English one) by family and tradition, bilingual and without the experience of the "hardy pioneer." Why did André enlist? He recalled that there was a sense of adventure, of adventure undertaken not alone but with friends, in response to the heightened atmosphere of political (albeit patriotic) pressure. Everyone thought that the war was not going to last long; it would be a "brief encounter." In retrospect, the national and patriotic motivation, which had been a part of his emotional involvement in 1915, has faded from André's memory. In contrast, the human and personal elements of adventure and comradeship that emerged from the experience remain.

Sainte-Anne-de-Bellevue, Québec, 1919
(Near the Veterans' Hospital)
Coloured pencil on card
15 x 18 cm
Private collection

Blanche Biéler, her sister Julia, André and his father
Charles, circa 1919.
A.B. Archives

William Shakespeare's *Merchant of Venice*
Stetson University Drama Department annual play for 1920
Painting the set was André Biéler's first paid job as an artist.
Stetson University Archives

Front cover of the 1920 Stetson University Yearbook by André Biéler
"Oshihiyi" is the word for mockingbird in the language
of the Seminole First Nations peoples of Florida.
Stetson University Archives

His mother visited him in February 1920 and spent an hour in the studio crowded with his latest works: pencil sketches, studies in oil, models to be photographed for the college yearbook, other projects for decoration – all of which so filled the room that his master said to her, laughing, "André takes over all the space; there is nothing left for me to do but to retire to the woodshed!"[16]

During this visit, mother and son discussed the possibilities for future studies in art. Should André look for a place to study in the Atlantic region of the United States, in California (where his teacher, Fluhart, would go in April) or in Europe, perhaps with his artist uncle, Ernest Biéler? André wrote to Switzerland and received a warm letter from Ernest Biéler, who outlined his own philosophy of art education:

But it is now a question of undertaking serious studies, in which you are a little behind. To my mind it is in Paris where you can best learn the basis of art studies. I am ignoring the value of studies in the schools of the U.S. When I was in the Paris atelier, I had many American fellow-students – at that time there were no art schools in the U.S. and all the young people who felt they had talent came to Paris. Perhaps they returned and founded ateliers... To give you good advice I should first see your work, in painting and drawing, then I would know a little of your tastes. If it is landscape or figure or decorative compositions which interest you, then I could say how much time you would need to give to your studies, and what studies to follow. Moreover, it will be important to know – if you intend to follow your career in Europe, in Switzerland or in Canada – national sentiment is not indifferent in artistic affairs – and internationalism has long since disappeared. As for me, I will not return to Paris... And if you come to Switzerland, I would be very happy. Next year I will be making a large fresco in Le Locle, for which I am

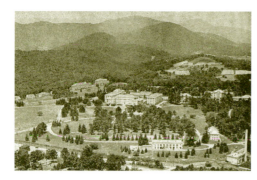

Three views of the Veterans Hospital at Asheville, North Carolina, in the 1920s. Asheville Hospital Archives

preparing the cartoons. 1 would willingly take you as my helper at that time, if you have followed serious preliminary studies, and you could also do here an apprenticeship as a decorator with several artists who will be working with me, among others the master of stained glass of whom you spoke in your letter... We will speak of this again...[17]

This tentative offer from his uncle, suggesting future possibilities, was very encouraging to him. It cost him very little to live in Stetson in 1920. He paid Fluhart fifteen dollars a month for his bed, and wrote: "We make our own breakfast on an electric hotplate, coffee, bread and preserves, and then to work. I have dinner and supper at the restaurant, forty-one cents a meal, which isn't ruinous."[18] At that time, he received a small army pension of thirty-six dollars a month and was therefore delighted to earn twenty dollars from the professor of drama for painting curtains and scenery for the annual theatrical performance – "the first earnings of his artistic career."[19] He also gave lessons in French to a student, and earned one dollar per lesson per day. Thus he reached a measure of financial independence which he strove to maintain in the years following.

There was, however, no miraculous cure for his asthma. In March 1920, having had a medical examination for his pension, he related in a letter to his father: "The doctor tells me things which are not very pleasant to hear; he does not believe that I will ever be free of asthma." In April, perhaps aggravated by the pollen of the trees and flowers, he had another attack – all of which served to add a practical consideration to his dedication to art: "More and more I believe that painting is my proper career. I can choose my climate, I can work outside or inside and after all it is not such a regular employment that if I have a little attack I will lose my position."[20]

In about May 1920, he started to go north through the southern states, earning money en route by retouching and painting opera house curtains. Later, he described this unusual activity:

Well, they were the big showy curtains, red plush with tassels hanging, all that painted by trompe l'oeil means. I must say I knew very little about it but by looking closely at what had been done... really the thing is that I found there was a need for it. I found out who was in charge in each town and I suppose I just charged in and asked them... after all, I had to eat.

This ability to see possibilities, exposing an imaginative but practical range of his personality, emerges time and again throughout André's life.

In Asheville, North Carolina, he spent several weeks in a veteran's hospital in June 1920: "The results are magnificent. I have never been so well since the armistice, the climate seems to be the very best..."[21] He recalled that in Asheville he met "a very fine person, Bertha Thompson. I think she was a social worker ... a great friend of Whitehead's, and she had a cottage near him at Byrdcliffe in Woodstock, New York." They became warm friends. After seeing some of his sketches, Miss Thompson encouraged André to go to the Art Students' League Summer School at Woodstock. André's decision to use his veteran's grant for study at Woodstock during the summer of 1920 was a crucial moment in his life. He took this step with seriousness as if to test himself: "It seems that this is quite a remarkable school and a centre for artists. It is absolutely essential that I see what I can do in an artist's milieu. Perhaps I will be disappointed and even perhaps renounce art completely, but I will never be satisfied before having tried this."[22]

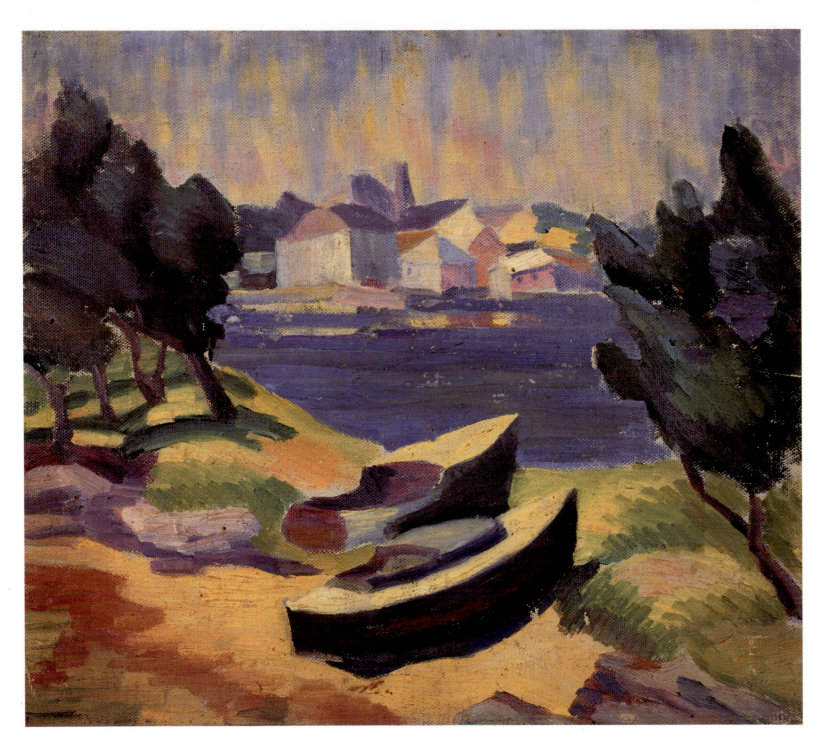

Hamilton, Bermuda, 1921
Oil on board
29.5 x 34 cm
Masterworks Collection, Hamilton, Bermuda

His experience in Woodstock proved to be one of the most important and exciting stages in his development. The Art Students' League Summer School was small at the time and the students were mostly veterans – an honoured status, he found, when *Le bon propriétaire* of his *pension* reduced the cost of his room and board from twelve to ten dollars a week in recognition of his war service. Perhaps, as veterans, the students also established particularly sympathetic relationships, not only with the teachers, Charles Rosen and Eugene Speicher, but also with other artists of the Woodstock group.

Through his friendship with Bertha Thompson, André was introduced to the American painter Birge Harrison, then about sixty-four years old. who had spent time in Paris during his student days and later. There was an immediate empathy between them, and Harrison would recall vividly in stories the life of the artists' colonies in Paris. He found André an eager listener; the background of his own early years in Paris and his visits during the war were points of contact. Miss Thompson also took him to Byrdcliffe, an arts and crafts settlement where her friend, Ralph Radcliffe Whitehead (1854-1929), an Englishman educated at Oxford and a follower of Ruskin and William Morris, endeavoured to embody their principles into the group. The small cottages, where individuals worked at their crafts, making jewelry, ceramics, furniture and other *objets d'art*, were accessible only by footpaths. A della Robbia, *Madonna and Child*, at the entrance established the atmosphere.

André also met George Bellows, who had been a member of the Association of American Painters and Sculptors at the time of the Armory Show in 1913 and who, to quote Andre, "was a splendid character, a very fine painter, a very interesting painter. He had ceased teaching but for us he opened up his studio and would show us his work and talk at great length about art, and about his own way of painting." At that time Bellows had become fascinated by Jay Hambidge's demonstration of dynamic symmetry and was experimenting with Hardesty Maratta's colour system. He could be seen in Woodstock, as in the old photograph reproduced on page 45, fixing a carrier on his car, which, the location having been reached, was taken off to reveal a wheeled cart which held "the kit" of 144 colours, easel and seat. He then proceeded to push this to his desired spot; once there he worked in a controlled harmony of colours in accordance with the new theory. Bellows' concern with theories, the suppression of his flowing brush stroke, may have produced work that lacked something of the organic vigor of his earlier paintings, but the lively curiosity and enthusiasm of his personality were very contagious and had a natural affinity with André Biéler's temperament.

Sketch of a Tree, 1921
Lead pencil on paper
21 x 16.5 cm
Private collection

View of Woodstock, New York, 1921
Oil on board
40.5 x 30 cm
Private collection

Front cover of *Vision and Design*
by Roger Fry (first edition)
A.B. Archives

The Armory Show of 1913 had left an indelible mark on Bellows and on the artists and teachers of the Woodstock colony. André names Cézanne as the hero at the Summer School: "We did all our sketches in the manner of Cézanne, trying to understand his arrangement of form, and so on, and it was very profitable because it gave me an inkling as to what was going on later with the cubists." André found the weekly group criticisms, one outside before the subject and one in the studio, extremely instructive and he began to use colour in a lively way, he reported that "here sunlight is painted completely in a lively key, not as Fluhart did, like the evening and things that were sad."[23]

André received the prize for the greatest progress at Woodstock, and the stimulating teaching there was augmented by the publication of Roger Fry's *Vision and Design* in 1920: "When I first got the book it was the big edition with the great full-page illustrations, a very fine book indeed. It just thrilled me so much that no other book has ever influenced me to such an extent. None whatever. I had no inkling that modern art was really connected with the art of the past – the beautiful relationship he makes with Giotto, Cézanne, Renoir and all these people... his lucid manner of presentation, all that was really a great opening for me." About that time, André was also introduced to Vollard's book on Cézanne; the French edition was lent to him by a librarian friend in Montréal, and also had a significant influence on him.

The generative influence in America of the Armory Show was manifold. This First International Exhibition of Modern Art was held from 17 February to 15 March 1913, in improvised rooms within the Armory of the Sixty-Ninth Regiment on Lexington Avenue, New York. It was the realization of what had seemed an impossible dream; without any official backing or support, financial or otherwise, the Association of American Painters and Sculptors had collected and arranged the exhibition of more than twelve hundred works of art, both foreign and American. Intended to stimulate awareness of modern art, and to shock American complacency, it opened to four thousand visitors on 17 February 1913, with flags flying and a fanfare of trumpets. It was hailed by the press as "sensational" and "magnificent"; the Association was lauded, and the American Academy of the Fine Arts was criticized and even ridiculed. The Armory Show offered an introduction to modern European art, to Cézanne, Van Gogh, Gauguin, to Fauvism, cubism and expressionism, which was a revelation to a generation of American artists, collectors and the American public – although that public saw much of it as an aberration. Many American artists had spent periods of study in Paris; there was considerably more movement between New York and Paris than between Montréal and Paris in the early years of the twentieth century. The Armory Show brought modernism home, pointed the way to new

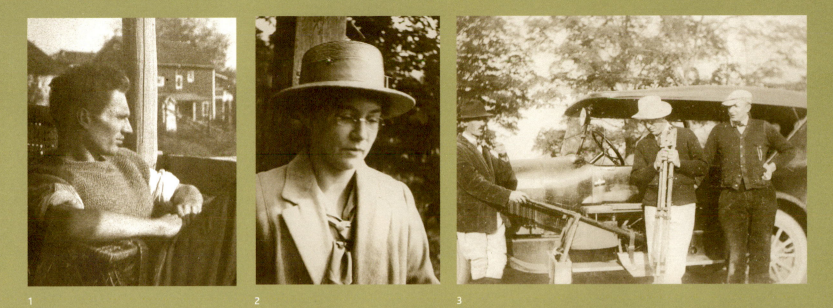

1 2 3

All images from A.B. Archives
(except for 2)

1. André Biéler at Woodstock,
 New York, 1920.

2. Bertha Thompson in North
 Carolina, 1925.
 (Thompson Family Papers,
 2000 M1)
 Schlesinger Library,
 Radcliffe Institute,
 Harvard University.

3. From left to right, Charles
 Rosen, Eugene Speicher,
 George Bellows at
 Woodstock, 1921.

4 & 6. André Biéler with his friends
 at Woodstock, 1921.

5. Dressed as "Pierrot" for the
 Woodstock Maverick
 festivities, 1921.

4

5

6

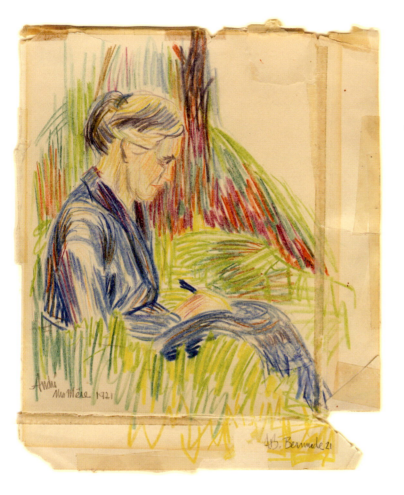

Page 49
Installation view, Metropolitan Museum of Art, New York, during the 1921 Impressionists and Post-impressionists Exhibition. This view shows a range of paintings, from Matisse through Gauguin, Derain, Picasso and then, on the right wall, Seurat, Toulouse-Lautrec and Cézanne. A Rouault and Cézanne hang in the doorway at right, Matisse's *Italian woman* is located second from the left.
Metropolitan Museum of Art archives
MM-254

Blanche Biéler in Bermuda, 1921
Coloured pencil on paper
21 x 17 cm
Private collection

Once again it was André's health that determined a return to the south and he went to Bermuda with his mother in February 1921, staying there until April after his mother's return to Canada in March. A house on a hill overlooking the capital, Hamilton, with its busy harbour, white houses, white coral, surrounded by pines – all this offered unending subject matter to the young painter, who delighted in the inexhaustible pleasures of sunlight playing on the shapes of landscapes and of people. In Bermuda, he made friends with the American painter Daniel Brinley and they spent much time together. But, on his own admission in letters home, part of the time he was not well. Then he discovered that a great number of the inhabitants of the island had asthma – perhaps owing to the persistent wind – and on the doctor's advice he spent his last two weeks in Bermuda in hospital at Hamilton. Only a few examples of his work as a student at Woodstock and in Bermuda remain. *Catskill Landscape* (repr. p. 51) and *Hamilton, Bermuda* (repr. p. 42) show the power of organization of form he had gained from the Cézanne-oriented teaching at Woodstock.

When he left Bermuda, he went directly to his good friends the Charles Rosen family, in New Hope, Pennsylvania, in May. "I showed my canvases to Mr. Rosen yesterday," he wrote, "and he congratulated me very much on my work ... I am much encouraged ... I have had many long conversations with Mr. Rosen. He is an extraordinary man; his discourses on art are captivating; I am indeed fortunate."[26] Another attack of bronchitis kept him with the Rosens for another week but he spent two days in New York City on the way back to Woodstock, to see an important exhibition at the Metropolitan Museum of Art, entitled "Impressionists and Post-Impressionists." He wrote to his mother: "On Tuesday morning I was at the Metropolitan Museum where I asked for an invalid chair and with this help I was able to see everything with ease. I went back in the afternoon... I hope I will quickly be in a position to paint."[27] This exhibition, at this particular time, with works by Bonnard, Cézanne, Degas, Gauguin, Manor, Matisse, Renoir, Van Gogh and others – really brought home to André the full significance of modern art. It was the richest exhibition of

modern French art in America since the Armory Show. Seeing ten works by Gauguin for the first time left the strongest memory:

> The excitement has been with me ever since, because there, instead of the form or colour of Renoir, then I began to understand line, the line of Gauguin, the line that dominates all his painting, and then of course there was the romantic side ... and the works of Gauguin had such unity that it was impossible to separate the painting from the subject. For me those magnificent colours, that splendid treatment – I was incapable of separating all that from Tahiti, from the exotic.

Back in Woodstock again in 1921, André was painting in a mood of high excitement and contemplating a return to Montréal and to La Clairière for part of the summer. A Canadian friend, Lloyd Parsons, was also a student there and they worked together. Then once more asthma intervened and he spent two weeks in a clinic, helped and encouraged in every way by his friends, the Rosens and Harrisons, and still continuing to draw. But what of the future? His return to his family in July was to face this question all over again. Many factors made the decision he took to go to Europe almost inevitable. First, and still foremost, was to improve his health and the climate of Europe, perhaps in the mountains, would be best; because the family roots were in Europe and there would be no barrier of language, he would be at home there; the opportunity to work in fresco with his uncle Ernest in Switzerland was very tempting; there would be a chance to study in Paris, a mecca for art students and, in the opinion of his uncle and other artists, the best school; he could begin a study of the masters of the past, inspired by Roger Fry, in France and Italy; and he could absorb more of the postimpressionist movement in France that had so captivated his attention at the exhibition in New York. On a more personal level, other reasons to go to Europe are contained in the wise counsel given to him by his friend and teacher Charles Rosen, both in conversation and in this letter of 1921:

Dear André,

Health comes first!

Without that, nothing else can possibly be of any value. Find if possible an environment that would be pleasant and helpful. Take the money that you might spend in schools for training, and invest it in pictures and books. Surround yourself with the very best there is and nothing but the best – books and photographs – Michelangelo, Botticelli, Rembrandt, Millet, Mantegna, Giotto, Cézanne, French Impressionists, Moderns (a new Matisse book is interesting). This list is of course hasty, but a suggestion of what I mean. Bask in the sunshine of the real great – it establishes standards. Art is not national! It is universal – has no country or time – your chances are now all within yourself and merely need proper development. You can't be greater than you are, but your job is to succeed in being as great as you really are. This may be little or much and it is what you stand or fall on – but the fun of the race is in the running.

I should say that you need (when you find a place where you can live), to draw, draw, draw. Go to nature with the utmost respect, and secure knowledge, that it holds everything – is marvellously unique – draw painstakingly, searchingly, keenly, with no preconceptions, attack it with a fresh unspoiled vision and there is no telling what it may give you in return – search out the things that are important to you. Style will probably take care of itself and some day you or somebody may discover that you are an artist. Of course a thorough and intelligent study of the figure would be invaluable – but of course not at the expense of your health – you must realize that must be your first and last thought just now. France or the States?

Charles Rosen and his family at Woodstock, 1921. Rosen Archives

It doesn't seem to matter. Would seem to depend on whom you were thrown with (for study). All your life you will find that you have but one job – to put on the canvas what you want on it, and of course this must be presented in a fine organized form. I don't know if this helps or not – it's definite and also vague. In any case you have my very best wishes for everything.

Sincerely yours,
Charles Rosen

This letter was written with a sympathetic understanding of André's personality, of his inner drive and of his potential to develop as an artist given the right milieu. It is classic and timeless in its wisdom and could well serve today as a guide to any aspiring artist in search of his identity, as it served for André Biéler.

NOTES FOR CHAPTER 2

1. Biéler Chronicle, p. 273.
2. André Biéler to his mother, 19 August 1915.
3. André Biéler to his family, September 1915.
4. André Biéler to Philippe and Jacques Biéler, October 1915.
5. André Biéler to his parents, October 1917.
6. André Biéler to his parents, 1 November 1915.
7. Biéler Chronicle, p. 251.
8. André Biéler to his mother, December 1916.
9. Biéler Chronicle, p. 263.
10. André Biéler to his parents, 5 November 1917.
11. Arthur Lower, *Colony to Nation: A History of Canada* (Toronto: Longmans Green and Company, 1946), p. 470.
12. André Biéler to Etienne Biéler, 22 July 1920.
13. André Biéler to his parents, January 1920.
14. Ibid.
15. André Biéler to his mother, 1 February 1920.
16. Blanche Biéler to her husband, 29 February 1920.
17. Ernest Biéler to André Biéler, 31 March 1920.
18. André Biéler to his father, "Papa," 22 January 1920.
19. Blanche Biéler to her husband, 29 February 1920.
20. André Biéler to his father, 20 March 1920.
21. André Biéler to his mother, June 1920.
22. André Biéler to his mother, 29 June 1920.
23. André Biéler to his parents, 1 August 1920.
24. Etienne Biéler to his mother, 10 September 1920.
25. Ibid.
26. André Biéler to his mother, 25 May 1921.
27. André Biéler to his mother, 8 June 1921.

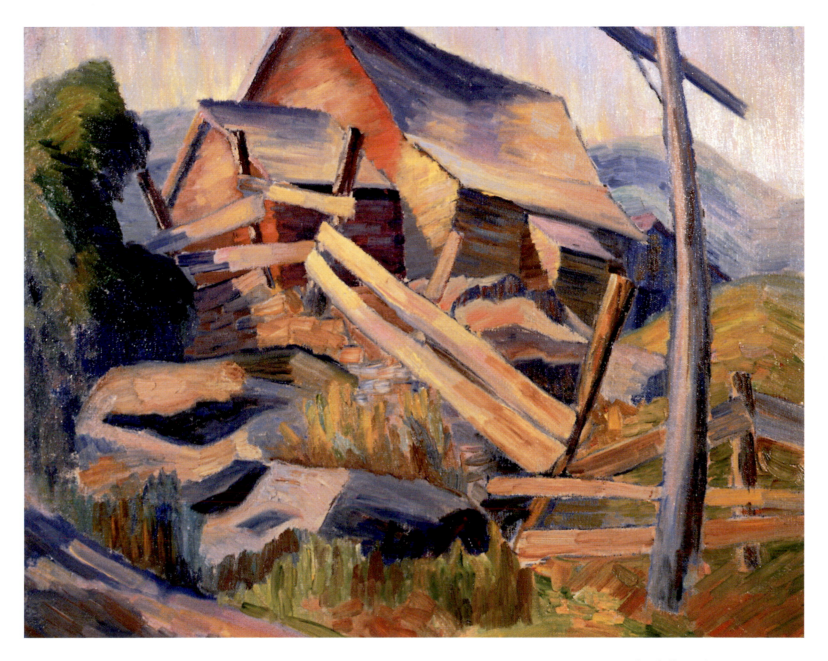

Catskill Landscape, August 1921
Oil on canvas
40.6 x 50.8 cm
Private collection

...search out the things that are important to you; style will probably take care of itself and some day you or somebody may discover that you are an artist.

Charles Rosen

1921 - 1926

APPRENTICESHIP

The Amiral de Coligny Sanatorium
Les Courmettes, Alpes Maritimes, 1920s
A.B. Archives

Dr Monod, director
The Amiral de Coligny Sanatorium, 1921
Monod Family Archives

In Rome, "la ville céleste," he was welcomed by his uncle Théodore, his father's brother, and his family. Théodore's attitude as a citizen of Rome was neatly summarized by André: "Rome is Rome and the rest of Italy is a distant country, savage and unexplored..."[3] Visits to St. Peter's and the Vatican, particularly the Sistine Chapel, resulted in "une révélation" of the genius and power of Michelangelo and gave André his first vivid impression of the baroque of Bernini and others. His exuberant nature and sense of drama were particularly sensitive to the style of the baroque period, and he eagerly absorbed all that he saw. But Rome was more than the baroque. As if witnessing the continuity of history, moving from the pre-Christian Rome of the Forum and the Colosseum during the day to the Rome of the present, prowling around with his uncle in the streets and cellar drinking-spots at night, was a haunting experience. But the dust of the city was terrible and compelled him to leave, after only a few days, for the sunshine and fresh air of the Mediterranean coast of France.

From Nice, by train and mule back, he journeyed into the Alpes Maritimes, through a country of "enchanting landscapes, villages perched on inaccessible peaks, gorges whose depth cannot be seen."[4] His goal was Les Courmettes at 850 metres, for the "cure d'air et de soleil" at the sanatorium Amiral de Coligny, named for the French Huguenot leader and martyr – an appropriate association considering André Bieler's Merle d'Aubigné ancestry. Commanding magnificent views over Provence and the Mediterranean, the community had been established by Dr. and Mrs. Monod (both were doctors), who had modern views on the convalescent treatment of respiratory diseases. André stayed for four months of a fairly constant daily regime of rest, sunbathing, fresh air, walking and a good but simple diet. In addition, he enjoyed the human interest of games of chess with the fascinating Dr. Monod, accompanied by long discussions ranging from his communistic theories to his views on modern art, about which he was extremely knowledgeable; a journey to the Basses-Alpes with the Monods, to a fair at Castellane in search of a pair of oxen; a visit from "tante Julia": a descent to Nice or to Cannes to see the world strolling along the promenade of La Croisette, and where he chanced to see Lloyd George and Aristide Briand just before their departure for Paris in January 1922.

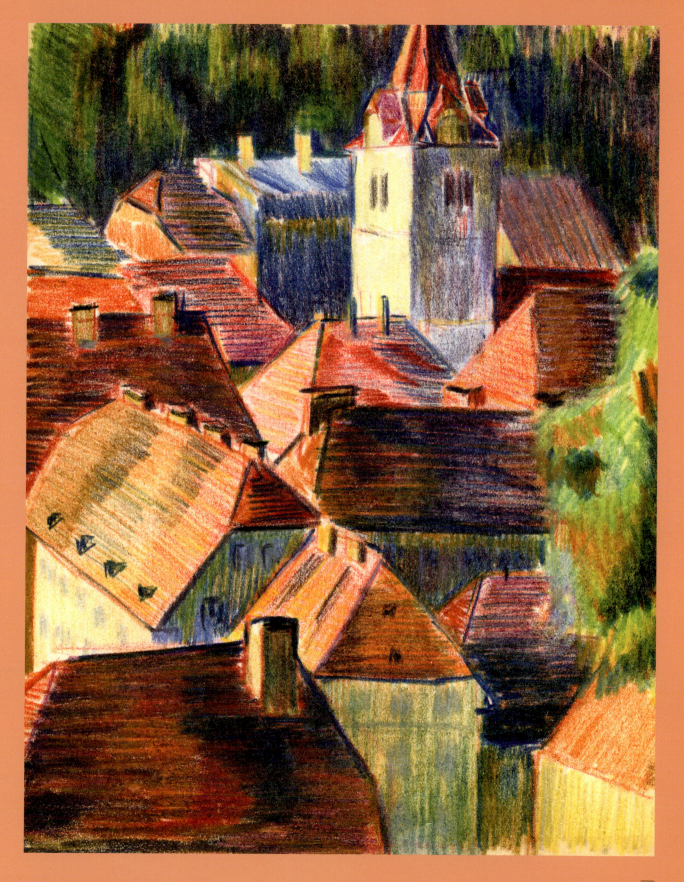

*Vue du village du
Locle*, Suisse, 1922
(View of the village of
Le Locle, Switzerland)
Coloured pencil on paper
21.5 x 16.5 cm
Private collection

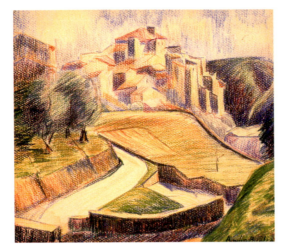

Les Courmettes, Alpes Maritimes, 1922
Coloured pencil on paper
22 x 25 cm
Collection of the Musée national des beaux-arts du Québec
Gift of the estate of André and Jeannette Biéler

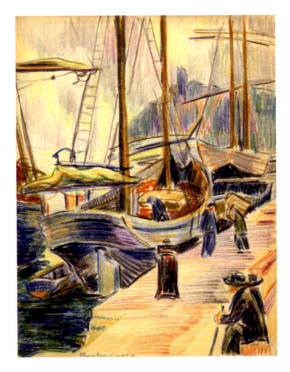

Bateaux dans le port de Bastia, Corse, 1922
(Ships at Harbour, Bastia, Corsica)
Coloured pencil on paper
21.5 x 16.5 cm
Private collection

On Christmas Day, 1921, finding that the festival made no difference at all to the family regime in the Monod household and missing the traditional family celebration, André decided to spend the day of warm sunshine alone. He descended the six kilometres to the nearest village of Tourettes-sur-Loup: "A strange sort of village, it appears to have been built a long time ago by released convicts. All the houses one on top of another, arches across the street supporting those who don't have any 'Real Estate': there must be about 1,465 inhabitants piled up on top of each other."[5] After dining in a small restaurant, he climbed back to Les Courmettes before nightfall made it difficult to find the path. In the Basses-Alpes, in a country with little vegetation save for the careful cultivation of terraces supported by walls, he found the mountain villages to be perhaps in ruins, seemingly almost deserted: "It is sad to see how these mountain villages have been absolutely depopulated by the war, in each hamlet a memorial tablet with more names than there are houses; it is the ruin of the country."[6] It was not until the period of the Second World War that people, many of them Dutch, migrated south, established themselves and changed the face of these villages.

There was a strong visual orientation in letters from that winter and André began to sketch and paint again. The few works that have survived show the influence of the Cézanne-oriented Woodstock teaching in their structure of form and relationship of planes. But the question of his health still dominated and he clutched at every suggested cure with perennial optimism; he must be free to paint. In a letter to his father he mentioned: "Do you know that I am converted to a system a little analogous to Christian Science? A certain chemist, Monsieur Coué, has written a book on autosuggestion in the subconscious – very remarkable. The Monods have studied it and Madame says she has been cured by it."[7] So he began repeating twenty times, morning and night, "Every day, in every way, I feel better and better." André's lively curiosity was open to all new experiences. It seems to have been a similarity of temperament that brought Roger Fry, whose writings on art had so profoundly influenced André, to also submit, in 1923, to "the queer little man in the big shed at Nancy [Dr. Coué]" in another effort to rid himself of mysterious internal pains when all else had failed.[8] It would have been an electric occasion if Roger Fry and André Biéler had ever met in person at the establishment of Dr. Coué.

With a renewal of health, it could not be expected that André's energy could find an outlet at Les Courmettes, isolated from the world of art. It was time to move on. In April 1922, his brother Etienne, then studying at Cambridge, and his mother joined him on

a journey to Florence and Siena. Inspired by Roger Fry, André was anxious to see the work of the masters of the past. He stayed on alone in Siena and wrote of having made eleven sketches in watercolour, gaining facility in this medium; none of these can be traced now. He found friends there – Mr. and Mrs. Tallman, the American architect and his wife – who had been on the boat to Europe with him in 1921. Together they explored the architecture of Siena, and its environs – villas, farms, castles and hills. An English art critic staying at his *pension* accompanied André to see and discuss paintings. He also gave André valuable criticism of his own sketches.

Sudden friendships arose from chance meetings everywhere André went; he was an eager, animated and vital person when he was well, with red hair and laughter near the surface and a natural and spontaneous interest in people which attracted them to him. And, of course, he had an insatiable curiosity about art. From Siena he returned to Florence to study the Raphael drawings again for two days. Then on "une de ces journées sans pitié, un soleil à bruler l'eau!"[9] he travelled by train, third-class, to Pisa. Ezra Pound and his wife were his chance companions for the day (9 May 1922) at the cathedral, which André thought was an excellent example for the study of the evolution of architecture. Lunch together was a picnic in the shade of a palm tree near the leaning tower, but most time was spent in the Camposanto examining and discussing the remarkable frescoes – particularly *Triumph of Death* by Francesco Traini – still fresh but destined to be badly damaged by fire in 1944.

From Pisa, curious to see the island of Corsica, and very conscious of its long and varied history, André went to the Italian port of Livorno where he discovered a small French boat bound for Nice via Corsica. This allowed him to spend several days on the island, taking the same boat on to Nice on a later trip; he was delighted to find this much cheaper than travelling by train. There were few tourists in Corsica and he made many watercolour sketches around the picturesque fishing harbour of Bastia and in the cemeteries with their long avenues of tombs. But, alas, it was somewhat disastrous that the only blue he could obtain in the shops was Prussian blue, which he had not used before, and he described it as "a vicious dye – much too strong – it takes over everything, so that in the end I destroyed my sketches. It is seldom used now."

After his travels in Italy and Corsica, he left Les Courmettes and returned to his native Switzerland to study with his uncle and to assist him with the fresco at Le Locle which was to be completed in that summer of 1922.

André and Blanche in Tuscany, April 1922.
A.B. Archives

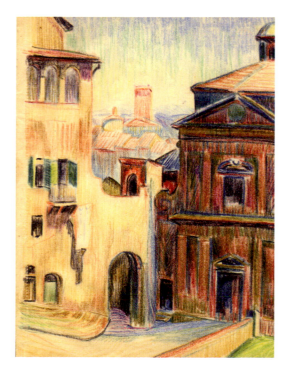

Vue de Sienne, 1922
(View of Siena)
Coloured pencil on paper
21.5 x 16.5 cm
Private collection

Scaffolding for the production of the fresco
commissioned by the Town of Le Locle, Switzerland, 1922
Coloured pencil on paper
21.5 x 16.5 cm
Private collection

Ernest Biéler was a somewhat aloof man; tall, well-dressed, always keeping his hat on, even inside, as sketched by André about 1924 in the studio at Monteiller House Rivaz (repr. p. 63). An extremely versatile artist, he worked in fresco, mosaic, stained glass, oil, tempera and woodcut, and was a master of all these techniques. J.B. Manson, director of the Tate Gallery in London, respected him as a painter who had no fear of being alone, "a painter whose quality, integrity and creative imagination attained and emulated those of the old masters, leading an existence apart, entirely dedicated to his art and working in a variety of techniques with equal mastery."[10] He had studied and worked extensively in Paris but remained indifferent to current fashions in art and completely followed his own convictions. His influence on André at this formative period of his training was gradual but important. His dedication to art, his energy, enthusiasm and independence of mind were qualities to which André's own temperament responded. Ernest's work showed a warm sense of humanity, of the character of the people, their customs, their traditional costumes, their land. This is particularly true of his many paintings and drawings of the peasants of the Valais in the tradition of Holbein, with an exquisite quality of line and a trace of the decorative qualities of art nouveau. All this, combined with his uncle's expert technical achievements, provided an ambience André could not have found in America.

Ernest Biéler had been commissioned as early as 1919 to paint a fresco on the outside of the Hôtel de Ville of Le Locle, a town in the Jura mountains, the country of Corbusier. The building had been constructed between 1915 and 1918 and was designed by the architect Gunthert, whose plans included a large fresco in a semicircular area beneath the overhang of the roof at the top of the east facade. He wrote of his conception of the mural in 1919:

Searching for a poetic way of evoking the industry on which the prosperity of the town rests, watchmaking, I think I have found it in the symbolization of the Hour, a theme which lends itself to expression by ornamental figures. For without the Hour, where would watchmaking be?... In my plan the procession of the Hours is enclosed between the Past and the Future. The Future, young, still uncertain, charming and seductive, is conducted by Hope; the Past, veiled in Legend, is sustained by History.[11]

The development of this theme, the preparation of the designs in colour and of the large cartoons necessary, occupied Ernest Biéler for the next three years. He had already revived and worked in the Renaissance method of pure fresco painted on fresh mortar, and was one of very few artists at that time to do this: it was a technique in which he was an exacting master.

1

2

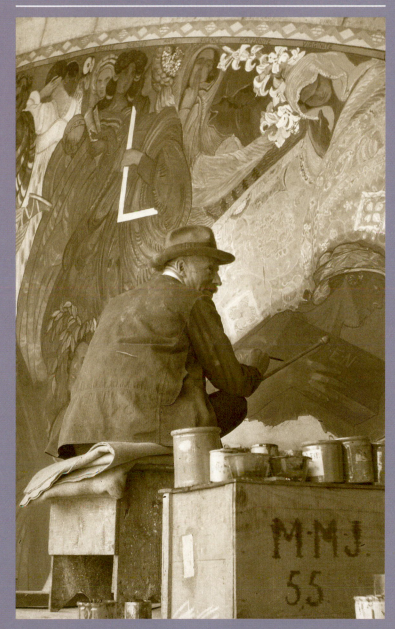

6

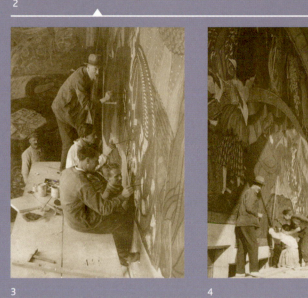

3

4

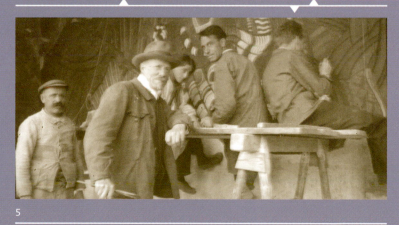

5

All images from André Biéler Archives (photographer unknown)

1. Overall view of the fresco, protected against the weather as it dries.

2 & 5. The group of painters hired by Ernest Biéler to execute the fresco.

3 & 4. Ernest Biéler (wearing a hat) and his team painting the fresco.

6. Ernest Biéler at work.

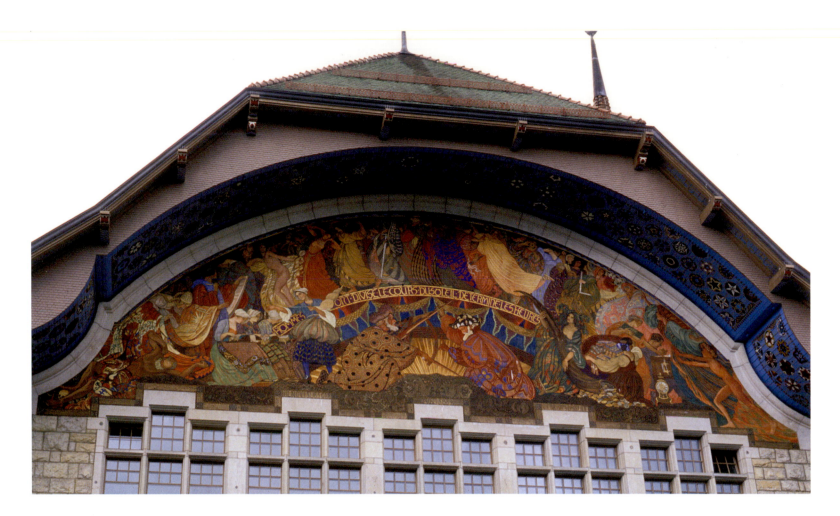

Contemporary photograph of completed fresco on the facade of the Town Hall, Le Locle.
Photograph by Pierre Bohrer

In June 1922, André was a member of a team of four (two other painters and a mason) assisting his uncle, high on a scaffold, in the execution of this mural. They worked from seven in the morning until seven in the evening, with a short break at noon for lunch, for a period of over two months. They had first painted 144 rosettes, in oil, all different, on the overhang of the roof which protected the wall for a distance of two and a half metres. The preparatory work for the fresco proper, to cover seventy-five square metres and to include some fifty figures, had been done; designs had been transferred and tracings pricked ready to be pounced with red ochre to transfer the line drawing to fresh mortar; alignment was made by fine threads stretched from one end of the work to the other; colours used were powders, most of them natural earths from Italy, ground and mixed with water. Then the painting began on the fresh wall surface, sometimes building up with whites to give greater brilliance. Work had to be done directly and fast, as the fresh mortar was laid by the mason; there was no opportunity to correct the work, the chemical reaction fixed the colours to the wall surface permanently. They

washed a section that had become soiled "as if washing a plate, absolutely fixed." André was very absorbed in these technical aspects of true fresco, and gained much insight into the work of the Italian painters Giotto, Mantegna, Piero della Francesco and other fresco painters whose work he was to study later.

The style of the mural has much of the graphic elegance of art nouveau. The flowing lines of the clothes form marked linear and decorative patterns. No space is left unfilled in the colourful, flowing movements of these figures symbolizing the Hours – the calm, the gay, the sad, the tragic – of the human condition. Ernest Biéler had related his theme to the local situation by presenting the past in the left portion of the semicircle by busy lacemakers, working at a craft fast disappearing, balanced on the right by the watchmakers of the present with the cornucopia of plenty. The inscription, visually linking past and future, reads: "Les hommes ont divisé le cours du soleil, determiné les heures." The interest of the citizens was so great that the team of painters had to lock the door to their scaffold

Ernest Biéler au « Montellier », Rivaz, 1924
(Ernest Biéler at Montellier House, Rivaz)
Watercolour on paper
24 x 29 cm
Collection of the Musée national des beaux-arts du Québec
Gift of the estate of André and Jeannette Biéler

to work without interruption. This demonstration by the people of Le Locle, who were so proud of their Hôtel de Ville and obviously appreciative of the role of the artist in the conception and painting of the fresco, left a deep impression on André and a feeling of pride in his own involvement in the making of the fresco.

The work of the fresco completed and his health apparently much better, André decided that a year's study in Paris would give him the *coup de main* he felt he needed. He was encouraged in this by his uncle Ernest, who stressed the traditional art training Paris could offer, and sent a warm letter to Blanche Biéler about André's progress:

> You will have learned already, doubtless through Jean, how happy I have been with the company of your son, and it is with great pleasure that I give you a fine testimonial to his artistic aptitude which appears to me to be very real, and to his active and intelligent work... Although in an artistic career one has to reckon with events, and also with chance, you need not fear for André – he will follow his tastes in dedicating himself completely to art. I think also that your son has a practical sense which will enable him to get along in life. The Anglo-Saxon education he has received has its usefulness, although it is perhaps rather opposed to artistic imagination, as one understood it at least in my youth. But everything passes, and everything changes, and I often amuse myself in studying André, finding him so different from myself, at the same time feeling so many affinities with him. He seems to me to have a good constitution, and a sturdy one, and certainly at his age I had neither his vigour nor his good looks. I hope now that he will be able to undertake some serious studies in Paris with the best master, or in the best atelier that one can find. It is necessary for him to draw during at least two winters, for him to follow a course in anatomy, in history of art, and that he develops a taste a little less American. The old Greco-Latin culture is still the best and tradition, in spite of numerous detractors, has not lost its raison d'être and its rights. Paris seems to me the best centre for art at the moment and André will develop there quickly. He seems to me to have an excellent sense of mass, and of proportions, and great natural facility...[12]

In November 1922, André was installed in "une mansarde du quartier Latin." His attic room, with a fireplace and oil lamp, was at 46, rue de Vaugirard in Montparnasse, a house which was in effect a students' club, Protestant Students Guild, across from the Luxembourg gardens. Life was cheap: his room, with service, cost ninety francs a month and dinner at the club was only three francs. He managed on his small war pension, and on Sundays he used to visit his Merle d'Aubigné cousins for supper.

A morning walk across the Luxembourg gardens brought him to Rue Vavin and then to La Grande Chaumière, where he worked until noon drawing from the model. But this studio was too academic in approach for his taste and very soon he gravitated to the Académie Ranson in Rue Joseph Bara nearby for the morning sessions, where he worked under Paul Sérusier and Maurice Denis and among serious students oriented to the modern school and expressive drawing. Here he was much more at home. As with most Paris studios, it was a free association of students working, more or less assiduously, from the model, who changed poses from time to time. Periods of criticism were given weekly by Denis and others, and André found himself translating at times for some of the American students. The atmosphere was revitalized when Paul Sérusier, the friend of Gauguin, made his occasional visit, striding in in his long black cloak and large hat as if emerging from another world. In the afternoons at the École des Beaux-Arts, André spent some time drawing from the antique for the competition for admission as a free student. He succeeded, and was greatly interested in the lectures on the history of art and aesthetics there, but much less in the studios, where drawing had to aim at the exactitude of a photograph. At the evening "croquis" sessions from 5 to 7 P.M., groups of students met to sketch from the model at one of the Montparnasse studios.

Outside the daily work of the Paris studios, which was largely a matter of dedication and self-discipline, life in the "quartier Latin" was stimulating and often gay. Jacques Copeau's theatre, the Vieux Colombier nearby, offered avant-garde plays by Cocteau and other contemporary and experimental writers and was frequented by the students (it later became a cinema). André mentioned in a letter having seen *une pièce* there "played to perfection" with his brother Etienne, who visited him at Christmas time in 1922. His sensitivity to drama, influenced by his mother's personality, was cultivated and enriched in Paris.

The Louvre and the Musée du Luxembourg, which exhibited Cézanne, Renoir, Degas and other moderns, as well as the artists of the Salon, were constant goals. Perhaps most valuable of all was the free discussion of the intellectual and artistic ideas of the day with students of quite diverse interests. The whole atmosphere of student life and the warmth and friendship of the cafés was conducive to a free exchange of ideas; secrecy and Paris did not go together! In a letter to his father he made this point: "It is strange, it seems to me in these recent weeks that I have never left Paris. I have more comrades and friends here than in all my days in Montreal."[13] He renewed his friendship with Lloyd Parsons, a graduate of McGill University and a fellow student at Woodstock, who had a studio in Paris where they worked

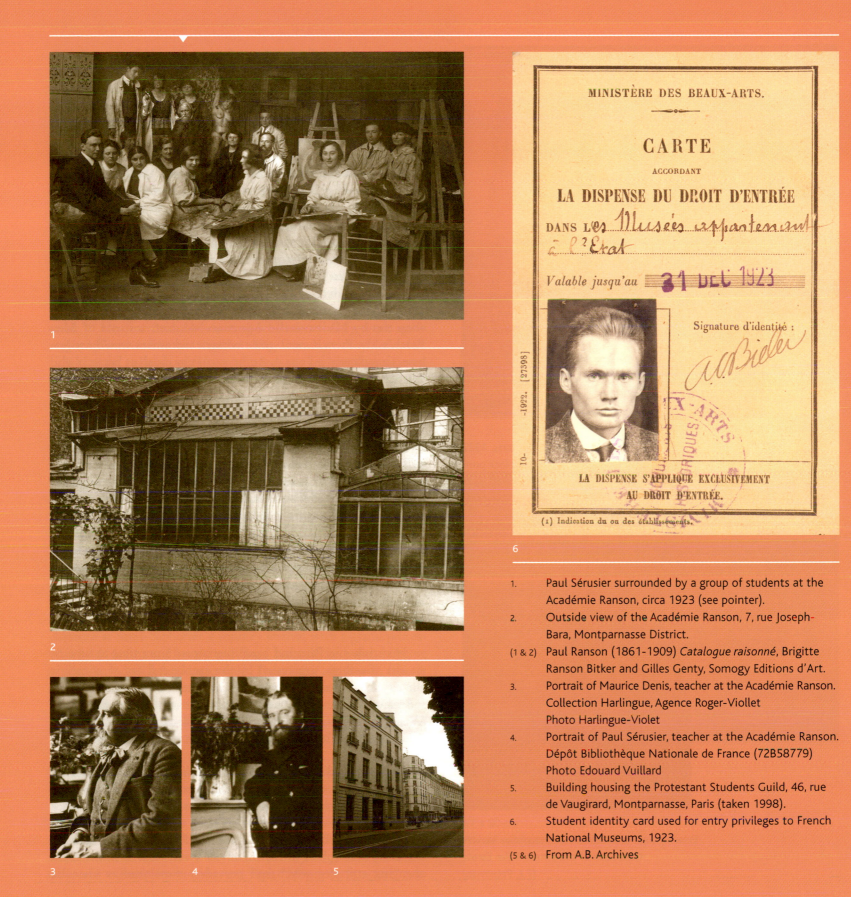

MINISTÈRE DES BEAUX-ARTS.

CARTE

ACCORDANT

LA DISPENSE DU DROIT D'ENTRÉE

DANS LES *Musées appartenant à l'État*

Valable jusqu'au 31 DEC 1923

Signature d'identité :
A.B.Biéler

LA DISPENSE S'APPLIQUE EXCLUSIVEMENT
AU DROIT D'ENTRÉE.

(1) Indication du ou des établissements.

1. Paul Sérusier surrounded by a group of students at the Académie Ranson, circa 1923 (see pointer).
2. Outside view of the Académie Ranson, 7, rue Joseph-Bara, Montparnasse District.

(1 & 2) Paul Ranson (1861-1909) *Catalogue raisonné*, Brigitte Ranson Bitker and Gilles Genty, Somogy Editions d'Art.

3. Portrait of Maurice Denis, teacher at the Académie Ranson. Collection Harlingue, Agence Roger-Viollet Photo Harlingue-Violet
4. Portrait of Paul Sérusier, teacher at the Académie Ranson. Dépôt Bibliothèque Nationale de France (72B58779) Photo Edouard Vuillard
5. Building housing the Protestant Students Guild, 46, rue de Vaugirard, Montparnasse, Paris (taken 1998).
6. Student identity card used for entry privileges to French National Museums, 1923.

(5 & 6) From A.B. Archives

Soirée au bord du fleuve, vallée du Rhône, 1925
(Evening on the Riverside, Rhône Valley)
Conté and tempera on brown paper
47 x 62 cm
Private collection

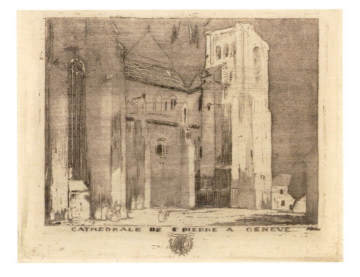

Cathédrale Saint-Pierre à Genève, 1925
(Saint-Pierre Cathedral, Geneva)
Etching
10.5 x 13.8 cm
Private collection

Feeling the need to rely on himself, to find his own direction, to be his own critic before returning to Canada, André made a decisive change in March 1925. With growing confidence he established himself independently at Sion, Valais, in the valley of the Rhône. He stayed at the Hôtel de la Paix and experienced a sense of elation at working alone, although he visited his uncle from time to time to discuss his work and plans. His parents visited Europe that summer and joined him at Sion in June. It was a memorable and warm visit but it was followed at once by an attack of asthma. Was it the climate of Sion? He went to the mountains near Simplon to paint, but the asthma continued, and again there was a note of discouragement, although he received help and kindness from the proprietors of the small hotel where he stayed.

In spite of the dominating effects of war gassing, he constantly managed to renew his vitality. Back in Sion after visiting Jean and his Uncle Ernest, his letters recount another study of printmaking:

> ... having reviewed all the ways of engraving, of reproduction, etc., we fixed on a process which lends itself specially to my style of drawing – aquatint – and I decided, therefore, before returning to Canada, to have this skill in hand and to find out where best I could learn it. Geneva? In France? ... Once learned (much less slow and tedious than wood engraving), I will be able to reproduce, with the utmost fidelity, drawings and paintings in Montréal or elsewhere. Don't you think this is a good thing, with the practical bent in my temperament? As Uncle Ernest says, it is just what I should do. Nothing [of this] will prevent me from continuing with painting or with decoration as the occasion arises.[20]

Later, however, he reported that all inquiries about learning the process in Geneva were unsuccessful. He borrowed several books on the subject from the library. Aquatint did not seem to be too complicated and, although he would prefer some lessons to get "the tricks of the trade," he felt he could start out on his own. He was "terribly tempted to try to buy a printing press; an opportunity in France might arise." Although he made relatively few experiments with etching and aquatint for some years, his study of process proved valuable in later years; his interest in printmaking has continued, parallel with painting. He has gone on to experiment and invent with printmaking in new and unexpected ways.

In Switzerland, André's inspiration was the people and the land. He described, for example, the autumn fair at Sion with its animated crowds, including one thousand head of cattle, three hundred peasants in their native costumes, "each one as picturesque as the other," and peddlers of pots and articles of devotion. He also commented about a change in his method of working:

Vallée du Rhône, Sion, 1925
(The Rhône Valley, Sion)
Tempera on board
62 x 86 cm
Private collection

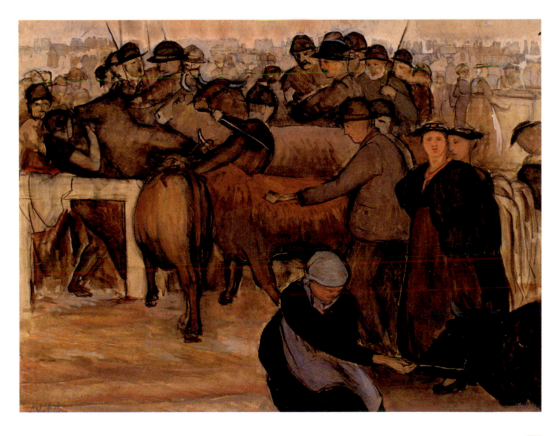

La Foire de Sion, 1925
(The Cattle Fair at Sion)
Tempera on board
47 x 62 cm
Private collection

Vallée du Rhône, Sion, 1925
(The Rhône Valley, Sion)
Conté and tempera on paper
47.6 x 61.9 cm
Collection of the Musée national des beaux-arts du Québec
Gift of the estate of André and Jeannette Biéler

I have also begun to exercise my visual memory and now I do almost all my work in my room, which gives me very much more freedom with the composition, with colour and the personal stamp of the work. Most of the sketches that I have done this autumn would do well as engravings, if I ever find the time to do them. As soon as I return to Canada I must do some of Québec, of the market, in Montréal – I enjoy it already![21]

Many sketches and paintings in gouache, made during this period of independence in 1925, have survived. The group illustrated show not only the range of subject matter but also his remarkable power of organization of large compositions, influenced by mural painting. The drama and romanticism of a land that has known the Roman legions and Napoleon's armies are reflected in such works as *Rhône Valley, Sion.* The neighbouring peaks rise vertically from the plain. One is crowned with the mass of the church of Notre Dame de Valère, and the other with the ruins of the castle of Tourbillon. They dominate the valley and are painted with full dramatic impact of light and shade. In this region, perhaps from this same spot, J.M.W. Turner painted his atmospheric impressions of Sion and the valley of the upper Rhône. *Evening on the Riverside, Rhône Valley* (repr. p. 76) has romantic and decorative elements in a more lyrical mood.

Procession à Sion, one of many paintings of religious festivals of this Catholic canton, is a forerunner of a subject that continued to fascinate André in Canada, particularly on le d'Orléans. Here the artist is still the objective observer. The people are dominated by the vertical lines of the architecture and of the church of Valère on the peak, but in this, as in other works of this genre, the visual challenge of the group of people is the focus of his interest. The human element, however tentatively handled at this stage, began to take precedence. Three years later, in Canada, faced with a more intimate milieu, similar subjects were handled with greater immediacy and expressive freedom, as in *Fête Dieu à Sainte-Famille* of 1928 (repr. p. 103). André also painted in the marketplace in Sion, getting directly involved in the activity of the crowds of peasants and cattle. The market as subject was also a forerunner of André's interest in it as a point of human contact, a place that brings people together. It has been a constant source for his evolving interpretation of the human scene in innumerable sketches and paintings.[22]

A visit to his brother Jean in Geneva in December 1925 was also the occasion for a consultation with a young specialist about André's health, which seemed to have been helpful. In the early spring of 1926 he was able to make a lengthy painting trip to Italy, this time on his own. He visited Orvieto, Perugia, Assisi and Gubbio. At Orvieto, "la ville de rêve" of 1923, he stayed at the Palace Hotel, where by chance he met David Morrice (who became one of André's first patrons in Canada) and his sister. They were the nephew and niece of the Canadian painter J.W. Morrice. André and the Morrices had many mutual friends in Montréal, among them Lloyd Parsons, as well as a passionate interest in all periods of art. A considerable number of sketches and paintings resulted from this visit. Many continue the lyrical mood and contain elements of the international art nouveau which André

Procession à Sion, 1925
(Procession at Sion)
Conté and tempera on paper
46 x 62 cm
Private collection

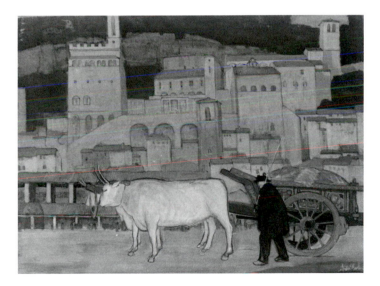

Gubbio, 1926
Conté and tempera on paper
46.4 x 61.6 cm
Private collection

Le Vieux bûcheron, Sainte-Famille, 1928
(The Old Log Cutter)
Oil on canvas
29 x 37 cm
Private collection

Page 92
Vieux trappeur à la tuque rouge, Tourville, 1927
(The Old Trapper with the Red Tuque, Tourville)
Watercolour and pencil on paper
38 x 27 cm
Private collection

A.Y. Jackson, however, did not find the landscape of the island a satisfying one for his purpose, which was to paint pure landscape rather than landscape with figures – and he wrote of it in his autobiography:

On another occasion, with Marius Barbeau and the Lismers, I went to L'île d'Orléans on the St. Lawrence just below Québec. This island was considered as the private preserve of Horatio Walker, who had his home and painted there for many years. He sold his paintings mostly to art galleries and private collectors in the United States. He made little effort either to interpret the environment or the atmosphere of the place, and he continued to produce good Barbizon pictures years after they were superseded in France by the work of the Impressionists. I did not find the Island much of a place for landscape. It is a long island, high in the centre, and it slopes down to the river on both sides, so that compositions all seem to be sliding down the canvas..."[13]

The island was a self-sufficient community by tradition and necessity, and the women in their homes played important roles. Across the road from André's house lived Marraine (repr. p. 105 #4). A godmother figure to the whole village, she was married to a sea captain, a rather frail but fine-looking man, who had a fund of good stories from his long trips. Sometimes André would ask Marraine to come over with her wheel and spin by the fire while he made sketches. *La fileuse, Sainte-Famille* is one of the sketches that resulted from such a visit; André also made a woodcut and pochoir print of *La fileuse*.

Dyeing the wool was a colourful task, performed outside. The dye was contained in a large cauldron over a log fire and the wool was laid to dry on the fences. Soapmaking was also done in a cauldron over the fire. When winter came, the habitants set to work on their crafts. The loom, with all its accessories, would fill up the main room of the house and was usually assembled just after the New Year's celebrations. The women would weave through the winter and "until quite late at night you would hear the shuttles." They made cloth from flax and wool for their own clothes, for the men's suits and for household items. In the 1920s, before the great influx of tourists that the road bridge brought (it was built in 1935), they were producing for the market. Saint-Pierre is still a weaving centre on the island.

Le Labour, île d'Orléans, 1929
(Ploughing, Île d'Orléans)
Oil on canvas
66 x 86.4 cm
Private collection

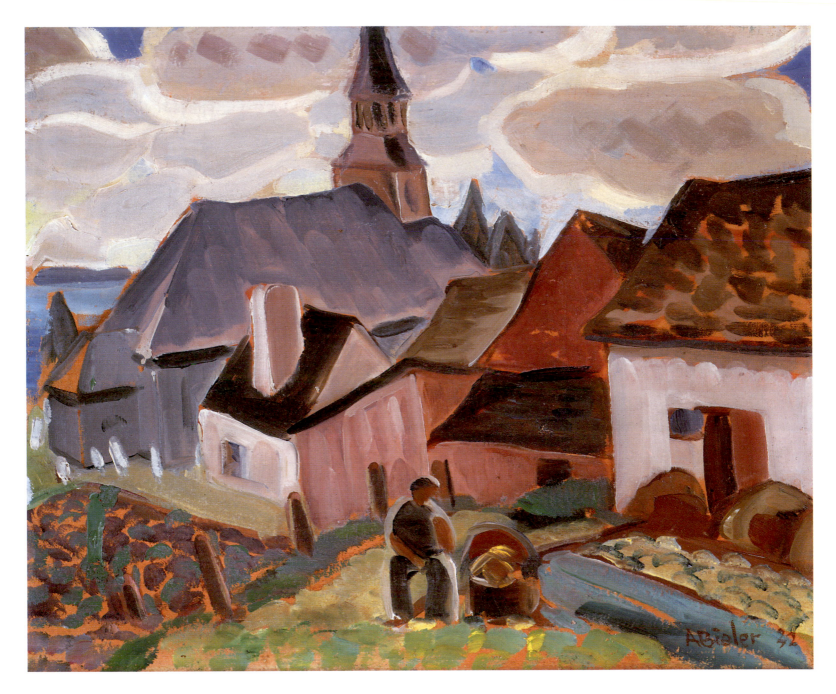

Saint-Irénée, 1932
Oil on board
26.4 x 32.9 cm
Collection of the National Gallery of Canada
In memory of Graham and Irene Spry whose painting this was
Donated by their children (1999)
(See reference to Graham Spry on page 96)

grandfather had gathered much of the wood sculpture that was being abandoned as too old-fashioned. André acquired a Corinthian capital "perfect in its classical form yet just hacked out of a chunk of white pine. A fine piece of eighteenth-century French-Canadian sculpture. This piece has been one of my treasures ever since." (repr. p. 105 #5)

The village of Saint-Irénée was another favourite haunt during these early expeditions along the north shore. Above the village, on a high hill overlooking the St. Lawrence, "stood an old house, a stone house of fine proportions but abandoned and open to the winds, windows and doors shattered. It was my favourite place to stay for a while. I would clean out a bit of the floor, get out my gear and make myself at home – even using the old rocker, taking it outside to look at the view." And in this old house "there as always was this great armoire. Just what I needed for my house in Sainte-Famille. So I struck a bargain with the farmer and the cupboard was mine – or so I thought! But this piece had been built right in the room and it would not go out of the door." (repr. p. 163 [left] and 216). Characteristically, André solved this problem by drilling out the wooden pegs, taking the cupboard to pieces, bundling it up and, with the help of the farmer and his horse, sliding it down to the Saint-Irénée wharf and so by boat to Sainte-Famille.

On one such expedition in the Rang Sainte-Marie, near Les Eboulements, André captured, in two watercolour and pencil sketches, two children, *Ti-Daniel* and *Jeune fille à la robe rose,* a fresh and vivid impression. It was amusing to find that, returning to this area in 1969 in search of a primitive wood carver, he met the subjects of these sketches again, both parents themselves by then. At first they could not recall the artist and the occasion of the sketches until "le petit char rouge" came into the conversation and sparked delighted recollections.

In the summer of 1938 André made a return sketching trip to the north shore, once more in direct contact with the lifestyle of rural Québec. This carriage and barn at Baie Saint-Paul is baroque in spirit with its lively contrasts of light and dark.

The village of Saint-Placide, with its interesting church, was the setting for many sketches that summer from which he painted, the following year, the watercolour *Après la messe, Saint-Placide,* now in the Musée national des beaux-arts du Québec. He discussed his approach to this subject:

Ti-Daniel, Rang Sainte-Marie, 1929
Watercolour on paper
18 x 10 cm
Private collection

Jeune fille à la robe rose, Rang Sainte-Marie, 1929
(Young Girl with the Pink Dress, Rang Sainte-Marie)
Watercolour on paper
18 x 10 cm
Private collection

Art, one of the curious necessities of the spirit of man, should come from experience, out of the pressures of life itself.

ROBERT AYRE

1930 - 1940

CREATING AND SHARING

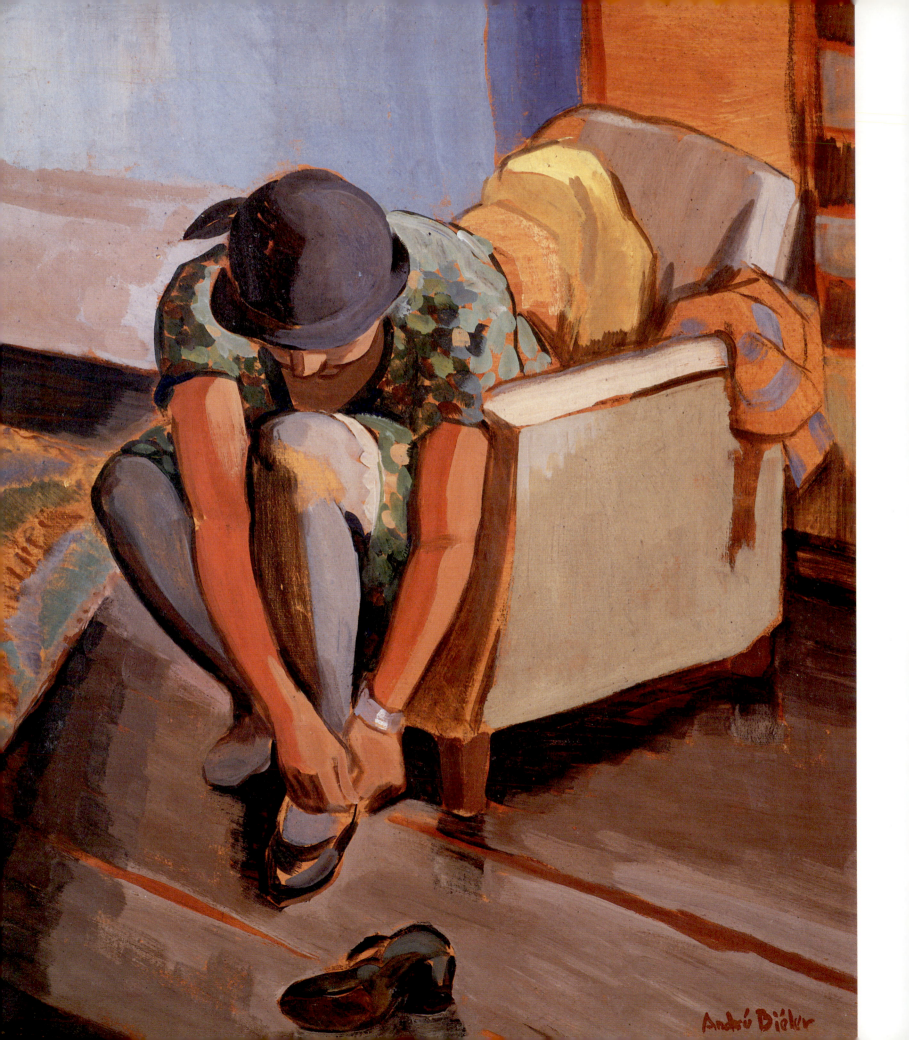

CREATING AND SHARING

5

Wanting to rejoin the mainstream of art and renew old friendships, André decided to return to Montréal in 1930. He established himself in a studio on the top floor of an old house with a north light at 1100 Beaver Hall Hill. It was reminiscent of the Paris studios. At that time, this section of Montréal was still very much an artists' centre, with nearby Beaver Hall Square, "a charming tree-shaded spot, with lawns and pigeons and many students in the rather beautiful old houses that surrounded it... there was an atmosphere of calm, an old world permanence, in the few blocks around Beaver Hall Square," according to André.

The area was still a good place in which to paint. In the fall of 1920, the Beaver Hall Group had been formed in a house on the opposite side of Beaver Hall Hill. The "Group" was an informal association of artists which included Emily Coonan, Randolph Hewton, Edwin Holgate, Mabel Lockerby, Mabel May, Lilias Newton, Sarah Robertson, Anne Savage and others, although there were varying accounts of the membership of the Group.[1] Edwin Holgate recalled the general tenor of the loose association:

... we had no officers ... we had no manifesto, we had nobody to do battle with, the battle had been pretty well won by the Group of Seven for their ideas, and ours were quite similar attitudes, and the dust had all subsided. But it was a question of getting studios, working space, and keeping the prices down, because none of us was flush. And this was one way of cooperating, grouping together and taking over a house, instead of little bits of individual driblets here and there scattered around. And there was a certain cohesion that automatically develops in a case like that, when a number of people get working together. There's a bonhomie that spreads through the building.

Beaver Hall Hill, Montréal, 1930s
Pierre Monette Collection

Pages 138-139
André and Jeannette Biéler, garden chores at La Clairière
Lac-des-Seize-Îles, Laurentians, 1931.
A.B. Archives

Page 140
Le Soulier, 1929
(The Shoe)
Oil on canvas
59.5 x 49.5 cm
Private collection

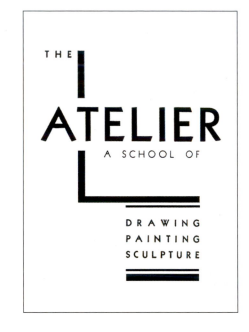

Front page of the prospectus for *The Atelier* school of art.
Queen's University Archives

An important event in the cultural life of Montréal was the formation of "The Atelier: A School of Drawing, Painting, Sculpture," as the prospectus entitled it, in November 1931. The founding members included John Lyman, Elizabeth Frost, André Biéler, George Holt and Hazen Sise, although a large "representative executive committee" was named in the press.[10] John Lyman, just returned from France, was generally considered to have been the motivating force behind the school, although George Holt recalled that it was probably Elizabeth Frost who first voiced the idea of developing a school from an existing life-drawing group. The early classes were held at Elizabeth Frost's apartment.[11] After several moves, the Atelier was established at 1461 Union Avenue, in part of the building occupied by the Montréal Repertory Theatre, in October 1932.[12]

John Lyman recorded in his journal[13] for December 1931 through February 1932 that he was occupied with "the organization of the Atelier." An entry for 28 April 1932 recounts: "The Atelier school developing slightly but progressively, the exhibition attracting much interest and comment."[14] The *Montreal Star* (30 March 1932) reported the exhibition as one by "a little group of free-thinkers in painting."

Teaching at the Atelier was in the hands of Lyman, Biéler and Holt, and later Elizabeth Frost and Kenneth Crowe participated in this capacity. The Atelier also provided models and a place for students to work on their own. The instructors were all very familiar with contemporary trends in art in Europe and were all committed to the modern movement, brought to America through the Armory Show of 1913, which included French impressionists and later schools. George Holt's interest in modern art had also been aroused as an architecture student at the Massachusetts Institute of Technology (where Hazen Sise also studied), largely through the exhibitions held in the gallery of the Harvard Society of Contemporary Art and in the Fogg Museum. Works by post-impressionists, surrealists, contemporary sculptors and others were shown at a time predating the existence of the New York Museum of Modern Art.

Hazen Sise, a Montréal architect who was completely committed to the modern movement in art and architecture, recalled in *The Thirties: A Very Personal Memoir*[15] the cultural lag in Montréal as exemplified by the founding of the Atelier, "a small school of art and a rallying point for that embattled minority concerned with the modern arts; such dangerous radicals as André Biéler, Prudence Heward, John Lyman, Lilias Newton and a few others of that generation formed the committee." In the prospectus of the Atelier, Sise, the chairman of the group, wrote a sort of manifesto which included:

In its attitude towards art, the Atelier takes a simple, definite stand: the essential qualities of a work of art lie in relationships of form to form and of colour to colour. From these, the eye, and especially the trained eye, derives its pleasure and all artistic emotion must find its expression through these means. During, however, most of the 19th century the prevalence of a literary and sentimental point of view coupled with a representational technique resulted in a degradation of all the plastic arts. The modern movement has been for the most part a return to a classical or formal point of view...

The Atelier attracted the attention of Colonel William Bovey of McGill University's extramural department. He asked the group to conduct night courses in art, which they were pleased to do until one morning they found themselves being attacked in *The Gazette* "as a suspicious and probably subversive organization of which McGill had better beware." Sise, summoned to the office of Sir Arthur Currie, then principal and vice-chancellor of McGill, was an unhappy witness to the charming and cultivated Colonel Bovey "being bawled out as if he were a lance-corporal on parade with his puttees drooping." The Atelier and McGill parted company in a Montréal still resistant to cultural and international trends.

To André Biéler, coming from a family of teachers, the Atelier offered an opportunity to test himself in that field. He recalled: "I felt that I should do something, because I felt confident when I was teaching in the school we established in Montréal. I found that whenever I went into the studio and started teaching, people would listen to what I said and really go to it." George Holt remembered André as a disciplinarian, although not in an authoritarian but in a positive way; he started his studio classes by calling, "All right now, get down to work." Allan Harrison, who was *massier* at the Atelier from January 1932 to May 1933, spoke very warmly of the relationship he had with both André Biéler and John Lyman: "My early memories of André are most positive and he was more than kind, enthusiastic and helpful. The Atelier was in my opinion a great boon to Montréal and was the first sign of modern or contemporary art in Canada."[16] The maxim of the school could be said to have been "Art lies in Creation and not in Imitation."[17]

Vividly remembered by individual artists in Montréal was the informal association made possible, in a time of difficult economic circumstances, through the Friday evening salons at the Lymans' Sherbrooke Street apartment. The Lymans could afford to entertain and John Lyman liked to have his "disciples" – devotees of creative ideas in art, in literature, in thought – around him. Evening gatherings also occurred in the studio of the Atelier, as Lyman recorded in his journal for 28 April 1932: "Our Wednesday

André and Jeannette Biéler on Jacques-Cartier Bridge Montréal, in the 1930s.
A.B. Archives

Tubular chromed steel furniture created by Jeannette Meunier Biéler. Photograph taken in the Peel Street apartment in 1933. The desk is in the Montreal Museum of Fine Arts furniture collection.
MMFA Archives

André Biéler was recognized for several important and unique achievements during the early 1930s in Montréal. The *Montreal Star* of 12 October 1931 reported:

> What is probably the first true fresco in Canada as distinguished from mere mural paintings, appeared last week at Saint-Sauveur des Monts, in the Laurentians, and puzzled while it obviously pleased the local inhabitants. It is a striking portrayal of St. Christopher carrying the infant Christ upon his shoulders, the work of André Biéler, a Montréal artist ... Mr. Biéler's painting is done with great decision – bold strokes which show no sign of hesitation – a great virtue in fresco work.

The fresco was painted on the outside wall of La Maison Rose, an old pioneer home in the village of Saint-Sauveur owned by André's brother Jacques, which became a "painting place" for André during this period. He and Jeannette would go there for weekends, summer and winter, to escape from the city and whenever possible André stayed on his own for a week, painting every day in and around the village, the mountain air seeming to give him some relief from asthma. They were frequently joined there by artist friends[19] and it became a centre for skiing. Hence, St. Christopher, the patron saint of travellers, was appropriate.

George Holt, whose interests were becoming more and more oriented towards techniques in art, was invited to Saint-Sauveur when André was completing the fresco. He followed the whole process from mixing the mortar, placing the wet plaster on the prepared surface, pricking the prepared cartoon, marking the lines with a pounce bag, mixing the colours and painting on the wet surface of the wall. It was his first experience seeing a fresco being painted and he recalled it took André two days to complete the St. Christopher. Hazen Sise was also there and took a group of photographs of the process, two of which are reproduced here.

La Maison Rose still stands at Saint-Sauveur, having survived a 1962 threat of demolition for the highway extension, but because of the increased traffic of the busy village street, the fresco has suffered through the years. The house has changed hands several times, but St. Christopher remains. It is no longer, unfortunately, a true fresco since it has been "restored" at different times with oil and acrylic paint, and has lost the special, subtle quality that fresco colours, incorporated with the surface plaster,

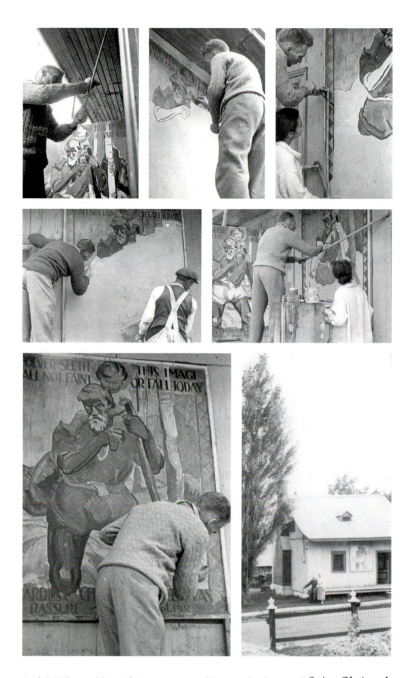

André Biéler and his wife Jeannette, working on the fresco of *Saint-Christopher and the Christ Child*, in 1931, on the facade of the "Maison Rose" Saint-Sauveur-des-Monts, Québec.
National Archives of Canada
Hazen Sise Fonds (PA206810, PA206818, PA206821, PA206814, PA206828)

Page 158
Intérieur de La Maison Rose, circa 1931
(Inside of the "Maison Rose")
Oil on canvas
67 x 51 cm
Private collection (in memoriam Jacques Biéler)

Vue de Piedmont, circa 1933
(View of Piedmont)
Oil on panel
13.5 x 18 cm
Private collection

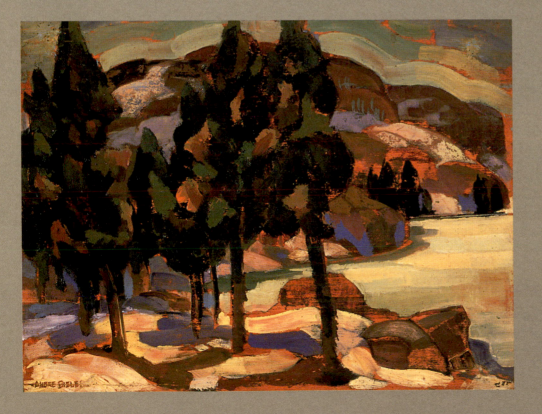

Pins sur la berge, circa 1933
(Pines on the Shoreline)
Oil on panel
25 x 33 cm
Private collection

View of the inside and portrait of André and Jeannette Biéler
The "Maison Rose," Saint-Sauveur-des-Monts, Québec.
A.B. Archives

In the spring of 1933, the Atelier, finding financing difficult with too few pupils, was forced to close. All these efforts to earn a living had meant a great diversion of time and energy away from André's real purpose and motivation, which was to paint. To escape a little from the pressures of the city, they moved to 3745 Avenue de l'Oratoire and here, in January 1934, their first daughter, Nathalie, was born, to the delight not only of the parents but also, and especially, to André's mother Blanche, who became deeply attached to her granddaughter. Jeannette continued with the interior design work, but André was finding that the pace of his activities was accelerating while his asthma was getting worse. Their thoughts turned to the mountains, where he had always felt at home. At Saint-Sauveur, they had many friends, both French and English, but it was being developed. Why not try a more remote village? André reflected that in the end, "we decided to go to Sainte-Adèle, and Sainte-Adèle meant time to paint and time to think, and time to plan the future. We would try, by living cheaply – the rents were ridiculous – to make a go; after all the depression couldn't last forever."

The move to Sainte-Adèle was undertaken with high hopes for alleviation of André's asthma and anticipation of the freedom to paint again after the demands of the commercial work in the city. "I can remember immediately going out sketching, going out painting and enjoying it very much ... and feeling that this was going to be my destination, as it were, feeling that my life would be made there." But this idyllic situation lasted only from 1935 to 1936, when he was faced with a new challenge on being offered an appointment to teach at Queen's University in Kingston.

André Biéler had met Dr. Hamilton Fyfe, then principal of Queen's University, at the home of a mutual friend in Montréal. Discussion centred around the possibility of establishing a credit course in art at Queen's University. The foundation for the study of art had been laid in Kingston in 1933, almost as a pioneering venture in a Canadian community, and it established the basis on which the structure of André Biéler's life as teacher and artist in this Ontario community, so different from rural Québec, would rest.

Professor Reginald Trotter, historian and the president of the Kingston Art Association, wrote on 9 August 1933 to Mr. H.O. McCurry, assistant director of the National Gallery of Canada, in his capacity as secretary of the Canadian Committee considering applications for assistance from the Carnegie Corporation of New York. The letter set out the situation regarding art in Kingston and stated: "The proposals have been formulated with the sympathy and cooperation of Principal Fyfe and the Administration of Queen's University and they are prepared to lend their aid in carrying them out."[22] The proposals were for an extension of the existing Art Association activities in the form of studio working sessions, lectures and exhibitions – under the professional guidance of an artist. Dr. Trotter added in his letter: "Art as a vital part of contemporary living is at present something foreign to the Kingston community as a whole. It should be domesticated there." This proposal was an enlightened one in considering the Kingston community, town and university as a whole and not as separate cultural units and has formed the ideological basis of later developments in the arts in Kingston.

Principal Fyfe supported the proposals by writing to Mr. H.O. McCurry on the subject: "It is not part of our plan to hold classes or courses in art for a degree but rather to stimulate an interest in art as an extracurricular activity unsullied by any association with credits. It would be – more obviously, perhaps, than virtue – its own reward."[23] This attitude was encouraged by the National Gallery as an experiment which would go some way towards the recognition of fine art in university life and would exert some influence on other universities and college towns in Canada. Principal Fyfe, however, was thinking further ahead, as he wrote in October 1933 to Dr. F.P. Keppel, president of the Carnegie Corporation of New York:

> Our "more serious plans" to which you allude are still in the region of prayer – a region, mind you, that in my thinking lies at the heart of reality. We should like to have a chair of Fine Art and make the holder the centre of some really effective radiation. But it would, I am sure, be a mistake to import a full professor before planting the seeds of artistic interest on the campus. It is with this sound horti-cultural idea that we are asking through McCurry for $1,500 to start our experiment. Do you think it possible that your Corporation would give us that help for three years so that we could plan ahead?[24]

The Carnegie grant was received and Goodridge Roberts was appointed resident artist at the beginning of November 1933, a position he held until 1936, when the Carnegie grant was termi-nated. Contemporary reports spoke extremely well of his fine contribution as a teacher but he wrote that he never felt fitted, either by temperament or training, to cope with the varied duties of the position.[25]

The probable termination of the Carnegie grant, due to a changing focus towards museum work, had been foreseen as early as December 1935 by Principal Fyfe, on the advice of H.O. McCurry. At the beginning of January 1936 Principal Fyfe wrote to Agnes Etherington advising her of this impending change and continued in the following terms:

Vue de Piedmont, 1930
(View of Piedmont)
Watercolour and pochoir technique on paper
33 x 48 cm
Collection of the Musée national des beaux-arts du Québec
Gift of the estate of André and Jeannette Biéler

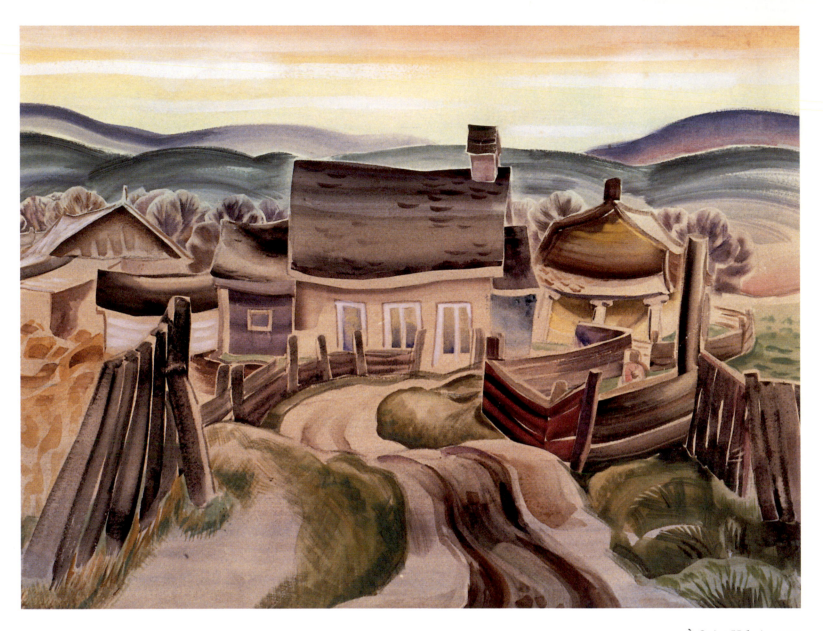

À Saint-Urbain, 1937
(At Saint-Urbain)
Watercolour and pochoir technique on paper
53 x 70 cm
Private collection

The choice of artists to represent Canada in several international exhibitions of this period included few, if any, French-Canadian contributors. For example, none of the works selected for the Canadian section of the San Francisco exhibition of 1939 were by French-Canadian artists. A.Y. Jackson wrote to André Biéler about this show and stated: "Lawren Harris is trying to arrange a Canadian art exhibit for the San Francisco World's Fair. What they are asking for is painting that reflects the Canadian background; they wish to avoid dull academicism and denationalized modern. Thomson and MacDonald stand for what they appear to want."[34] The catalogue of works in that exhibition reveals the dominance of the Canadian landscape as subject matter. The Québec region was represented by J.W. Morrice's *Ice Bridge over the St. Lawrence* and *The Road* by André Biéler.

Despite such exclusions, an important movement towards the support of contemporary trends in art took place in Québec. In January 1939, the Contemporary Arts Society was formed with John Lyman as president. Fritz Brandtner, secretary of the society, wrote to André Biéler in March 1939 informing him that the society aimed "to give support to contemporary trends in art and to further the artistic interests of its members."[35] He invited André to become a member, and enclosed a copy of the constitution with the letter. André's reply to Fritz Brandtner[36] is classic in the context of his character, of his open-minded, humanist attitude towards differences of opinion and the individual's right to be himself. It is quoted in full:

Queen's University, Kingston
April 21st, 1939

My dear Mr. Brandtner,

Pardon the long delay in answering your kind letter. I had hoped to come to Montréal and speak to you about your proposition, but was unable to do so. My first impression has not changed in these weeks; it seems a pity to divide ourselves in many groups, and secondly, to incorporate in the constitution the old and useless war against the Academy.

Reading some letters of Vincent Van Gogh, recently published, I came across one which seems to summarize my views:

"Paris, Spring 1887

... instead of disparaging these, you must, if you have quarrelled [speaking of the pointillism], above all esteem them and talk sympathetically of them. Otherwise one becomes sectarian, narrow-minded and like those people who have no use for anyone else, believing themselves only to be right. This applies even to the academicians: take for example a picture by Fantin-Latour or rather the whole of his work. Well, there's someone who's no revolutionary; but that does not prevent his having that sort of calm and correctness which makes him one of the most independent characters alive! Vincent."

What was true in 1887 is true now. These battles have lasted long enough and to no one's profit. The objects of the Society, as stated in your letter to support contemporary trends and further artistic interests seem to be an excellent objective, and with that I agree, but I am not in sympathy with discrimination against one special group, as put down in Article 3 of your constitution.

I was in Toronto the other day and was very interested in your contribution to the watercolour show. It was a very good exhibition and I hope you have it in Montréal."

Very sincerely,
André Biéler

The full import of the letter is apparent after reading Article 3 of the constitution of the Contemporary Arts Society:

3. Eligibility

All professional artists, born or resident in Canada, practicing painting, sculpture or any graphic medium, who are neither associated with, nor partial to, any Academy, are eligible as artist members (as referred to in the by-laws) in the Society. A professional is here defined as any person who makes art a vocation, but not necessarily his sole vocation. The Membership Committee, hereafter referred to, shall decide on eligibility of artist members. Participation in the activity of an Academy by an artist member shall be interpreted as notice of his resignation from the Society. In the event of difference of opinion as to what constitutes such activity, a majority vote at a regularly constituted meeting of the artist members shall decide.

André Biéler's reaction to Brandtner's invitation was a symptom of his natural independence of spirit; to him, art was not sectarian or nationalistic but was deeply involved with the integrity and freedom of the artist. He had become aware, however, from his experiences in rural Québec and Montréal, that although the artist might try to reflect his environment, Canadian society did not necessarily recognize or support the artist.

The move to Kingston offered André a measure of stability and an opportunity to focus on the broader issues of the artist in society as a whole. He had been impressed by the movement in the United States, through the Public Works of Art Project, to make the public aware of the artist as a participating member of society. As a teacher in a university community, he felt a need to know more about his country, to see what the artists isolated in the west, for example, were doing. Communication between artists was to become a goal, a means of awakening the public to their presence and their potential within a healthy cultural environment.

The culture of a society is the way that society lives – all of it. The expression of that culture can only be the outcome of intimate first hand acquaintance with life in that society. Cultural expression cannot be borrowed; it has to be made.

THOMAS HART BENTON

1940 - 1950

THE ARTIST IN SOCIETY

THE KINGSTON CONFERENCE

8

9

10

11

12

13

All images from National Archives of Canada, Hazen Sise Fonds. Photographs by Hazen Sise.

1. Thomas Hart Benton, André Biéler, Edward Rowan and Jack Shadbolt.

2. Left to right, Jack Shadbolt, Miller Brittain, Paraskeva Clark, Marian Scott, John Alfsen (partly hidden), Roy Moyer, George Pepper.

3. Pegi Nicol MacLeod, A.Y. Jackson and André Biéler. (PA-130635)

4. André Biéler giving a lecture.

5. In front: André Biéler, Michael Forester, A.Y. Jackson. (PA-151359)

6. Thomas Hart Benton giving a lecture. (PA-192884)

7. Arthur Lismer, Yvonne McKague Housser, Rick (H.G.) Kettle in white. (PA-169847)

8. & 10. Albert Cloutier giving a lecture in front of the delegates assembled on the grass in front of Ban Righ Hall at Queen's University.

9. Painting workshop directed by George Holt. (PA-169844)

11. Delegates during their visit to the National Gallery of Canada, Ottawa. (PA-e003525029)

12. Thomas Hart Benton, H.G. Glyde and Miller Brittain.

13. Edward Rowan explaining the fresco technique.

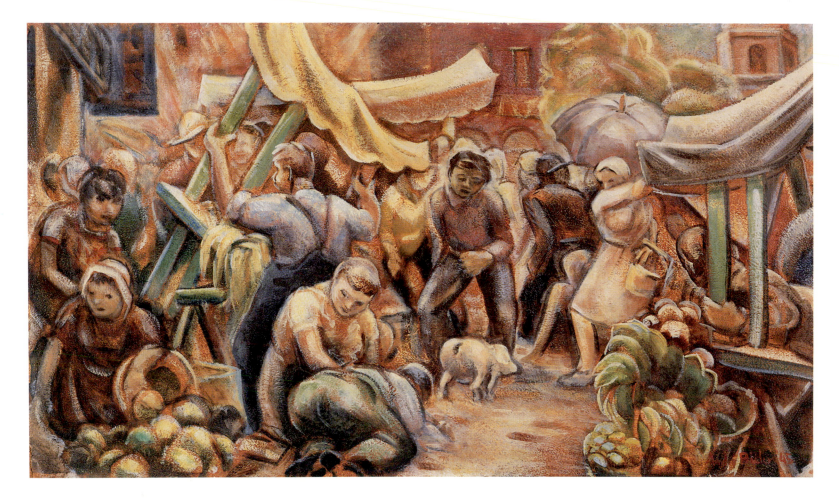

Swine in the market, 1945
Oil on panel
51 x 88 cm
Collection of the Musée national des beaux-arts du Québec
Gift of the estate of André and Jeannette Biéler

The interest was focused on the Americans who wanted to meet [André] Breton, who had an enormous influence over there. It was right then that it began, because before the war, there was an official organization called the WPA – or something like that – which would give every artist thirty or forty dollars a month (Ed. more like a hundred dollars), on the condition that he gave his paintings to the State. This was so he could live. It was a complete fiasco. The State's storerooms became filled with all the artists' rubbish. Beginning with the war, thanks to the presence of European artists, all that changed: it took the form of a movement in painting called Abstract Expressionism, which lasted for twenty years. It's barely over now, with some large-scale stars, like Robert Motherwell or Willem de Kooning, who make their money easily.[20]

To Duchamp, this was the birth of the American avant-garde movement under Breton's influence. Francis O'Connor, in a more objective report on the New Deal Art Projects in 1972, raises some prophetic questions:

Could it be that the 1930s saw the end of a certain superficiality in America? Could it be that it saw our last look at the landscapes and cityscapes which so dominate our past art?... Could it be that the polar archetypes of this profound change are Thomas Hart Benton stating "I am an American" and his pupil Jackson Pollock saying "I am nature"? Could it be, finally, that the essential tension between social concern and self-concern so palpable during the 1930s has been resolved on the side of self – and that true art, from now on,

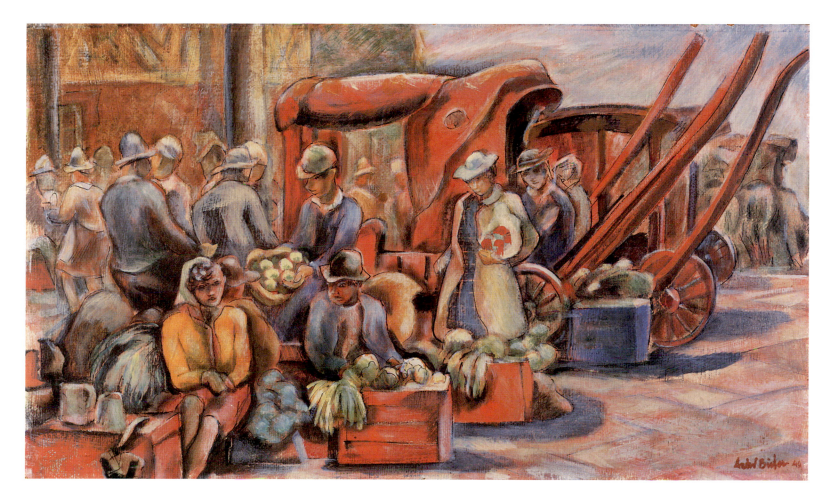

The Market in Québec City, 1946
Oil on panel
37 x 65 cm
Collection of the Musée national des beaux-arts du Québec
Gift of the estate of André and Jeannette Biéler

can only serve society as a sacrament of integrity, as a celebration of the inner life, as a prophecy of where stability lies beneath shifting intensities of chaos? [21]

International movements in art were, however, slow to take root in Canada; but the conference had served to sharpen the awareness of the artist in Canadian society and the federation had been set in motion, concerned "with something bigger than the tenets of any particular artistic creed – concerned with the welfare of art in Canada," as Walter Abell put it. Not without a feeling of personal satisfaction, André Biéler turned his energies back to teaching and painting, two demanding aspects of his creative psyche.

André was invited by the National Gallery to give a series of public lectures in the Maritimes early in 1942. Between 24 January and 4 February he visited Fredericton, Sackville, Charlottetown, Halifax, Wolfville and Saint John's, lecturing and meeting artists and groups of interested people for general discussion about art matters at every point and carrying with him the "gospel" of the federation. Travelling sometimes in blizzard conditions, something of the missionary spirit of his forebears emerged forcefully at this and many other moments in his life.

His lectures were mainly on the American Renaissance, fired by discussions at the conference. They were met with great enthusiasm. The *Halifax Star* opened a review with "Showing that

Saddle and Harness, 1949
Charcoal on paper
29 x 37 cm
Private collection

Fixing the Saddle 1, 1947
Gouache and ink on paper
37 x 48 cm
Private collection

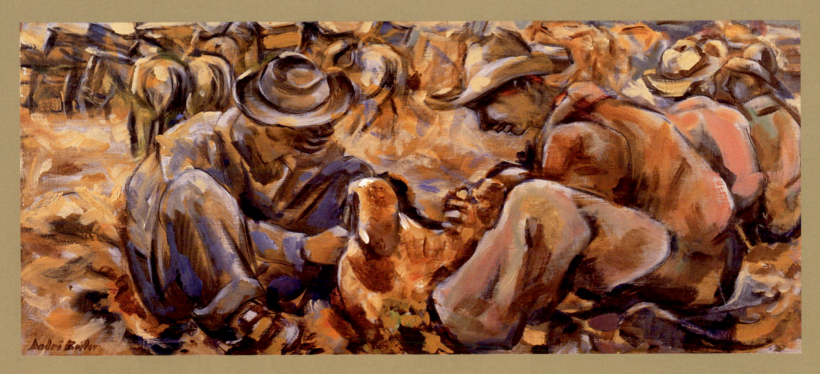

Fixing the Saddle 2, 1947
Oil on panel
31 x 71 cm
Private collection

In Banff, he found that the students "came to Banff and they wanted to do mountains, and that seemed to be the A to Z, nothing else but mountains. I tried gradually to show them other things, and we went into the streets, to the boathouses and painted and drew from life ... and of course when the Indians came for their encampment. ... I think that started a definite trend."

W.J. Phillips wrote a warm appreciation of Biéler in the *Winnipeg Tribune* in 1940:

I first met Biéler about fifteen years ago in Montreal, but it was not until this summer, when we were associated as instructors at the Banff School of Fine Arts that I got to know him... For the past five years he has held the position of "artist in residence" at Queen's University. Such a position is regarded generally as a sinecure, but not by Biéler, who is full of enthusiasm and abundant energy and who is possessed with the missionary spirit in the cause of art. Consequently his time is fully occupied in lecturing and teaching and his creative work is done in moments of leisure. He is never idle; he carries a sketchbook habitually, and little sticks of charcoal, and they are used many times during the day – in the cafe, on the road, wherever he happens on an idea. I have seen him walking along whittling at a piece of wood; later he showed us a charming figure of a mountie. Such tireless industry over years invests the artist with a knowledge of form obtainable in no other way and greatly increases the facility of expression...[27]

In his Kingston studio in the 1940s, André continued to work extensively and experimentally in the mixed technique manner, of which he had become the acknowledged authority in Canada. He wrote an article for *Maritime Art* setting out this method, step by step, based on his own experience and relating his comments to the achievements of the old and modern masters. In this technique, the support for the painting is covered with a white gesso ground; then a thin watercolour wash or veil is applied over the ground to give a unifying undertone to the finished work:

I have tried three colours for this job: raw umber, Venetian red and black. The veil painted with a thin wash of raw umber gives rather too warm an undertone to the finished picture. Venetian red gives it too definitely a pink cast, noticed by some in the pictures I exhibited in the group show last year. I have for the time being adopted the lovely cool grey veil made by a thin wash of black with just a tint of white in it; this neutral cool colour gives the best effects as an undertone for warm colours.[28]

The veil thus becomes the median value, and modelling from this proceeds in a more or less monochromatic way, building up values by the use of fine dry pigments mixed with the egg medium basic to the method, and allowing for degrees of transparency in the darks and an opaque quality in the lights. "The small areas of a passage between two planes, for instance, not only leave enough of [the veil, as in Rubens' sketches] to give this harmonizing effect, but allow the passage to be left unpainted. This, we notice, was one of the successful accomplishments of Renoir." He related his comments on the manner of applying colour in glazes, the next stage in the work, to his studies of El Greco:

Warm colours like red, yellow and brown acquire a very fine quality when painted in transparency on the grey veil. But for greens or blues it is well to rub a warm tone over the grey before painting. As these colours are painted in egg tempera, they dry immediately and no time is lost waiting for the undertone to dry. The painting would remain thin or without formal quality if white body colour was not worked over the glazes for modelling. This also increases that very vital quality of transparency and opaqueness.

The three-dimensional quality of a painting achieved by this system of building up with egg tempera and oil glazes and varnishes would have been impossible in a direct painting method, he felt. This three-dimensional quality of the mixed technique is clearly observed in *Picking Blueberries* from 1947.

In May 1945 André Biéler was awarded a commission to paint a mural. This was an important development in Canadian society, following the motivation of the 1941 conference, as it was to be on a Canadian theme and patronized by an important industrial firm, the Aluminum Company of Canada Limited. The competition was for a mural depicting the development of hydroelectric power and the aluminum industry in the Lac Saint-Jean and Saguenay River region of Quebec for the reception lobby of the development at Shipshaw.

André was fully conscious of the magnitude and complexity of the theme: he knew how many months Ernest Biéler had spent planning and preparing the fresco for the Hôtel de Ville of Le Locle in Switzerland. This experience, along with his study of the development of the mural in Mexico and the United States, stood him in good stead. Early in June 1945 he spent several days in Montreal with Aluminum Company officials, discussing plans for the work, making arrangements for a visit to the site, studying photographs of the power dam and associated buildings and talking with the engineers about the design of the lobby.

Picking Blueberries, 1947
Mixed media on panel
46 x 61 cm
Private collection

Then, on a brilliant Saturday afternoon in June, he went by plane to Arvida, passing over the mountains of the Laurentides national park where the trees were "still without leaves due to the altitude, but here [Arvida] we are lower, and the leaves are a tender green."[29] He stayed at the Saguenay Inn: "This hotel is magnificent, I am now in the library with great windows looking out on Shipshaw at some distance away, all surrounded by trees." Sunday was spent walking, exploring and sketching; on Monday was "my first visit to Shipshaw, it is absolutely immense, like a cathedral. The lobby is not yet finished, there are still contractors working, but it is very well lit and the stone work on the two sides gives me exactly the indicators I want for the panels of the mural."

Further explorations over the north country, by car and plane, were planned. It started with a visit to the Indians at Pointe Bleue on Lac Saint-Jean (a point on the railway line). The Indians assembled there each spring and spent the summer, coming down from the north to sell their skins. They were nomadic trappers – perhaps the loneliest people in the world, André remarked. He made many sketches in his notebook which show his absorbing interest in groups of figures; the drawing *Montagnais Indians* makes an interesting *mise en page* developed from these preliminary sketches (it was signed later and incorrectly dated 1944). The life of these Indians was described in a letter to his family:

The Indian family lives in a small tent with a tiny tin stove to keep them warm; the floor is made of pine boughs. The old women sitting on the floor smoking pipes, children and dogs tripping all over the place and a big growling wolf in a cage just to remind them of the wild woods they live in all winter long. Their skin is just as dark as my shoes; some of the men have long hair almost like women. I was told that sometimes the men start north for the winter in their summer shirts, forgetting I guess that winter is so cold and they will trap all winter with just a shirt and a parka. They start their long journey in September and live in the mountains until June. It is a hard life.

The flight over the north country by hydroplane gave André a perspective of the mountains, rivers and forests which form the gathering ground for the water that eventually reaches the Saguenay River hydroelectric power development. "After flying around for about two hours we sighted the little village of Peribonka ... just tiny toy houses, and we went down to make a perfect landing on the water just in front of the wharf." He was met there by Mr. Charles Miller of the Aluminum Company and they drove the few miles to the house of Eva Bouchard (Maria Chapdelaine from Louis Hémon's novel of the same name), where "she quickly prepared a good supper for the two hungry men then we sat around the table and talked till midnight ... it was a privilege to meet her and to know her story." There are several note-

Montagnais Encampment, 1945
Charcoal sketch on paper
34 x 42 cm
Private collection

La Chambre de Louis Hémon, Péribonka, 1945
(Louis Hémon's Bedroom, Péribonka)
Charcoal on paper
9 x 18 cm
Private collection

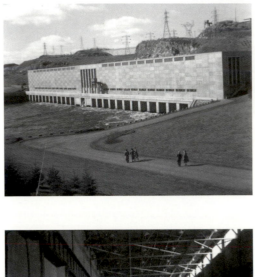

Two views of the Shipshaw Hydroelectric
power dam, Shipshaw, Québec, 1940s.
Photos by Jean Palardy
Musée de Charlevoix Archives

Page 211
Study for Shipshaw, Québec, 1945
Watercolour on grey paper
53 x 59 cm
Collection of the Musée national des beaux-arts du Québec
Gift of the estate of André and Jeannette Biéler

'flights' of Rivera and Orozco in Mexico and the United States, but it is really different in subject and in manner. I look forward very much to seeing it in colour."[34]

In the actual painting of the mural Biéler used the mixed technique, and he described the handling of it in his studio in Kingston:

> To carry out the design on the large surface the scale drawing was projected by means of slides onto the panels. The drawing in all its values was painted with India ink; the result was a strong light and dark design. Colour was applied in glazes over the drawing and impastos painted in egg tempera. The India-ink design, remaining visible through the glazes, gives a strong graphic quality to the mural, while the opaque sections of over-painting, in egg tempera, provided just the right solidity and variety.[35]

The black-and-white sketch for the whole composition, developed from preliminary sketches and "squared off to relate to the actual panels in size, is shown here. The final composition is very faithful to it. The photographs on pages 212 & 213 show Biéler working in his Kingston studio in 1947 on some of the actual panels of the mural, surrounded by sketches. There was not room to have all the panels in place at one time. The work created considerable interest in Kingston as it progressed; as one commentator said, "If this mural had been for a cathedral, nobody would care at all, but since it is for a power house – the modern cathedral – everyone is interested."[36]

To complete the mural in its architectural setting, "a border of geometrical design was put round the mural so as to relate, without harshness, its painted surface to the surrounding stone wall. Shown in this border are tools, instruments and machines, such as are used in the building and operation of the power station. The grey-green and light red colours of the mural are set off by the light orange of this border."[37]

Following a visit to Shipshaw by André Biéler in 1969, a letter to him from the Aluminum Company concluded: "Your recent visit to Shipshaw was a most pleasant surprise for us. We have talked of you many times in connection with your (and our) mural which has been seen by more than 400,000 people from some 104 nations."

André's involvement in society in the 1940s, through the Kingston Conference and pioneering in art education, had its culmination and a measure of personal satisfaction in the creation of the mural. It was, however, still an isolated instance of enlightened patronage in a country far from committed to the recognition of the artist. The public attitude was very slow to change.

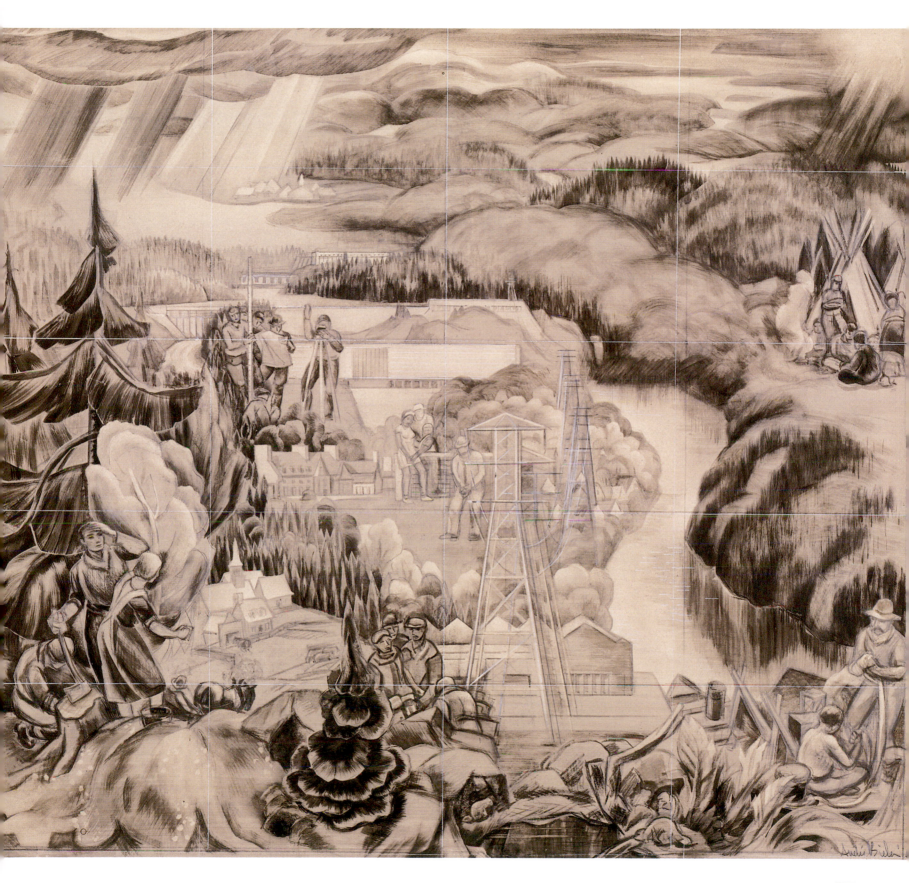

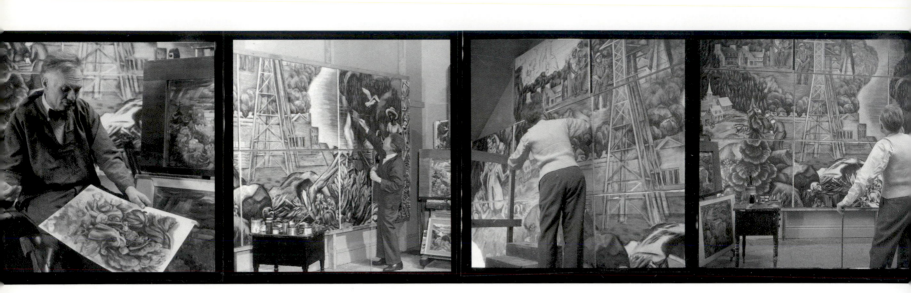

André Biéler painting aluminum panels in his studio at Queen's University, Kingston
Standard Staff photos by Glay Sperling, Montreal *Standard*, October 1948 edition.
A.B. Archives

NOTES FOR CHAPTER 6

1. Carnegie Corporation to André Biéler, 27 January 1941.

2. Bernard Ostry, in *The Cultural Connection* (Toronto: McClelland and Stewart Limited, 1978), pp. 53-54, is quite incorrect in stating that the conference was organized on behalf of the Royal Canadian Academy. It had nothing to do with the academy, but was the 'brainchild' of André Biéler and was supported by the Carnegie Corporation of New York, Queen's University and the National Gallery of Canada. I have found no evidence that financial help was also provided by J.S. Mclean as seated by A. Y Jackson in "Introduction" to *Paintings and Drawings from the Collection of J.S. McLean* (Ottawa: The National Gallery of Canada, 1952), also referred to by Charles C. Hill, *Canadian Painting in the Thirties* (Ottawa: The National Gallery of Canada, 1975) p. 14 and n. 25.

3. Kingston Conference 1941: *Planning*, QUA.

4. Jean Paul Lemieux to André Biéler, 1941, translated by the author.

5. André Biéler and Elizabeth Harrison, eds., *The Kingston Conference Proceedings*, (Kingston: Queen's University, 1941). Re-edited on the occasion of the 50th anniversary of the Kingston Conference in 1991 [N.D.T.].

6. Walter Abell, "Conference of Canadian Artists," *Maritime Art II*, no. 1 (October-November 1941), p. 3.

7. Sir Wyly Grier, "Sociability in Art," *Saturday Night,* 26 July 1941, p. 15.

8. Robert Ayre, "Benton No Humbug," *The Standard* (Montreal), 12 July 1941.

9. Francis O'Connor, *Federal Support for the Visual Arts: The New Deal and Now,* Second Edition (New York: New York Graphic Society, 1971), pp. 24-25.

10. Ralph T. Coe, "Thomas Benton: Reformed Radical," *Thomas Hart Benton, An Artist's selection 1908-1974*, The Nelson Gallery and Atkins Museum Bulletin, Kansas City, Missouri, V, no. 2 (1974).

11. The technical part of the *Proceedings* of the conference, with scientific information and formulas, was, in response to this demand, reprinted by the Federation of Canadian Artists in 1943, courtesy of the Artists' Supply Company, Toronto, and was freely available on request.

12. Bernard Ostry, *The Cultural Connection*, p. 54, incorrectly states that "the outcome (of the Kingston Conference) was the inauguration of the Federation of Canadian Artists, *led by sculptor Elizabeth Wyn Wood and Painter Lawren Harris* [my italics]." Lawren Harris became the *second* National President of the Federation, serving in that capacity from 1944-47. Neither Harris nor Wyn Wood were at the conference but their names appear on the membership list in December 1942.

13. The draft constitution included a fee structure (five dollars annually for artist members, three dollars for interested laymen), and set up representatives as "rallying centre" for the five regions agreed on as follows: West Coast (Lawren Harris); Western, with sections in Alberta (Gordon Sinclair); Saskatchewan (Ernest Lindner); Manitoba (Miss Byllee Lang); Ontario (A. Y. Jackson); Maritimes (Walter Abell).

14. *Federation Bulletin* (n.d.). Includes report on the annual meeting of May 1942.

15. Arthur Lismer to André Biéler, 19-21 July 1942.

16. The Carnegie Corporation continued to support the Federation of Canadian Artists during its first two years. for secretarial and travelling costs, in the sum of $1,750 (1941-42) and $1,500 (1943). Apart from this, the sole financial support of the federation seems to have been from membership fees.

17. Lawren Harris to A.Y. Jackson, December 1941. I am indebted to Dr. Naomi Jackson Groves for this reference.

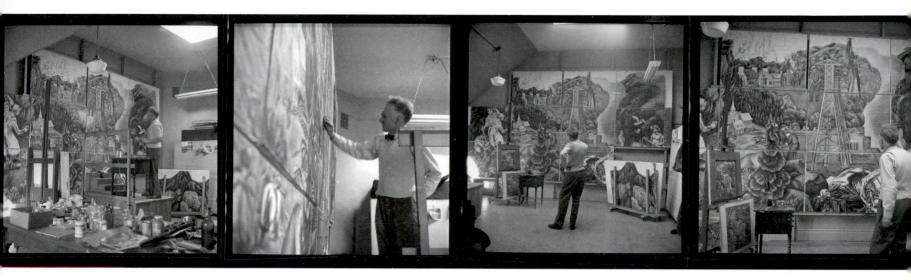

18. *Canadian Arts Council*, n.d. The aims of the council are listed in this folder, along with the executive, committees and founding associations, which included the Federation of Canadian Artists (the council became the Canadian Conference of the Arts).

19. Bernard Ostry, *The Cultural Connection*, pp. 57-58, is incorrect in his reference to the Canadian Arts Council's proposals made to the Turgeon Committee in 1944 The council was not formed until December 1945. Similarly, his statement that "the Canadian Arts Council thought the federal government should set aside $10 million to encourage the provinces to build community centres" is misleading. This proposal was contained in the Federation of Canadian Artists' individual brief to the Turgeon Committee in 1944, cited in "Special Committee on Reconstruction and Re-establishment." *Minutes of Proceedings and Evidence*, no. 10 (Ottawa: King's Printer, 1944), 21 June 1944.

20. Pierre Cabanne, "Dialogues with Marcel Duchamp" in *The Documents of 20th Century Art*, trans. from the French by Ron Padgett (New York: The Viking Press, 1971).

21. Francis O'Connor, *The New Deal Art Projects: An Anthology of Memoirs* (Washington, D.C.: Smithsonian Institution Press, 1972).

22. "Growth of Art Traced in Lecture," *Halifax Star*, 31 January 1942.

23. A. L. Wright to H. O. McCurry, 29 January 1942, National Gallery of Canada, Ottawa.

24. Grace Piper, "André Biéler Pictures Kingston as Art Centre," *Kingston Whig-Standard*, 23 July 1943.

25. The artists were Ralph Allen, Caven Atkins, Ghitta Caiserman, Stanley Cosgrove, John Gould, Robert Hedrick, Edwin Holgate, Jack Humphrey, Grant Macdonald, Henri Masson, Alex Millar, Will Ogilvie, David Partridge (who had been an early student at the school), Jack Pollock, Ethel Raicus, Carl Schaefer (a very popular teacher who came for several years), Burrell Swartz, George Swinton, Gentile Tondino, Tony Urquhart, George Wallace, Gustav Weisman and Peter Whalley.

26. Heather Logan, "André Biéler – Canadian Artist," *Queen's Journal*, 2 December 1947, p. 3.

27. W.J. Phillips, "Art and Artists," *The Winnipeg Tribune*, 14 September 1940.

28. André Biéler, "The Indirect Method or Mixed Technique of Painting," *Maritime Art* 3, no. 3 (February-March 1943): 82-84. The two following quotations are also taken from this source.

29. André Biéler to his family, June 1945. The three following quotations are also taken from this source.

30. André Biéler, "Mural of the Saguenay," *Canadian Art*, IX, no. 2 (Christmas-New Year 1951-52): 70-71.

31. "Shipshaw Mural Is Nearing Completion," *The Aluminum Ingot*, 6 August 1948, p. 4.

32. André Biéler, "Mural of the Saguenay," pp. 70-71.

33. Zoe Biéler, "Aluminum Mural," *The Standard*, 9 October 1948.

34. Marius Barbeau to André Biéler, 2 December 1948 (translated from the French by the author).

35. André Biéler, "Mural of the Saguenay," pp. 70-71.

36. Heather Logan, "André Biéler – Canadian Artist," p. 3.

37. André Biéler, "Mural of the Saguenay," pp. 70-71.

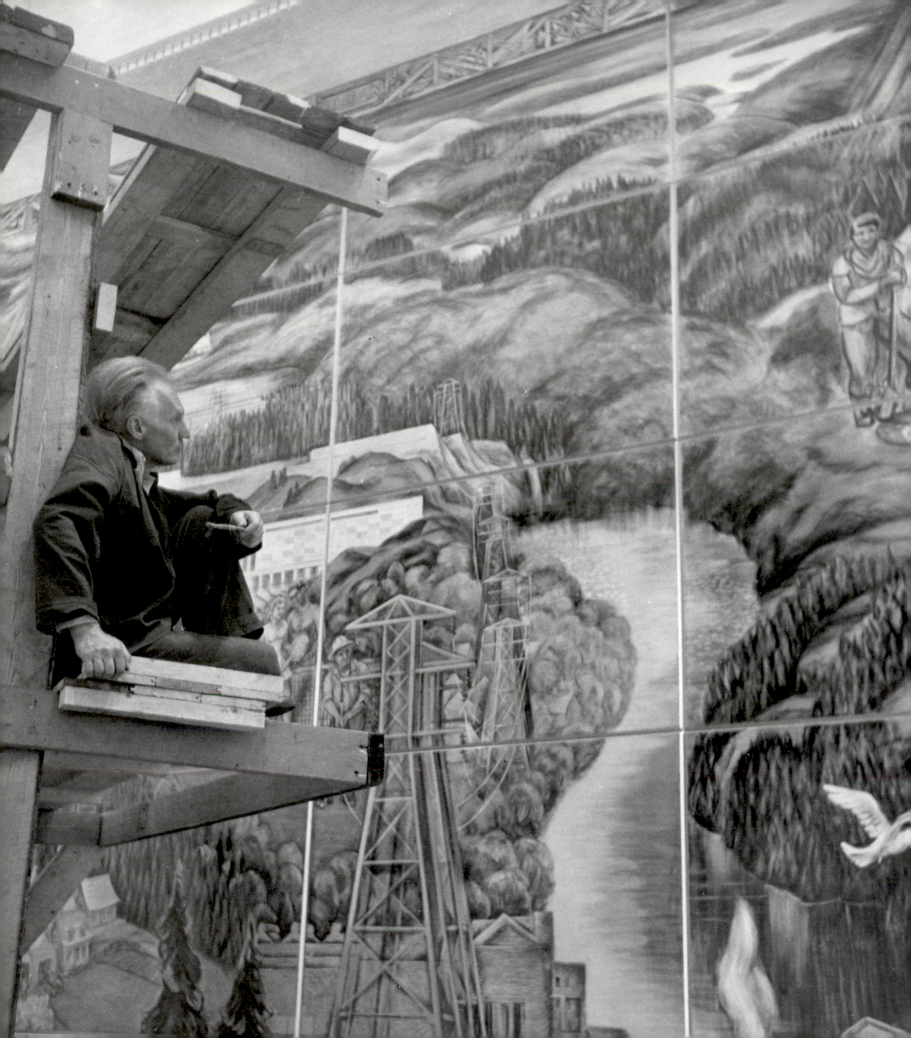

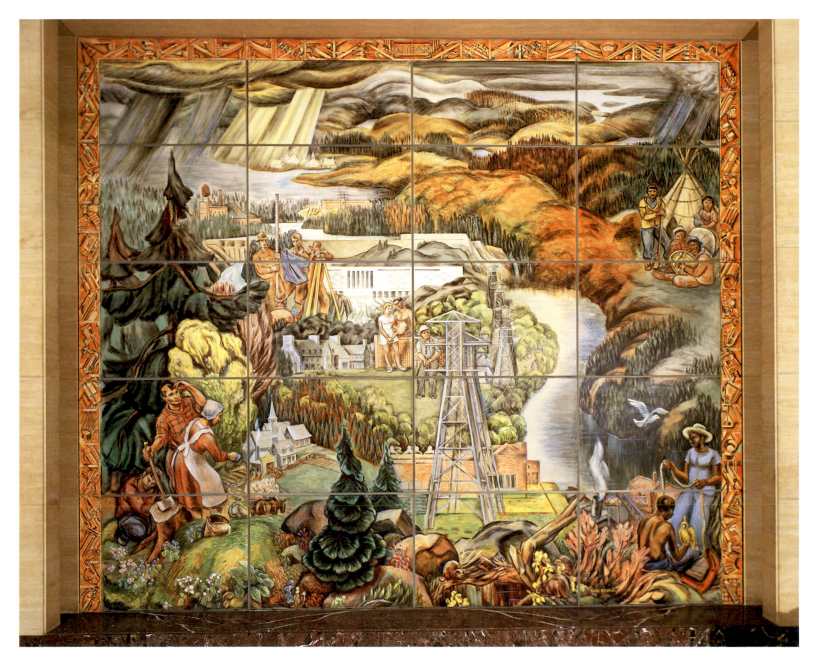

The Shipshaw Mural, Shipshaw, Québec, 1947
Painted aluminum panels
4.9 x 5.8 m
Collection of Alcan Inc

Page 214
André Biéler on the scaffolding during the installation
of the *Shipshaw Mural*, Québec.
Photograph by G. Sperling
A.B. Archives

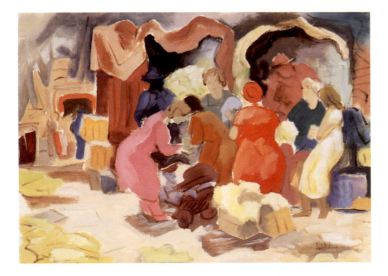

Les Dames au marché, 1950
(Ladies at the Market)
Tempera on paper
40 x 57 cm
Collection of the Montreal Museum of Fine Arts

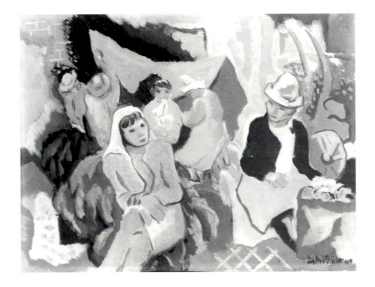

Marché Jacques-Cartier 3, 1949
Oil on panel
45.7 x 61 cm
Private collection

Bernard Ostry, in *The Cultural Connection,*[2] has traced the pervasive, although sometimes ambivalent role of the government in relation to cultural development before and since the establishment of the Canada Council and has challenged the national consciousness to concern itself with cultural issues. The challenge of the Kingston Conference of 1941 is renewed in a more complex political situation in Ostry's book.

But André Biéler was essentially an individualist and in the 1950s he withdrew a little from the public arena, having contributed to important national developments through the conference and the Federation of Canadian Artists in the previous decade. Kingston was somewhat isolated, outside the artists' groups of Montreal and Toronto. There were few artists in the community, although the summer school continued to bring both teachers and students to the city and stimulated the climate of understanding. He was able to devote more time to painting after the Shipshaw mural was completed, and there were significant signs of a change in his style. A one-man exhibition at the Garfield Fine Art Gallery in Toronto in March 1950, in which about fifty paintings and drawings were shown, attracted favourable attention:

> Biéler has worked through to an expression with more poise and yet more freshness than the paintings shown by him in recent years. He combines a French feeling with the forms of Canadian life, with colour patterns more sunny and ingratiating than he has ever used before.[3]

One of the best of the paintings in this exhibition, *Marché Jacques-Cartier 3,* has a degree of this freshness and spontaneity when compared with the sometimes laboured mixed technique works which had preoccupied him in the 1940s. The experimentation with mixed technique was to a great extent linked with André's art history classes and discussions of the techniques of the old masters. His method of teaching was to have the students work in the studio, in the technique and style of the artists they were studying. This movement from the theoretical aspect of lectures to the practical experience greatly enhanced the students' understanding of the artists' approach. But, as André himself later agreed, he had spent too long working in mixed technique; he was to find far more expressive freedom, in keeping with his temperament, working directly in colour in a manner more related to the French postimpressionists. The School of Paris was his touchstone.

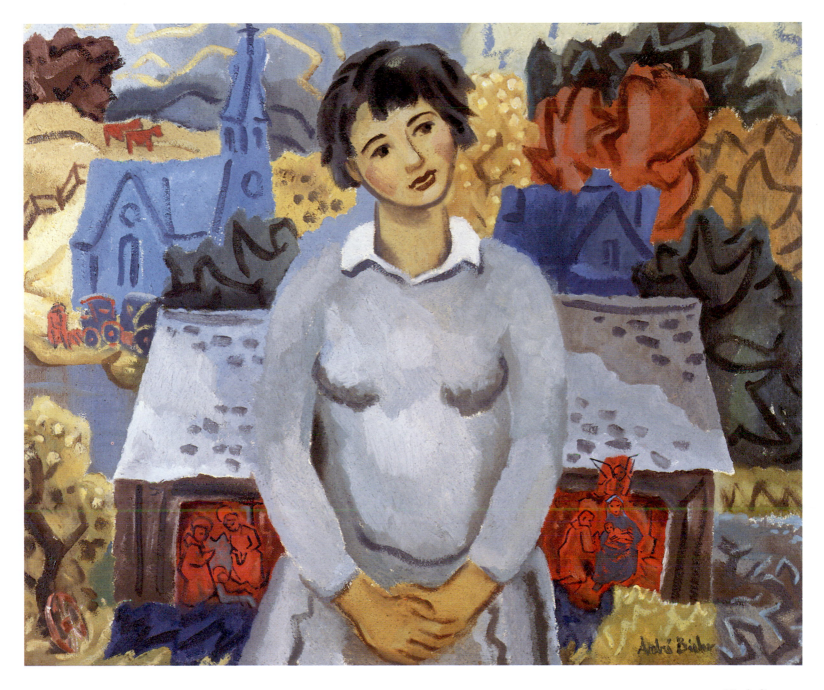

Nathalie, 1950
Casein on board
76.2 x 91.4 cm
Private collection

André had become affectionately known as the painter of the *Gatineau Madonna* (repr. p. XXIV) following the publicity attending its purchase by the National Gallery of Canada in 1945 (a watercolour version is in the collection of the Art Gallery of Ontario). Charles C. Hill wrote in 1977: "Biéler, following the model of Diego Rivero and the Marxist art of the W.P.A. sanctifies the rural family,"[4] but he was inspired much more directly by his regional interest in rural Canada and by the enjoyment of his own growing family. Nathalie was born in 1934, Sylvie in 1937, Ted in 1938 and Peter in 1943. There has always been a very warm relationship within the Biéler family and this was reflected in a number of works of this period, such as *Family in Blue* of 1952 and especially *Nathalie*, a portrait of his daughter from 1950 (repr. p. 221). In the original sketch Nathalie is set against a Laurentian landscape at Morin Heights with the farm cart in front of the barn, the implements seen through the open door and the village church in the background against the hills (repr. p. 224). In the final painting he places the girl, with all the charm and the vulnerability of the adolescent, in front of the barn, which becomes a stable. Two vignettes of the nativity scene on either side of Nathalie extend the association inherent in the title of the painting. This work, shown for the first time in the 1950 exhibition of the Canadian Group of Painters, was illustrated in the *Winnipeg Tribune* with this comment:

> One of the finest pictures in the exhibition is André Biéler's *Nathalie*. The background is worthy of this wonderful blossom of a girl. The French genius for achieving tenderness without sentimentality is here like sunlight, unspoiled in its new-found Canadian strength.[5]

Within the immediate family circle there was always an atmosphere of creating things, recollected by his son Ted, now a well-known sculptor:

> I started out to work with my father... in the basement workshop in Hill Street and my earliest memory of working with him was there; he was always framing, and we made frames and other things, like boats and so on. I was always with him, and he always made an assumption – he never seemed to find out whether or not I was interested – an assumption that I would be ready to hold the other end of the board, and there was very little talk during those sessions; working for the children, making toy trains, mechanics, etc., there was always something new, never a repeat performance ... And I never considered it a chore because there was always some new angle, something I hadn't thought of ... and he would accept some suggestions, he was completely open ... there was always some constructive base behind it ... there wasn't a certain way that things had to be done; you work it out from scratch, while you are working, starting with the idea, letting it evolve ...

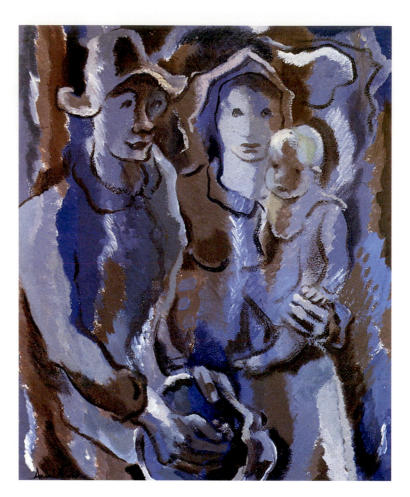

Family in Blue, 1952
Oil on panel
76.2 x 61 cm
Collection of the Edmonton Art Gallery

All images from A.B. Archives.

1. The Biélers with their children Ted, Sylvie and Nathalie.

2. The Biéler home built at 33 Hill Street, Kingston, Ontario.

3. Peter, Jeannette (partially hidden), Sylvie and Ted Biéler, in the dining room at Hill Street, circa 1952.

4. Jeannette Biéler with Ted and Peter visiting the Château de Talcy, France.

5. The Biélers in their garden at Hill Street.

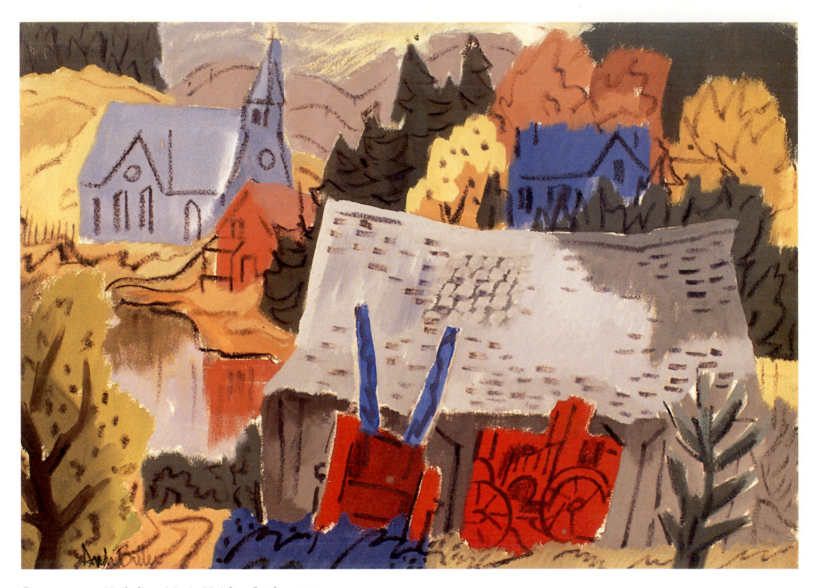

Paysage pour « Nathalie », Morin Heights, Québec, 1950
(Background for "Nathalie," Morin Heights, Québec)
Gouache on paper
39 x 56 cm
Collection of the Musée national des beaux-arts du Québec
Gift of the estate of André and Jeannette Biéler

His son Peter, who is now involved in film production in California, and whose interests lay in writing and in organizing people rather than in the visual arts, recalled the encouragement he had always received from his parents and from his sister Nathalie, who was nine years older; it had always been encouragement towards an active creative development. Peter also remembered the "Sunday makings" as the family called them, where they would get together on Sunday afternoons to make things – mechanical things, with an electric motor, or things with wood – but always something new and inventive: "I stood by and watched – I wasn't much good at that sort of thing – but actually I used to love it, this was a high point for me."

In 1950, in the interlude between the summer school and the beginning of the fall term at Queen's, André "escaped" to rediscover Montreal. He lived for a month in Lilias Newton's studio at 522 Pine Avenue and enjoyed the holiday from teaching, the freedom to create and the opportunity to renew old friendships with Québec artists. Art critic Robert Ayre observed that "with that freedom, and the excitement of seeing the old city with fresh eyes, has come a release of energy which has resulted in a group of pictures painted with a joy which I hope will be shared ... by adapting some of the ideas of Dufy, and some of Matisse, to his own uses, Mr. Biéler is introducing a new element into Canadian painting."[6] This lively series of sketches in gouache, painted on the spot in the markets and squares of the city, shows a continuity of the fresh approach which had been noticed in the March exhibition. A number of them were included in a group exhibition under the rather flamboyant title "Artists of Fame and Promise," at the Dominion Gallery, Montreal, in September that year:

> The market pictures – Bonsecours, Champlain, Atwater – begin as colour patches, suggested by a grey truck, a mound of apples, a pile of baskets or the clothes of the people. The drawing, which goes on afterwards, brings out the character of the scene and its elements and lifts it from the abstract into the human dimension. The line runs spontaneously over the surface, not only revealing but enhancing ... Mr. Biéler makes no attempt to introduce the third dimension or be otherwise realistic, but the pictures give you, as in a sort of blithe shorthand, the essence of the scene and the pleasure there is in it for those with eyes to see.[7]

In the spring of 1951 André visited the northern part of Ontario with a neighbour, driving as far as Timmins. In the Group of Seven landscape of sombre lakes and rocky terrain, of luxuriant but untamed nature, his interest centred on the pioneers in their tarpaper shacks trying to clear what was really marginal farmland. He found a marked contrast between this and the more settled

Perkins Mills 1, 1950
Gouache and felt pen on brown paper
38 x 49 cm
Private collection

Perkins Mills 2, 1950
Gouache and felt pen on brown paper
38 x 49 cm
Private collection

Château de la Dame Blanche, Grez-sur-Loing, 1959
Felt pen and gouache on paper
30.5 x 37 cm
Private collection

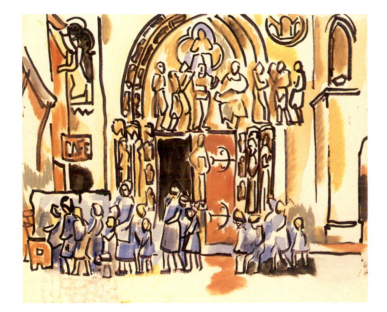

Autun, 1959
Felt pen and gouache on paper
30.5 x 37 cm
Private collection

In May 1953 André left Canada with his family to spend a year's sabbatical leave in Europe, his first return visit since the wedding trip in 1931. They arrived in Paris to spend a few weeks visiting their Merle d'Aubigné cousins at Vétheuil, Grez-sur-Loing and Neuilly. Immediately, André began to make sketches in the villages. Many quick drawings using felt pen (for the first time) and crayon capture the essence of his subject, as in the sketch of the ruins of the *Château de la Dame Blanche* at Grez. He worked mainly in gouache, however, in a continuation of the technique of the Montreal market sketches, with free colour areas superimposed by drawing. Both colour and drawing were becoming stronger. Paintings in Vétheuil, La Roche Guyon and Grez-sur-Loing are among the first impressions of his return to France.

After buying a second-hand car in Paris, the family journeyed to the south of France for the summer months. The journey was a sort of pilgrimage; they stopped to visit the cathedrals of Sens, Auxerre, Vézelay and Autun. This sketch of a class of school children competing for interest in the romanesque doorway at Autun was made on this journey. At Lyons they visited the Museum of Silk Fabrics. Old Etruscan designs were still being used in the region. They followed the valley of the Rhône to Orange, where the Roman presence still presides in the statue of Augustus in the theatre; and on to Avignon, Saint-Remy and Aix-en-Provence, where André sketched Cézanne country around Montagne Sainte-Victoire. They resided in Châteauneuf-de-Grasse while André sketched along the Mediterranean coast at Antibes and Juan-les-Pins; sketching in Vence and Nice was combined with visits to the museums; and in the Alpes Maritimes he retraced his steps of thirty years earlier when he stayed at Les Courmettes.

His gouache paintings reflect the Midi, the land and the people, in all the sun-drenched colours with which Pierre Bonnard filled his canvases made in that region. *Cézanne Country* (repr. p. 218) captures the red soil, the red-tiled roofs, the green of the land that Cézanne painted. *Alpes Maritimes* bears witness to the "perched" villages of the region, which were necessary for protection against successive invasions in ancient Provence. *Village sarrasin* reflects another aspect of the history of Provence, the harassment of the Saracens, particularly in the region of the Maures, from the eighth to the tenth centuries and later. The Saracens left elements of their Moorish origin, including the flat house tiles and decorative elements. In many paintings of this region André returned to the subjects that had fascinated him in

Québec – people gathering in the markets or going about their daily tasks on the land, such as stacking wheat or harvesting grapes. The sense of place and the atmosphere and colour of Provence are unmistakable in his work.

In September a brief visit was made to Assisi, Siena, Ravenna and Rome. The few days spent in Assisi were mainly to study works by Giotto and others in the upper and lower churches for art history lectures – a study made possible only by "purchasing light" from the friar! It was also the opportunity for many sketches in and around the piazza. *Assisi II* (repr. p. 235) is classic in its organization of architectural elements suggestive of a stage back-drop, and has the precision of Giotto. Ravenna was a delight, with the newly cleaned mosaics in the church of St. Vitale "as bright as the day they were put together."

Returning to Grasse, they followed the Route Napoléon through the Alps to Grenoble, then on to Moulins to see the famous painting by Maître de Moulins. From Bourges, with its jewel of a cathedral, they visited the châteaux of Blois, Chambord and Talcy (repr. p. 223, #4). Of special interest to the family was Talcy, where Agrippa d'Aubigné courted Diane Salviati (a niece of the great Medicis) and where an uncle of Renée, wife of Guillaume Merle d'Aubigné, lived until his death when the estate, intact, with furniture and tapestries, was given to France. From there they went to Paris, where they had an apartment on Rue d'Assas from October 1953 to April 1954.

Paris was a place of study for the whole family: Nathalie was at the Sorbonne, Sylvie and Peter were at French schools, and Ted was working mainly with Lurçat and the sculptor Zadkine. André attended a series of superb lectures by René Huyghe on the Irish manuscripts at the Collège de France; lectures on aesthetics by Etienne Souriau at the Sorbonne; and a series on contemporary art by Ferraton at the Louvre which drew a stand-ing-room-only audience on each occasion. This return to the stimulating cultural environment that Paris provided was in marked contrast with the Canadian situation. Interviewed in 1954, he observed:

In France, the emphasis is on cultural and intellectual achievements, and on giving the individual freedom of expression. It is the indi-vidual who counts. I feel this contrasts greatly with the emphasis on technological advances, particularly in the United States.[8]

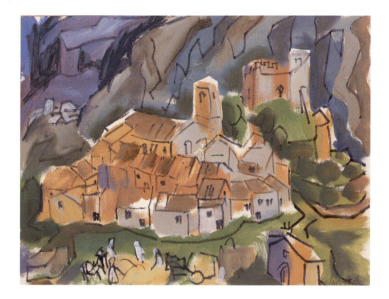

Alpes Maritimes, 1953
Gouache on paper
32 x 42 cm
Collection of the Musée national
des beaux-arts du Québec

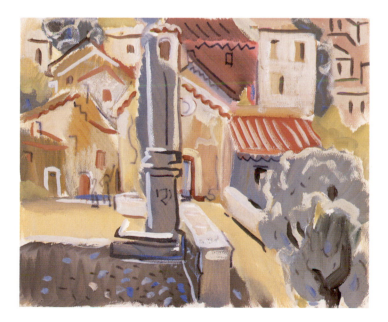

Village sarrasin, 1953
(Saracen Village)
Gouache on paper
30 x 37 cm
Private collection

Church at Auvers (Homage to Van Gogh), 1953
Ink on paper
23.5 x 12.7 cm
Private collection

His own sketching and painting in Paris took second place to his studies and visits to the museums and art galleries of the city, and to the cathedrals and châteaux near Paris. But his sketchbook was always ready. A day at Auvers-sur-Oise resulted in this drawing of the church, which is from the same angle as Van Gogh painted it. The narrow streets near their apartment were full of life: the fruit and flower vendors, the Punch and Judy shows and, of course, the cafés. The beggars who made the Paris streets their home particularly fascinated André. *Les Clochards* (The Homeless) in gouache is one of the most fully developed and successful of the Paris works and is reminiscent of the work of Braque in its overall patterning and colour range of muted blues, greys and browns. The incident that motivated the painting was when one old man, in the line-up for the daily handout of hot soup, keeled over and was thereafter solicitously tended by his confreres. The mood is sombre, reflected in the greys and greens and blacks, a colour range that was also a response to Paris in winter.

The studios of Montparnasse, where he had studied in the 1920s, had changed remarkably by the 1950s. He was later reported to say:

> The spirit of the students, the talk of the students, had gone; sometimes it seemed as though he had been replaced by the tourist... Montparnasse had an international air which it lacked in his own student days. A visitor now would usually find a Canadian in a studio, working on a government grant, but French students found it difficult to join because of the high cost of living ... [students used to work] hard during the week, awaiting the arrival of the master, on Saturday. They were forced to acquire a mastery of drawing, from life ... What a change! The students *[now]* seldom looked at the model. They painted abstracts, while the model read comics![9]

To study the work of the Dutch and Flemish painters, the Biélers travelled to Belgium and Holland in March 1954, visiting Antwerp, Bruges, Ghent, Delft, Rotterdam, Amsterdam and other places of interest. Commenting on this, their first visit to the Netherlands, in a lecture on the Dutch masters in Kingston in 1955, a newspaper reviewer observed that André:

> ... had been struck by the democracy of the country, its fine housing and the absence of evidences of extremes of poverty. They went first to the house in Antwerp where Rubens had lived and painted. They were interested to see the way in which one room adjoined the next in a suite, to give the familiar long perspective, the black and white tiled floors, and the large windows which admitted the plentiful light that characterized the work of the artist. In Rembrandt's home *[in Amsterdam]*, by contrast, the light seemed to come only from above, and the effect was made even more striking by the dark oak

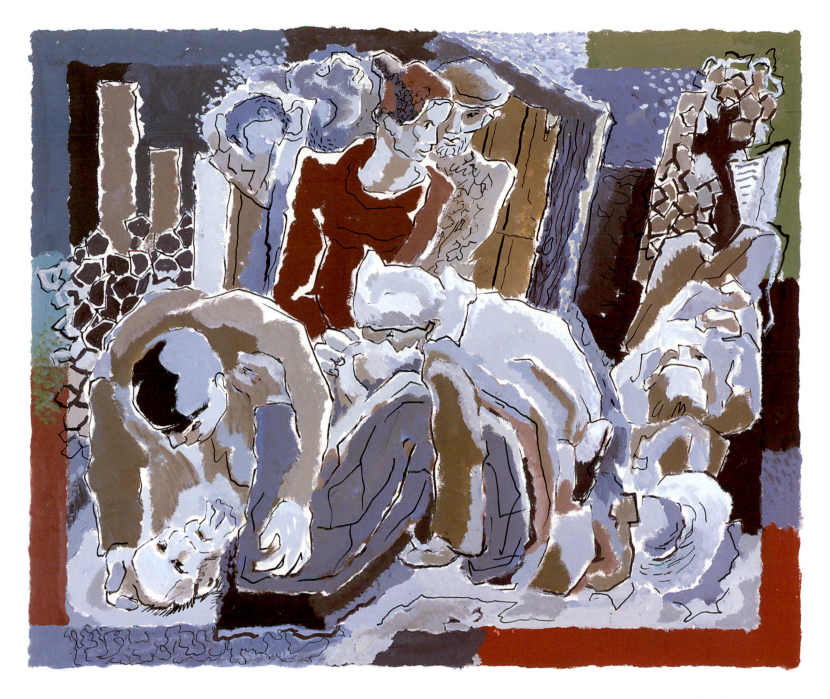

Les Clochards, 1954
(The Homeless)
Gouache on paper
50 x 65 cm
Collection of the Musée national des beaux-arts du Québec
Gift of the estate of André and Jeannette Biéler

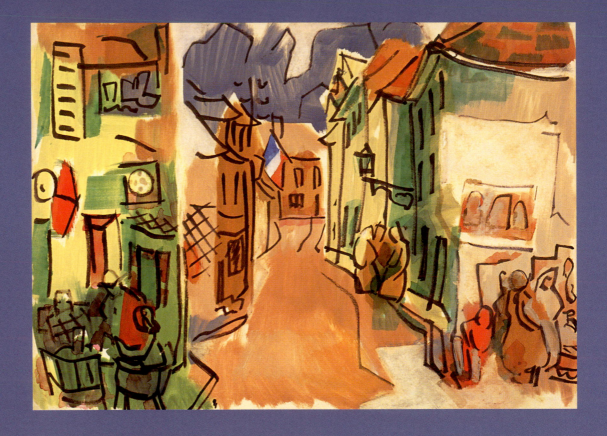

Vétheuil, rue de l'Hôtel de Ville, 1953
(Vétheuil, Town Hall Street)
Gouache on paper
31.7 x 43.5 cm
Private collection

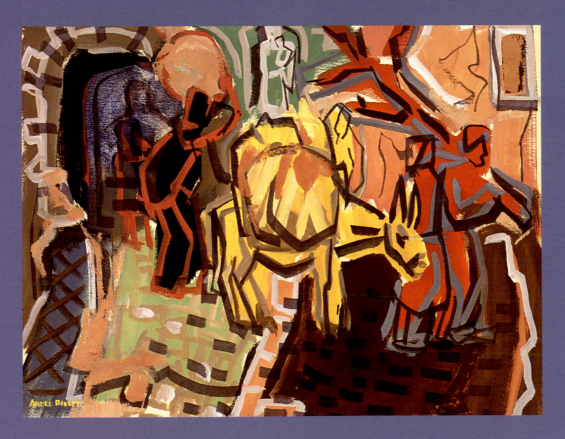

Tourette-sur-Loup, 1953
Gouache on paper
32 x 42 cm
Private collection

The Biélers' sabbatical year ended with five weeks in London, visiting museums and galleries, attending concerts and plays and exploring the English countryside – Winchester, Salisbury and Oxford. The friendship with the artist Edward Bawden, formed at Banff, was renewed in a weekend at his home in Great Bardfield. André contrasted London and Paris at that time. He felt that the war experiences were still evident in France. The mood of the young artists in Paris was sombre; their colours were predominantly grey and black. London was much happier and brighter than Paris – and the cost of living was much less! The Tower of London was painted in several contrasting moods. The one illustrated from the river is dramatic in the lighting effect but classical in its organization; the dramatic history of the Tower is suggested by the chiaroscuro.

Following his return to Canada, over thirty of these European drawings and paintings were exhibited in the Robertson Galleries in Ottawa from 15 to 27 November 1954. An interesting review, which called attention to the charm of his rich subject matter and the free modernity of treatment, also included a critical note: "We see flower sellers, the Luxembourg gardens, clochards – sometimes in too rich, too confusing, nervous mosaic-like patterns."[11] This is justified; his patterns, linear or tonal, were sometimes confusing, as if with tremendous exuberance he had tried to crowd too much onto the flat surface of the paper. The excitement and the richness of his subject matter precipitated this tendency, perhaps, but Andre always believed that paintings should not be too easy and should require effort on the part of the viewer to understand and participate.

From all these experiences, André brought back to Canada an intensified awareness of the continuity of art and ideas through the ages. He had been particularly impressed with René Huyghe's lectures on the Irish manuscripts which showed influences from Celtic, Saxon, Scythian and Byzantine sources. The fantastic forms suggested by the art of the barbarians became, in the hands of the monks, woven into rhythmic, decorative patterns which disdained mere realism, as in the *Book of Kells* of the eighth century. The spiritual aspect of the work of manuscript illumination was seen by Huyghe, and by André, as a natural result; the monks, busy with their hands, could liberate their spirits to soar into communion with God. André was to find something of that liberation of mind and spirit when he came to experience the manual aspect of sculpture in the 1960s.

André resumed teaching in Kingston in 1955 with a new vitality from the "refreshment at the source" that Europe had given him. In his lectures, he had the ability to recreate the historical

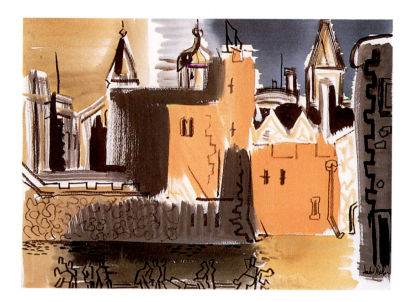

Tower of London I, 1954
Gouache on paper
33 x 43 cm
Private collection

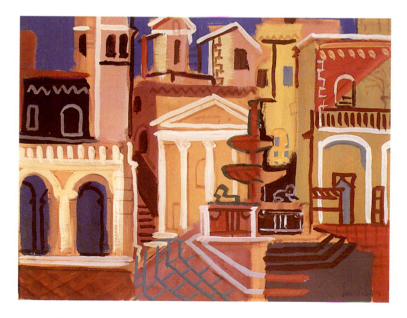

Assisi II, 1953
Gouache on paper
32 x 41.3 cm
Private collection

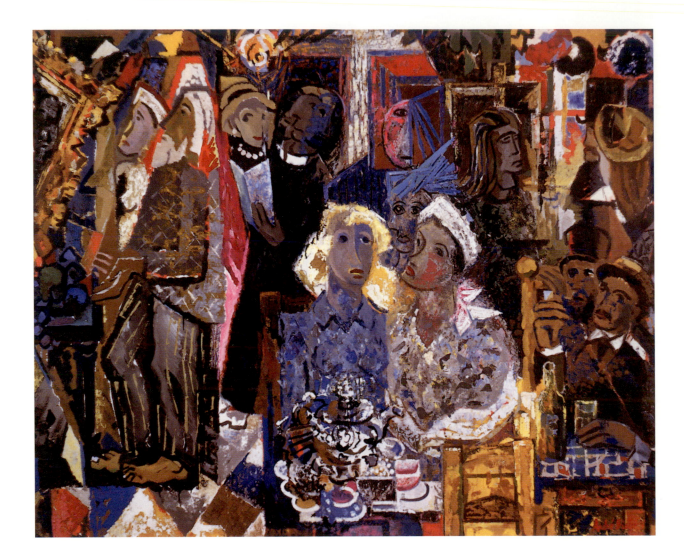

Art and Society:
The Private View, 1956
Oil on panel
122 x 153 cm
Private collection

shapes, overlapping planes and a patterning of colour areas, woven into a strong design – all elements used in the much more spontaneous sketches he made in Europe. Here the effect is comparatively heavy, and demands serious participation from the viewer in order to find the intention of the artist in the images in the work.

Art and Society: The Private View was the second work in the series to be completed, in 1956. This four by five-foot painting is rendered in rich blues with accents of red, and takes a gently satirical look at several aspects of the art world. The private view, or the opening of an exhibition "by invitation," is comparable to "opening night" in ballet or drama; it becomes a social occasion. In the centre foreground two women preside over the silver teapot; they wear colourful dresses and hats and are surely members of the ladies' auxiliary of the period. Behind them are suggestions of the people who come to see and be seen; the curate, with Picasso-

like ambiguity, is not quite sure which way to look. On the right, a masterful vignette in itself, is the café scene, the Parisian left-bank group forever discussing art over wine or beer. André recalled that "it was the people of the sidewalk cafés of Paris who sparked the revolution in French art which set the pace for the rest of the world."[15] On the left of the canvas we find the artist himself, the bearded Bohemian with bare feet and casual dress; he is the only one looking at the paintings and perhaps he is only looking at his own. There is delightful humour in this work as well as conscious visual suggestions of the stylistic tendencies of French artists such as Renoir, Picasso and Toulouse-Lautrec.

As the third work in the series, *Art and Society: The Studio Group* of 1957 presents a group of students working from the model at an evening class, a familiar situation to André Biéler. Stylistically, it is an abstraction of shapes based on a rhythmic

repetition of angles imposed on figures and objects alike. Colour is an important factor in the overall glowing effect; warm orange and ivory tones are set against cool blues. This work is the epitome of the formal compositional aims of the artist at this period. The painting won the J.W.L. Forster award for the best subject painting at the annual exhibition of the Ontario Society of Artists in March 1957; it was also "enthusiastically received and accepted" as André's Royal Canadian Academy diploma painting.

Another painting of 1957, *At Dusk,* is carried out with a jewel-like quality of colour in the interplay of reds and blues, reminiscent of medieval stained glass; the scene is one of workers returning home in the evening glow. As in the *Art and Society* series, humanity is his subject matter. Interviewed about his career in 1957, he commented: "The school of war is a harsh school, and at the Front [1915-1918] I gained my first inklings of the power and movement of humanity. Perhaps this will explain the fact that unlike most Canadian artists, I'm more a painter of figures than of landscapes." And referring to his studies in postwar Paris with Paul Sérusier and Maurice Denis, both friends and disciples of Gauguin, he continued: "Gauguin's paintings, with their vivid yellows, sultry reds and sombre tints gave me my love for colour. Sérusier was a marvellous character – like Gauguin he believed in the exotic, the colourful. He was a flamboyant man who strode about the studio in a black hat, swinging a silver-tipped cane."[16]

The human theme as his motivation, he made his first large colour woodblock print, *The Return of the Prodigal,* in 1955. It is based on an episode witnessed in the market square of Assisi in 1954:

> The scene was on that square in Italy where there were women grouped together as usual and from the other side of the square came one man, I think he was followed by someone else, I am not too sure, but anyway one man came – not exactly limping but you felt he was exhausted – came to the group of women, and there was a startled look in their faces. The recognition did not come immediately. But when it came it was very emotional. You felt that this had been an acquaintance of some intimacy and that his unexpected return was a great moment in their lives.

There is a Giotto-like feeling in the grouping and gestures of the women that projects an austere dignity, which is enhanced by the colours used. Of the three blocks cut for this print, one was printed in muted tones of blue, for which André used a true indigo, ground from crystals; one in light tones of burnt umber; and the third block, the line block, in a darker brown. The white areas strengthen the design. The prints were hand-rubbed on Japanese paper.

Art and Society: The Studio Group, 1957
Oil on masonite
122 x 153 cm
J.W.L. Forster Award
Collection of the National Gallery of Canada

The Return of the Prodigal, 1955
Woodblock print
37.5 x 50.5 cm
Collection of the Agnes Etherington Art Centre

While André was busy with his large-scale projects, on the national scene, the government was slow to implement the recommendations of the Massey Commission. It was not until 1957 that the bill was passed establishing the Canada Council. As the decade advanced, however, there were signs of greater public patronage of artists. In 1955, with the assistance of the Royal Canadian Academy, a competition was held for the creation of three murals for the recently completed Department of Veterans' Affairs building in Ottawa. Selected artists, all veterans, were invited to submit designs. André's design was selected for one wall by a committee of the Royal Canadian Academy; the two artists whose sketches were chosen for the other walls were Charles Comfort and George Pepper. The theme assigned to André was:

> A representation of the many and varied functions performed by the Veterans Welfare Services Branch in the programme of rehabilitation and also depicting the work of the Veterans Land Act in establishing veterans on small holdings, on farms, in commercial fishing, and in training and assisting them in the building of their homes.[17]

The wall area measured 7' x 20'6", with a recessed section in the centre which is the counter of the canteen. The completed mural represents the veteran and his family building their home in the left panel. In the right panel, veterans are shown in various occupations taught in the rehabilitation program: farmers discuss the operation of a new tractor; the scientist works in the laboratory; the fisherman with his nets; the land surveyors with their instruments. In the recessed centre of the mural, animals in their natural settings are depicted in cool blues, in contrast with the dominant yellows of the side panels. A quiet landscape joins the two side panels across the top, above the recess. The symbolism of the work was outlined by the artist:

> The dominant note of yellow [in the side sections] is optimistic, the veteran launching out in life in confidence because of the training given him and the faith in the future of the country he has fought for. The main lines of the composition are vertical and horizontal giving a sense of order to which he wishes to conform in life. The central part of the mural is symbolic of peace. The cool blues contrast with the yellows and also give a feeling of depth to the ideal for which we have fought, peace on earth.[18]

Other commissions followed. One was for a mural in the foyer of MacGillivray-Brown Hall, the church hall of Chalmers United Church in Kingston. André decided on mosaic as the medium, and used small wall or floor tiles made locally by the Frontenac Tile Company; especially for the project, the company also made some gold tiles, incorporating gold leaf, which André used to highlight elements in the design, giving it a touch of Byzantine splendour.

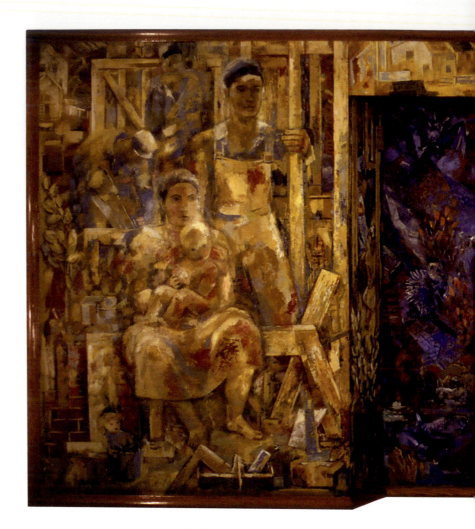

Veterans Welfare Services, Rehabilitation, 1955
Oil on canvas applied to plaster wall
2.14 x 6.25 m
North wall of 6th-storey conference room
Justice Canada Building, Ottawa

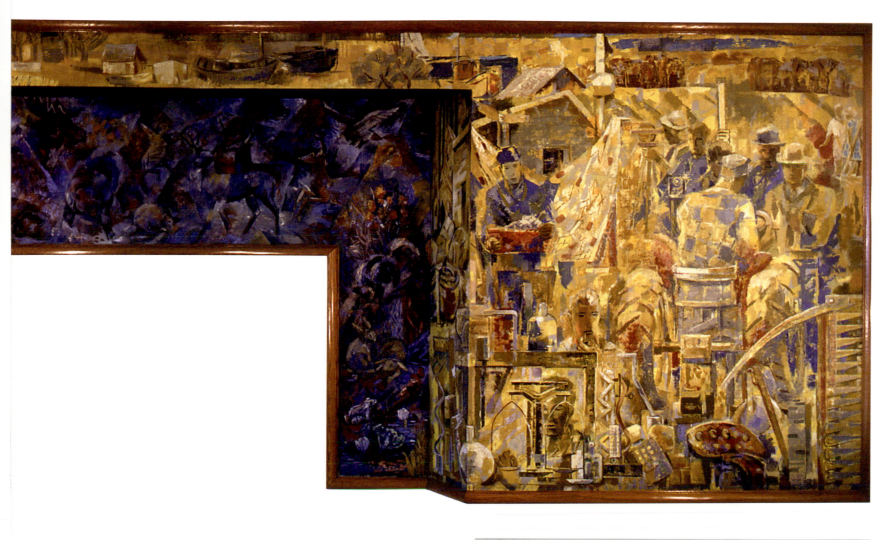

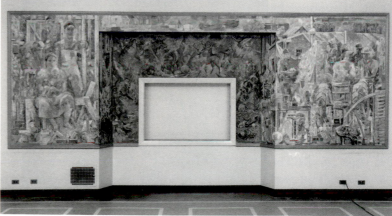

The mural in its original setting in
the cafeteria of the Department
of Veterans' Affairs, 1956.
A.B. Archives

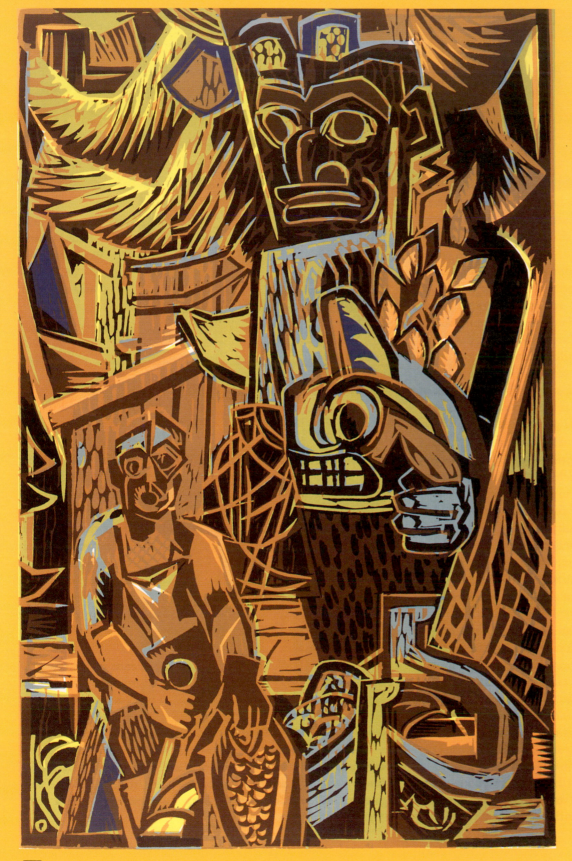

Skeena Fisherman, 1980
Silkscreen version of an original
woodblock print from 1956
60 x 38 cm
Serigraph print on paper
112 x 72 cm
Private collection

The Indian agent had to take up the new schoolteacher to the far village and said "Why don't you come along with us in the truck?" *[along with]* her baggage, cat, furniture, etc... "the Hudson Bay factor might put you up," he said, so we took off for this fascinating trip and bumped along some pretty stiff roads. Just before the village we crossed the Skeena River, a swift stream about as wide as the Richelieu... Turning a bend in the road, suddenly, tall and slender, a row of some fifteen totem poles and on the ground the remains of many more ... after an hour there, on thirty miles up a valley to Kitwancool through magnificent forests, suddenly the lost valley opens out, almost a little Eden, poles everywhere and remains of the old-type houses, mostly on stilts to keep out of the damp ground... The poles belong to the families, they can only alter a pole with the consent of the whole family... which would need a potlatch feast... so the poles rot on the ground... The next day, Friday, looking at poles and sketching. In the afternoon I took a walk in the woods; after penetrating a while, behind some trees, I got a glimpse of a large strange statue, a primitive woman some ten feet high with a bird in her hand in dull yellow and black and white. She seemed to stand in front of what was a burial house ... it was a strange figure there in the solitude of the woods... I sketched her and took some photographs.[20]

From this experience a number of sketches have survived, among them *Burial Place, Kitwanga, B.C.* in watercolour and ink, of the woman in the forest with the bird in her hand, guardian of the burial place at Kitwanga. Another work, in which he used coloured inks, *Salmon Nets, Skeena,* is a vivid impression of the Indians bringing in their salmon against the background of the smokehouse. On his return, André created a woodblock print in which a large totem pole figure looms out of a stylized forest background over the smaller figure of the fisherman with his boat and salmon by the banks of the Skeena River. A print of this was sent to Marius Barbeau who, in expressing his thanks, referred to it as "votre admirable rhapsodie des totems."[21]

These years were a remarkable period of creativity for André Biéler, the artist. He also planned the teaching and exhibition program, both in summer and winter, and his dream of an art centre for Kingston became a reality with the opening of the Agnes Etherington Art Centre in 1957.

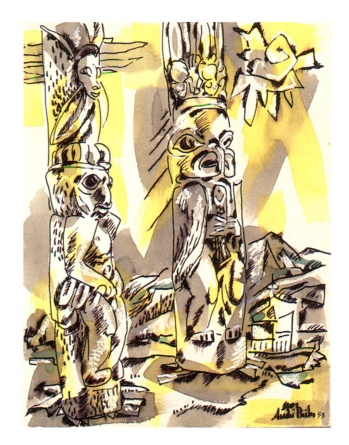

Two Totems, 1955 (1956)
Acrylic and ink on paper
30 x 22.5 cm
Private collection

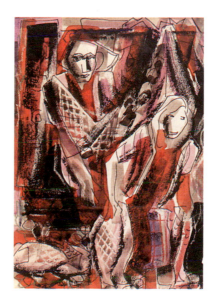

Salmon Nets, Skeena, 1956
Acrylic and ink on paper
38 x 28 cm
Private collection

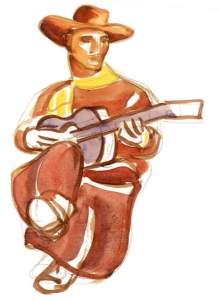

The Guitarist, 1954
Watercolour on paper
30 x 22 cm
Private collection

Glacier view #5, 1952
Charcoal on paper
16 x 25 cm
Private collection

The year 1962 brought one more achievement of lasting importance to the cause of art in Kingston. Ayala and Samuel Zacks, whose generosity as patrons of art has already been recorded, donated a collection of ninety contemporary Canadian paintings and sculpture to the Agnes Etherington Art Centre in December. They were works that had been collected, with sensitivity and discrimination, in the previous few years from studios and galleries in Toronto, Montreal and Paris. It was a wonderful way for Samuel Zacks to say "thank you" to his alma mater: André Biéler was invited to select the works to be included in the donation. In the collection there are paintings by Borduas and Riopelle, expatriates in Paris, Jock MacDonald, Jack Bush, Jean McEwan, Graham Coughtry and Harold Town. André Biéler observed: "This is the first large gift of its type to the Agnes Etherington Art Centre. It will be a splendid addition to a growing permanent collection built up over the years at Queen's University through the generosity of alumni, other friends and from the George Taylor Richardson Fund."[33] The collection was formally presented by Mr. and Mrs. Zacks to Principal Corry at a gathering in the new galleries of the Art Centre on 5 January 1963, where it remained on exhibition until February. Dr. Evan Turner, director of the Montreal Museum of Fine Arts, spoke about the collection and urged Kingstonians to take advantage of it. "Appreciating contemporary art takes time," he said, but he urged people that "the really exciting thing is to return and think about the paintings in your many moods."[34]

This gift was of inestimable value to the Art Centre and has formed the nucleus around which further development of the Canadian collection has been built in succeeding years. A warm tribute to the Biélers was given in a letter from Samuel Zacks:

I have just written to Principal Corry telling him what it means to me to see our pictures installed in a happy home. To you and your wife, who have done so much to further art and the arts at Queen's, a special thank you is due. You have warmed and inspired us.[35]

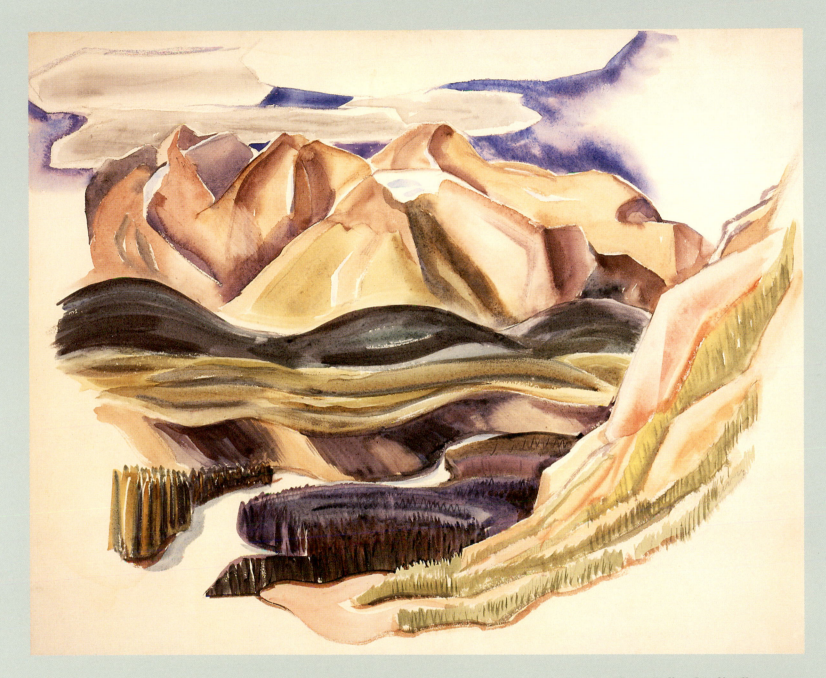

Bow River Valley, Banff, Alberta, 1950s
Watercolour on paper
50 x 61 cm
Private collection

The achievements of the decade, in both a personal and sociological sense, were remarkable. André had found renewal and satisfaction in his work as a painter and teacher in both Europe and Canada. Artists were beginning to be recognized in Canadian society. André had shown, more than most, the "will to develop a distinctive Canadian culture" as envisaged in the *Massey Report*. In the community, his vision and enthusiasm had resulted in the Agnes Etherington Art Centre through the generous help of Agnes Etherington. Appropriately, the Canada Council contributed to the 1962 extension of the Art Centre, considering the role of the Kingston Conference in setting in motion events that led to the establishment of the council.

André's creative energy, however, was by no means exhausted by his various activities, and he turned to new avenues of search and accomplishment in the 1960s.

NOTES FOR CHAPTER 7

1. A.R.M Lower, "The Massey Report," *The Canadian Banker* 59 (Winter 1952): 22-32.

2. Bernard Ostry, *The Cultural Connection* (Toronto: McClelland and Stewart Limited, 1978).

3. Pearl McCarthy, "Art and Artists: André Biéler's Exhibit Highlight of Openings," *The Globe and Mail*, 18 March 1950.

4. Charles C. Hill, *Canadian Painting in the Thirties* (Ottawa: The National Gallery of Canada, 1975), p. 116.

5. Randolph Patton, "Canadian Group of Painters," *The Winnipeg Tribune* (n.d.).

6. Robert Ayre, "Biéler's New Group of Paintings Show Artist's Warm Personality," *The Montreal Daily Star*, 23 September 1950.

7. Robert Ayre, "Dominion Gallery Presenting Wide Array of Canadian Works," *The Montreal Daily Star*, 30 September 1950.

8. "Says France Art Centre of the World," *Kingston Whig-Standard*, 7 July 1954.

9. "Visits Paris' Bohemian Quarter, Tells Art Guild About it," *Lindsay Daily Post*, 12 January 1955.

10. "Queen's Alumnae Hear Prof. A. Biéler in Illustrated Story of Dutch Masters," *Kingston Whig-Standard*, 19 March 1955.

11. "Biéler Opens Exhibition of Paintings," *Ottawa Citizen*, 16 November 1954.

12. Charles Comfort to André Biéler, 14 December 1955.

13. "Professor Praises Exhibition of 'Canadian Artists Abroad,'" *London Free Press*, 10 March 1956.

14. "Queen's Art Teacher Paints Dynamic Series," *The Globe and Mail*, 19 April 1957.

15. Ibid.

16. Toni Stephens, "Professor Biéler: Canadian Artist," *Queen's Journal*, 29 October 1957.

17. R. W. Pilot to André Biéler, 9 March 1955.

18. André Biéler to E. A. Gardner, 6 December 1955.

19. Robert Ayre, "Arts and Crafts in the Queen Elizabeth Hotel," *Canadian Art* XV, no. 2 (April 1958): 98-103.

20. André Biéler to Jeannette Biéler [August 1956].

21. Marius Barbeau to André Biéler, 13 February 1957.

22. Muriel Richardson to Jeannette Biéler, 5 March 1955.

23. "Queen's Art Centre Opening called Historic Occasion," *Kingston Whig-Standard*, 15 October 1957.

24. "Exhibition of Paintings is opened at Art Centre," *Kingston Whig-Standard*, 8 November 1957.

25. Ibid.

26. "Canada Council Sessions Concluded Here on Weekend," *Kingston Whig-Standard*, 30 December 1957.

27. "Lascaux Cave: Queen's Art Professor Praises Ancient Works," *Kingston Whig-Standard*, 25 September 1959. Lascaux dates back to 18,000 years BP., The oldest European cave paintings known to exist are in the Chavet cave at Pont d'Arc, Ardèche. They were discovered in 1996 and are 35,000 years old.

28. Helen Cappadocia, "André Biéler at the Agnes Etherington Art Centre, Kingston," *Canadian Art* XXI, no. 1 (January-February 1964): 7-8.

29. Colin Sabiston, "Queen's Quality is Rising," *The Globe and Mail*, 26 September 1959.

30. Lauretta Thistle, "Renowned New York Pro Musica launches arts centre at Queen's," *Kingston Whig-Standard*, 29 October 1962.

31. "Principal Corry Opens New Art Centre," *Queen's Journal*, 30 October 1962.

32. Robert Ayre, "Etherington Art Centre," *The Montreal Star*, 3 November 1962.

33. "Toronto Couple Gives Collection to Queen's," *The Globe and Mail*, 15 December 1962.

34. "Zacks Collection Rare Gift: Citizens Urged to Visit Art Centre," *Kingston Whig-Standard*, 7 January 1963.

35. Samuel Zacks to André Biéler, 7 January 1963.

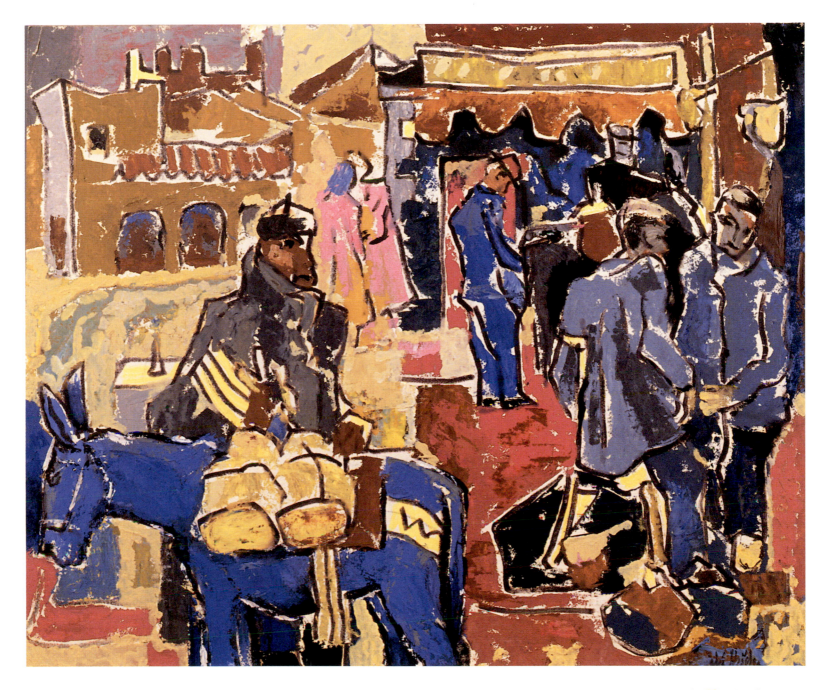

The Blue Donkey, 1954
Oil on panel
51 x 61 cm
Private collection

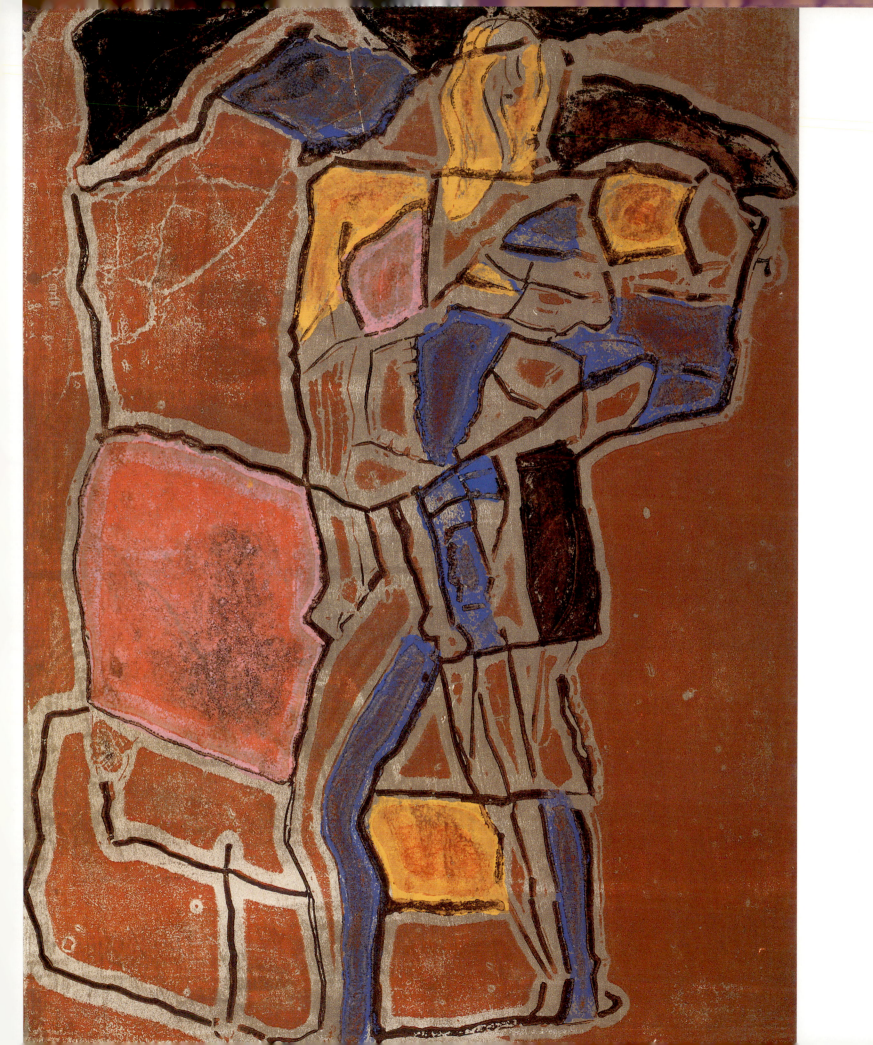

NEW DIMENSIONS

8

Recognition of André's work for the community in the previous decade came in 1963 when he was named "Man of the Year" by the Kingston Junior Chamber of Commerce for "the development and promotion of the Agnes Etherington Art Centre."[1] It was timely recognition as, in April 1963, his retirement from Queen's University, to take effect in September, was announced. In anticipation of this, André had built a fine studio, with a north light, in his new home in Glenburnie; he also quickly turned his garage there into a workshop as "retirement" for him meant a new and vigorous attack on life. As Ralph Allen said in looking back at this period, "It is totally fitting for a man whose capacity for renewal is so strong that his retirement should be seen merely as the commencement of a new period. André Biéler was quick to show that this was exactly so."[2]

In the summer of 1963 he began to make sculpture for the first time. He worked in wax and cast from the wax model in cast cement for large pieces, or in bronze for smaller pieces. André commented: "Life is interesting when you are tackling new problems all the time, and sometimes it seems you are diversifying yourself too much, you are doing too many things, but that depends on your character." It was completely in line with André Biéler's character to enter into this new creative field. He had always taken great pleasure in working with his hands, and he was fascinated by what his son Ted was doing in sculpture:

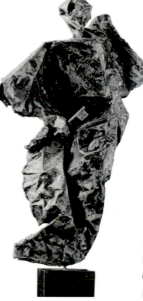

Saint Peter, 1964
Papier mâché
61 cm
Private collection

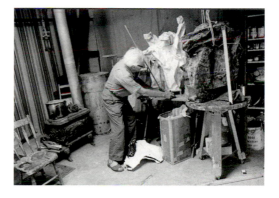

André Biéler in his sculpture studio, 1964
Twelve Pines, Glenburnie, Ontario.
Photograph by F.K. Smith

L'Homme, 1968
(The Man)
Intaglio relief print on paper
76 x 56 cm
Private collection

Pages 258-259
André Biéler sketching in the vicinity of Twelve Pines
Glenburnie, Ontario.
Photograph by F.K. Smith

Soldier's Row describes the habitat well enough:

A double row of small log houses lined up as straight as soldiers on parade and indeed, that is what the discharged regiment wanted, order in the wilderness. With a trapper as guide we set off in the general direction of the south, straight through fields, forest, trees, and jumping over rail fences almost five feet high. I could hardly keep up with him. But on his part a stream of stories about the land, its people, just as fast as his legs would go. He was great, a lovely fellow, an amusing fellow... Then suddenly he said, "Look over there." And we found a clearing in the cedar forest and right in the middle of the clearing stands the log cabin ... looking really like a wreck. The roof was practically off, the windows were broken ... but I took my hatchet and sounded the logs and found they were in good shape. The lower part had been inhabited by porcupines for a number of years and they had eaten holes in the floor, but I was able to climb upstairs... There was one peculiarity about this log cabin in that it was completely covered with beaverboard and on it wallpaper! They had tried to make it look like a town house! And of course, this was fortunate as it had preserved the logs – perfectly clean.

It seems to me to be just what I am looking for. So he takes me to the owner and we find him on his big tractor seeding potatoes. So I approached him and yelled, "Hello! Is that you the owner of this cabin? ... I'd like to buy it." And he says, "Oh!" And one thing after another, yelling at the top of our voices - he never stopped the tractor at all - we struck a bargain."

The intention had been to have the cabin lifted to a float and removed to Glenburnie but that proved to be impossible. So, engaging the help of Mr. Drummond and his son of Almonte, skilled in such an operation, all the logs were numbered, the cabin dismantled and moved as lumber. As they were leaving the site, André asked Mr. Drummond to take the old pump that had been in front of the cabin. "Then as I was passing the owner's place I called in and said I was going to take the pump along, is that all right? And he said 'Oh, no, my goodness, the pump is an antique – I can't let you have that for nothing!' But the cabin, which was infinitely older than the pump, couldn't be an antique at all!

The summer of 1965 was spent reassembling the log cabin at Glenburnie with the help of two high school students and a fork-lift: "the strange thing was that putting the logs together was not really a very big job. We did it in two days quite easily with a forklift. In the old days they would have had about twenty men to lift the logs in place with ropes." All the logs were cedar with the exception of the top log on each side which was of oak so

rafters could be attached to it; cedar would not hold a nail. Cement blocks had been placed at the corners but it was not until the walls had been reconstructed that leveling of the cabin was done, using jacks and inserting wedges as needed; then, with some help, forms were made and concrete foundations poured, thus providing for the irregular shape of the logs. What to put between the logs was the next problem: "I decided to use rock wool, which is very good insulation, and wire mesh, and with this to use a mixture of sand and mortar, no cement whatever, adding to the sand and mortar some cut nylon so as to give it that felt quality. And this went very well."

The original floor had suffered from its last inhabitants, porcupines and skunks. One of the large pines, which had led to his christening of his home Twelve Pines ("really there were thirteen, one for insurance," André said), was in bad shape and it was cut down and sent to the mill and cut into big boards about two inches thick. This provided wood for the whole floor, with a few boards left over. When it came time to put the roof on, André enlisted the help of old-time experts who "knew just what they were doing and brought along some ironwood with them to peg down the four corners so that in a hurricane the roof would stay on."

This log cabin – André Biéler's latest sculpture – became a fitting setting for the interesting objects he had collected through the years: pieces of furniture from the years on Île d'Orléans; cocks that had once graced roadside crosses in Quebec, but were sacrificed when the roads were widened; a small horse and more cocks made in recent years by a habitant farmer on the north shore; early Canadian prints found in Paris. Although there was some concession to modern times (the cabin was heated electrically and a kitchenette and bathroom installed), there was also a wood stove in the centre of the main room. In this small environment, André achieved something that became very precious to him:

... it's been so rewarding in the quietude that I get when I sit here sometimes, just to sit and read, to get away from everyday sights, to see something else, or to get back into a French-Canadian atmosphere that I used to like so much; because I am surrounded here with the pieces of furniture that I had when I was a young man; I was just back from Paris, you see, and had bought this furniture, it was the first time I had a house of my own, very much like this one, and to have that same type of atmosphere, in just about the same dimensions, and the same type of furniture as I had then, and the same solitude that I had when I was a young man, certainly gave me a recall that is very pleasant and very well worthwhile.

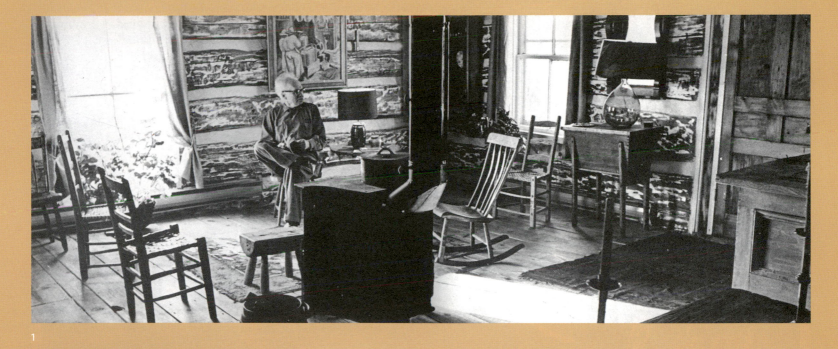

1

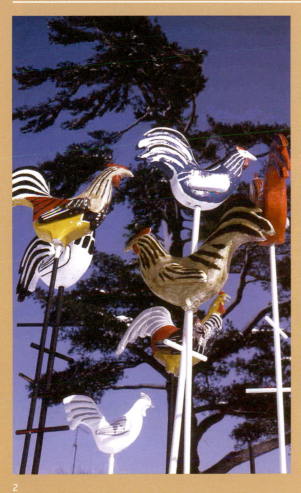

2

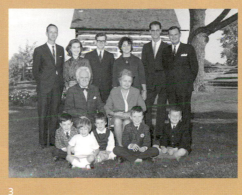

3

4

5

6

1. André Biéler in the pioneer cabin rebuilt on his property at Glenburnie. *Globe and Mail* Archives.
2. A collection of wooden roosters sculpted by Charles Edouard Gaudreault and painted by his nephew Daniel Gaudreault, les Eboulements, Québec.
3. The Biéler family with sons-in law and grandchildren, "Twelve Pines," Glenburnie.
4. The cabin in winter, grandchildren in the foreground.
5. André Biéler building the cabin, 1965.
6. Same as above.

All images from A.B. Archives (except for 1)

Jacques de Tonnancour (1917-2005)
in his Montréal studio, circa 1963.
Université du Québec à Montréal Archives.
Jacques de Tonnancour Fonds
(170 P.660.F6/6)

André Biéler in his studio
Glenburnie, circa 1967.
A.B. Archives

Printmaking took second place to painting for a time, as visits to Mexico in the winter of 1964 and 1966 gave him considerable source material for painting, as did sketches of the Glenburnie landscape. In January 1967, Jacques de Tonnancour, Montreal artist, was invited to speak about his work at the Agnes Etherington Art Centre and André, in introducing him, set the pattern for the program as a dialogue on creativity. As so often happens "in real life" there was an unexpected bonus:

… the visit of Jacques de Tonnancour, it was a marvelous evening, wasn't it? And we had one of those terrific snowstorms, and his train was canceled, and canceled again, so that he spent almost two days with us at Glenburnie, which was very pleasant. There was no one who was better company, a most interesting talker, and at the same time a philosopher … and he looked through my prints and commented on them: "You've gone as far as you can with this process, but hand-rubbing doesn't go any further. You must have a press." And I'll always be thankful to him for having said it in such a way that I was persuaded that the next step must be a press. As he showed, by having different blocks, the demarcation between one block and the other is very sharp, too sharp. There is no amalgamation of the inks, one into the other, and there are difficulties of registration, and other aspects.

The laborious hand-rubbed process that André had used to this time may be contrasted with the Japanese process in which three men were always involved: the artist who made the initial sketch, in colour; the craftsman who carved the blocks; and the third man who would be in charge of the actual printing. Experts were always involved at each stage of the work, making it possible for a great number of prints to be made in the Japanese system.

André visited Montreal at de Tonnancour's invitation to see the French presses in use in the Beaux Arts school. He inspected the rollers and techniques used. The idea began to take form:

Coming back from that visit, I think is the moment when I had to make a definite decision. If I was going into using oil inks and a new type of block, therefore I would go the whole way and adopt the three-roller process of William Hayter.

Then I would gain infinitely. I wouldn't have to make multiple blocks… But there were certain limitations, to my mind, in that he used copper plates, which are very thin, and you cannot etch very deeply in a very thin plate… The three-roller system is simply this: you have three rollers, one hard, one medium and one very, very soft, about as soft as a rubber pillow. And by rolling first the soft

one, you get into the deeper indentations of relief, the second one would go mid-way and the hard one, the surface, the line. In that way you get three colours that are separate in places but that tend to get together on the edges and form that beautiful quality and that unity of the print due to the blending of colours and the superimposition of colours... And as I had developed the cement block plate, I saw that because the cement was an inch thick I can have relief much much deeper than with copper, even possible to have a relief of a quarter of an inch *[more accurately one-eighth of an inch]*. That is the extreme, not for the block but for the paper.

Could this be handled on the presses he had seen? He also had catalogues of similar presses from England, and corresponded with the manufacturers – could a press be adapted for the type of relief he wanted to print? It might be possible with a very, very heavy blanket, was the response, but without much conviction. More presses were seen in Toronto, but it was all rather discouraging. On that visit, he spent some time with his son Ted, who was making some sculpture commissioned for a building. He had invented a process for casting using a pneumatic process and had purchased a compressor for this. On the train, returning to Kingston, André pondered the problem:

> Suddenly it dawned on me, why of course, we could use a pneumatic press and print in such a way that would have been impossible in the old system. So just as soon as I got home I started to make drawings of the press. I consulted some engineers who helped me on the stress aspect and designed the steel rods or beams, you might say, that would hold it together. I consulted some people in plastics for the type of pneumatic control, and so on...

There was, of course, no turning back now; it would not have been in character. André made a simple experiment first, using a football bladder, and had excellent results even with a rather crude arrangement. So he proceeded to plan a press to accommodate 20" x 26" cement plates – the size suitable for available supplies of pure rag paper. "I designed the construction, then had the steel parts made in a machine shop, found a compressor second-hand, and bought valves and a pressure gauge at a hardware store. The assembly was a matter of diligent carpentry."[9]

There were problems to solve as he proceeded. The first trial of the inflatable rubber cushion attached to the top slab of the press, into which compressed air would be fed through a valve, was not completely successful and he returned to Toronto to get rubber with special flexible qualities. The second attempt

Cavalcade (upper half), 1975
Intaglio relief print on paper
Each part measures 50.8 x 66 cm
Private collection

Auction Sale, Québec, 1972
Intaglio relief print on paper
56 x 70 cm
Private collection

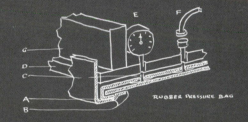

1A PNEUMATIC RELIEF PRESS

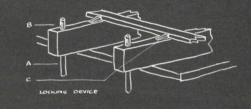

1B RUBBER PRESSURE BAG

1C LOCKING DEVICE

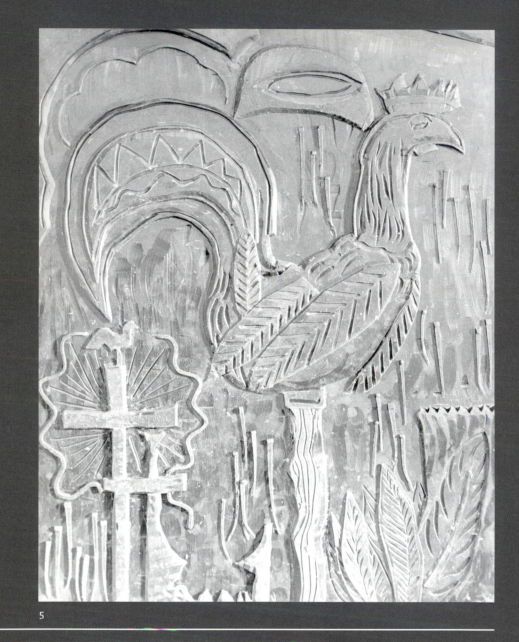

5

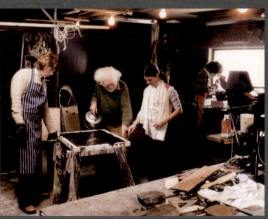

2

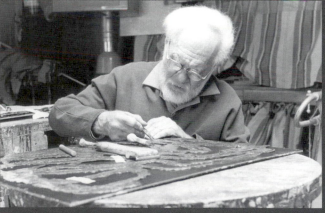

3

4

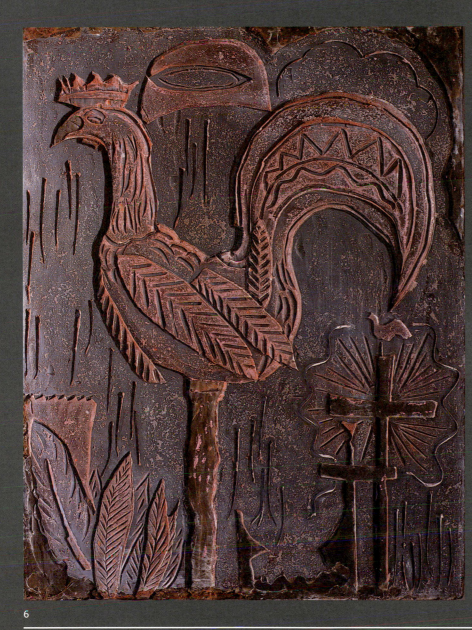

6

All images from A.B. Archives.

1 A, B, C	Drawings for the compressed air press invented and built by André Biéler.
2.	André Biéler casting wax, together with three of his three grandchildren, Philippe, Nathalie and Véronique Baylaucq, 1974. Photograph by Jacques Baylaucq.
3.	André Biéler engraving wax for the work entitled *Le Coq*.
4.	Twelve Pines press.
5.	Positive original wax plate.
6.	Negative cement plate.
7.	Applying ink to the engraving plate with synthetic wool rollers.
8 to 10.	Preparing the press.
11.	Intaglio print coming out of the press.

(3, 5, 10 & 11)	Photographs by F.K. Smith.
(4, 8 & 9)	Photographs by Ted Biéler.
(6)	Photograph by Bertrand Carrière.

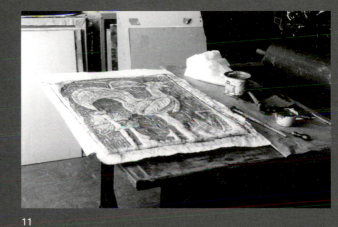

11

7

8 & 9

10

Tools, circa 1974
Intaglio relief print on paper
72 x 54 cm
Private collection

Keys, circa 1974
Intaglio relief print on paper
72 x 54 cm
Private collection

At the Kingston Conference of 1941 the question was raised: had it been intended as an end in itself or as leading to an organization? André's brief answer, "When a child is born, who knows what it is going to look like?"[13] is classic in its condensation and can be related to his invention of the Twelve Pines Press. First conceived as a method of inking with three colours in one process, to give the variety and subtlety that is possible with relief, he was delighted to find that the relief itself had its own character and offered unexpected possibilities. The print *L'Homme* (repr. p. 260), one of the earliest from the new press, was realized in terms of embossed areas of colour with line as an integral part of the design. The male figure is slightly aggressive,

in a typical matador stance. The subtle colour areas were achieved by glazes which masked the base colours, yet allowed them to come through. The effect of this print prompted further experiments with colour printing and referring to another print, *Auction Sale* (repr. p. 271), André described what he was trying to do with the colour: "to get a tremendous fiery colour underneath, and then to dampen it, to keep as though it was a person that is full of vitality but keeps it cool, let us say. So I put a cool colour in front of the very powerful one to get the effect that way, much as Jean McEwen does in his painting." All of this could be achieved on the Twelve Pines Press in the one process of inking and printing.

Wake! for the Sun, circa 1974
Intaglio relief print on paper
72 x 54 cm
Private collection

Byzance, circa 1974
(Byzantium)
Intaglio print on paper
72 x 54 cm
Private collection

Experimentation with found objects, such as figurines of votive pieces from Mexico, small ivory reliefs and household tools, gave him the opportunity to present unusual aspects of very common material through the relief print. He also moved from the three-colour conception to making prints in one dominant colour only; he relied on transparent and opaque tonal areas, obtained by skilled use of the different rollers, and the relief planes, to provide interest through the play of light as in a sculptured frieze. There was a further unforeseen bonus, as André remarked:

Now the other interesting thing is that the plates themselves are indeed very beautiful. They've been inked, and I leave the ink on

them, and they make bas-reliefs so they could be put on walls; several people have asked me to sell them.

There is no doubt that this pneumatic process, departing from conventional methods of printmaking, opened the way, in the hands of André Biéler, for totally new effects. In response to numerous requests for information about how he made his prints, which were exhibited in the major group shows, he decided to outline the whole method from making the press to the final stage of printing – a generous sharing of his experience. This was published as *Occasional Paper No. 1* by the Agnes Etherington Art Centre. André wrote in his introduction:

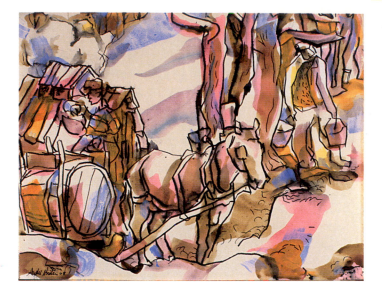

Spring, 1968
Watercolour on paper
26.2 x 35 cm
Private collection

Scenery around Glenburnie, 1967
Ink on paper
26.7 x 35.6 cm
Private collection

Frequently in lectures, as a basis for a philosophical discussion, André would quote Matisse's definition of a work of art – that it should be like an easy chair for the tired businessman at the end of the day. Should pain and conflict therefore be eliminated? Did André see his own work in these terms? That would be too easy an answer. His essential humanism, his portrayal of people going about their daily lives in the marketplace, at work, with their family groups and their religious rituals is a communication of great sensitivity but without sentimentality; it invites a more active participation on the human level than Matisse's dictum would suggest.

Glenburnie offered him not only the contained environment he tailored to his own delight, but woods and swamps and sand quarries in which to walk and sketch. *Glenburnie Landscape* was developed from a strong line drawing made in 1967 to the colourful painting in 1968 that foreshadows the domination of colour in André's work of the 1970s. It is one of a fairly small number of "unpeopled" landscapes made at this time and is redolent with the sensual appeal of colour and pigment found in Renoir and the fauve painters. Painted in the studio, colours are invented rather than observed; transposition of the artist's sensations of nature by means of colour answers the demands of pictorial composition rather than those of reality. In contrast to *Is It Really True?* this is surely a work of supreme and positive optimism.

Honours continued following André's retirement. In 1967 the Centennial Medal was conferred on him in recognition of his service to Queen's University and to Canada. In 1969 he was awarded an honorary doctor of laws degree by Queen's University at the convocation on 31 May and was invited to give the convocation address. The citation described André:

... member of the Royal Canadian Academy, lately Resident Artist and Professor of Art at this university; who, as a teacher, conveyed the excitement of learning so skillfully to his students that they and he became true partners; whose great energy and vision, expressed through the first Conference of the Arts in Canada, led to the formation of the Federation of Canadian Artists, and the Canadian Arts Council; whose creation and development of the Agnes Etherington Art Centre have brought this university in close harmony with the community of Kingston; and whom we honour as an artist of great versatility, giving to his subjects the colour, vitality and the warm humanity which he himself brings to the art of living.[16]

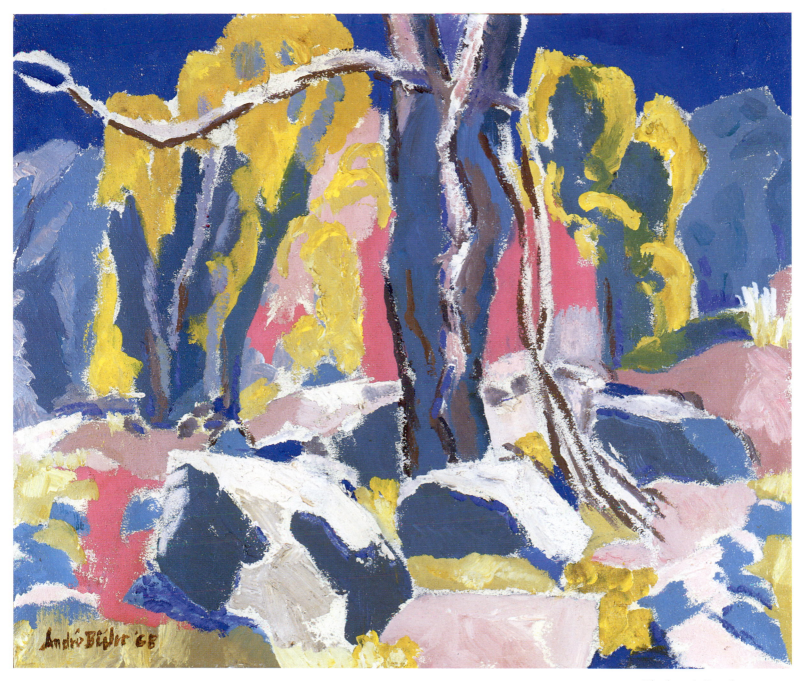

Glenburnie Landscape, 1968
Oil and acrylic on pressed board
51 x 61 cm
Private collection

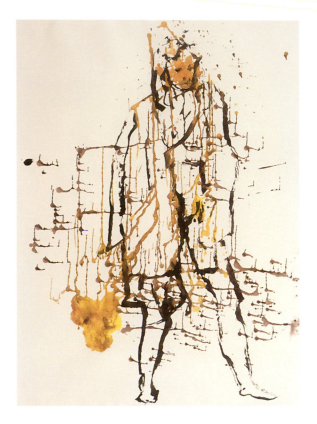

Standing in the Rain, 1967
Ink on paper
61 x 50 cm
Private collection

André Biéler at his Twelve Pines property
Glenburnie, 1970.
Photograph by F.K. Smith
A.B. Archives

The occasion started with a fanfare of trumpets. André's colleague, Dr. Graham George, professor of music, composed a salute entitled "Music on the AB factor," which he described in a note to André:

I enclose a morsel which will be played by a brass quartet as you stride up the aisle on Saturday. Its staggering technical achievement is that the notes AB are present on every beat except six (the six being reserved for freedom of expression)... I think the piece will amuse you – if you have any attention left to spare for it – in that there is at first hearing (I think) no awareness of the omnipresence of your initials, and this is just the kind of technical conundrun which has especially fascinated you in your own field, if I understand your way of work aright...[17]

A standing ovation greeted the conferring of the degree on André and marked the respect and affection with which he was regarded by the university community. His address to the convocation was as lively and unorthodox as one might anticipate knowing something of his character and of his skill as an orator; it was also very revealing of his mature personality:

I have been fortunate to have had two interests in life, one academic, the other artistic, the one observing the other. Why not, therefore, even if they are immature, pass on some of the findings of the one on the other? The hands are of first importance in an artistic process so that, in my long career they have not been left behind by their brother the brain, and have enjoyed a parallel development. This development in later life enables them very often to surpass in vigour the aging partner in the cranium. Today we are graduating together. This gives me the same right that you have to protest. Mr. Principal, I PROTEST! I protest! The hands should get a fair share in the training of our university. In the last three or four years your cerebral system has been crammed to the full ... attention has been concentrated on the training from the neck up, and very little from the shoulders down ... the little grey matter in the head is all very well, but its partner the hand should share in the benefits of this great university...

Next, he launched into the subject of the hands in a gesture-filled monologue: the symbolic use of hands in history, the hands of action, the hands as communication, the hands of blessing and the hands of artistic creation:

As a painter and sculptor I have long discovered that the hand must be allowed to create without the constant control or censorship of the mind. A partnership must be formed on an equal footing and it is for the mind to accept the contribution of each in its proper value...

His address was received with warm applause. In retrospect, it is evident that his experiences of the previous six years – the joy of using his hands in making sculpture, rebuilding the log cabin, making the Twelve Pines Press – a period in which he had also had time to think, brought him to a fuller appreciation of the wholeness of the individual and had prompted the tenor of his talk.

An artist, especially one whose work has evolved around an affectionate observation of the continuum of human life, must return to the fountainhead for his inspiration. Retirement from teaching gave André freedom to travel in the winter months and he sought this contact with people close to the soil in Mexico. His first visit in 1964 also proved to be of great benefit to his health and he has returned to Mexico many times since, to avoid some of the Canadian winter by spending a month or more in San Miguel de Allende, in Cuernavaca and exploring the country. He discussed what this means to him:

Mexico has always been very stimulating to me, because I like to sketch people, to see them in groups and so on, and there's no better place in the world than Mexico for that; because of the climate, they're outside, the marketplaces are very important ... so I like it because of the groups of people, the human relationships that I find on the marketplace; and of course also because of the Mexican baroque, which is a very strange and exciting kind of art...

I go there, I get tremendously enthusiastic – I would never live there for any length of time because I would get bored, but the excitement of the moment is tremendous, and the sheer love of drawing – anywhere, everywhere, there is something going on and I turn them out by the bookful ... I gain so much material, which never occurs in Canada, you cannot do that type of thing, you have to hunt for the subject, whereas in Mexico it's just given away...

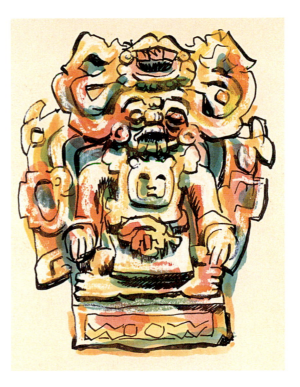

Statue of an Aztec God, Mexico, 1964
Watercolour on paper
24 x 15.5 cm
Private collection

André Biéler sketching a church near San Miguel
Mexico, February 1966.
A.B. Archives

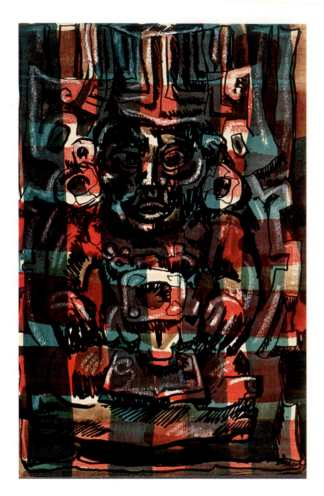

Aztec God, 1964
Watercolour on card
24 x 15.5 cm
Collection of the Musée national des beaux-arts du Québec
Gift of the estate of André and Jeannette Biéler

His mastery of drawing in an endless variety of techniques and subject matter is nowhere more evident than in the large body of work created in Mexico. His approach recalls Charles Rosen's advice to him in Woodstock, some forty years earlier: "draw, draw, painstakingly, searchingly, keenly, with no preconceptions, attack it with a fresh unspoiled vision…"

Language is no barrier to the artist recording with a visual eloquence innumerable vignettes of the daily lives of the Mexican people. We, too, can anticipate a Mexican snack in *Tortillas II*; we can enjoy the bustle, the coming and going of *Hacienda Courtyard* and intrude on the women in their colourful shawls with their children, pots and baskets in many sketches of the marketplace; we can stand and enjoy the lively banners being assembled in the square in *Processional Banners, Mexico* and understand the significance of these rituals in the lives of the people. We might wish we could share the point of the story so obviously reached among the group of three *On the Market Square, San Miguel,* but we need no words to sense the warmth of their ponchos (repr. p. 286).

André ended his first visit to Mexico with a one-man exhibition at the Galeria San Miguel on the central plaza of San Miguel de Allende, showing about sixty-two drawings and watercolour sketches. The Mexican news release referred to his work as "by an artist with mature experience in catching the tenor, rhythm and heart of a scene with a professional economy of line that suggests much without overstating … the universality of these people is symbolized by the rebozo, the Mexican form of a shawl which is characteristic of country people everywhere."

A number of more fully developed and larger drawings resulted from his explorations of the land. In *San Miguel,* the composition moves in a great arc around the trees in the foreground in a completely linear manner. *Silver Mine at Guanajuto* (repr. p. 290) is realized in delicate colour washes strengthened with ink lines and washes, and is a superbly organized composition evocative of Mexico's past.

Another group of works are in a technique he found peculiarly appropriate to the Mexican scene and developed during his first visit in 1964. Line had always been an important factor, as he described his method:

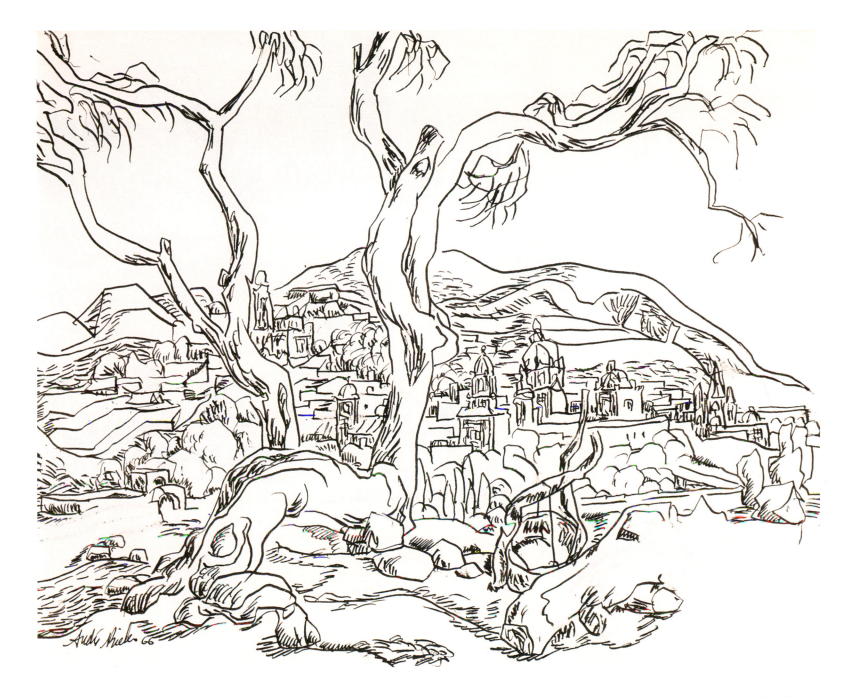

San Miguel, 1966
Ink on paper
32 x 42.5 cm
Private collection

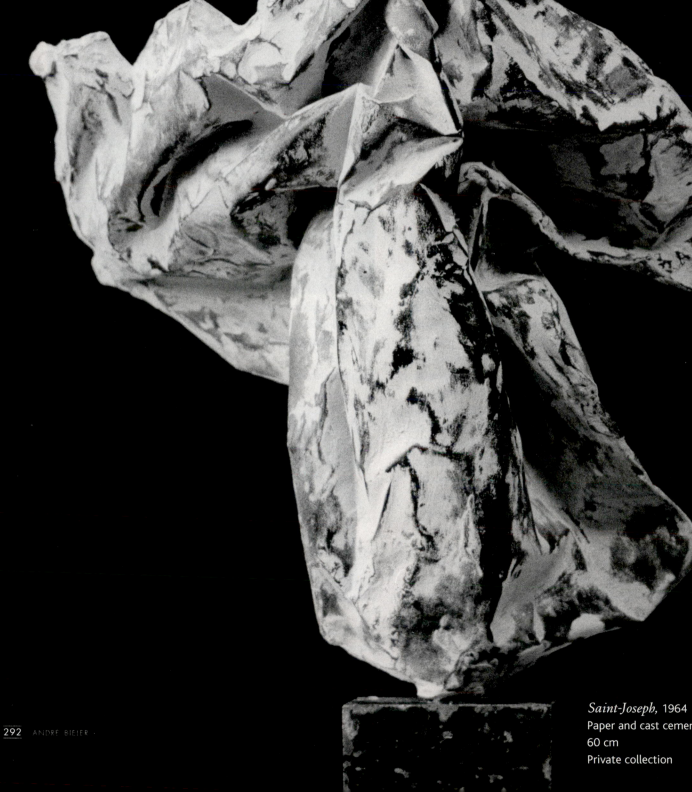

Saint-Joseph, 1964
Paper and cast cement
60 cm
Private collection

The innovative technique used for making the mural was influenced by André's experience with the manipulation of papier mâché into folds and textured shapes in Mexico. Aluminum foil, however, had its own characteristics and before he could work with it successfully, he had to experiment with the metal to determine the lines of stress as he applied pressure in certain areas of the relief. The shaped foil, blown with varnish and filled and backed by reinforcing material, gradually hardened until it became very resistant. The beauty of foil, in contrast with cast aluminum, for example, lies in its reflective quality. Shadows and textures can be formed at will in the creative process.

A comparison may be made between the *Toyal* and the Shipshaw mural (repr. p. 215) of twenty years earlier: both were commissioned by the Aluminum Company of Canada; both are on the theme of man harnessing the elements in his environment; both involved an innovative use of aluminum. The similarity ends there, however. In style and technique the murals are quite different. It is not merely a question of the artist's versatility, although we will grant him that; his life has always been one of continuous growth, of new ways of seeing and creating, so that the way he tackled the theme in the 1940s would no longer satisfy his inner compulsion in the 1960s. On being asked about his continual searching in life by Ralph Allen in 1972, he reflected:

> The individual is born with certain qualities and faults. Is it a quality or fault, that drive of the artist? He is driven. I think of this: "The world's leading behaviourists argue that a poet can no more take credit for a poem he writes than a goose can for the golden egg it lays." You can't take credit for what you're doing because it is born with you, you are urged to do it ... it is this urge that I'm answering ... all I can do is answer it to the best of my ability and the best of my ability is to exploit certain characters within me.

The mural for Japan completed, André found himself with some material left over so he started making what he called "elegant shapes," sometimes using coloured glass in conjunction with shaped, hardened and filled aluminum foil, and steel reinforcement where necessary to hold the sculpture in position. These are three-dimensional works; *Azur and Boreal* incorporate heavy blue glass: "by the use of coloured glass you get reflections in the aluminum which are rather handsome ... they are entirely contemporary, they are things that have a decorative value, are pleasant because of that fine material, aluminum, which had not been used in this manner at all. The glass, with cast aluminum, would have done nothing at all, whereas with the foil it reflects every play of light, every twist of the metal, in an interesting manner."

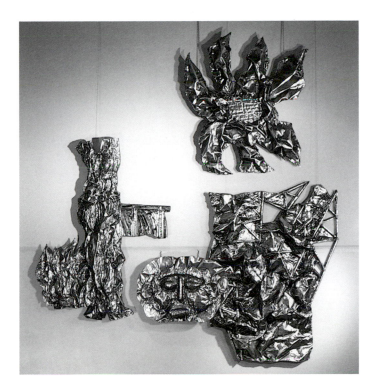

Toyal, 1968
Aluminum and cast cement
Overall dimensions: 250 x 232.5 cm
Sun: 190 x 94 cm
Mask: 50 x 70 cm
Left piece: *Flame, growth, water;* 137 x 102.5 cm
Right piece: *Earth into steel;* 136 x 99 cm
Collection of the Toyo Aluminum Company, Osaka, Japan

Madonna and Child, 1964
Paper and cast cement
76.2 cm
Private collection

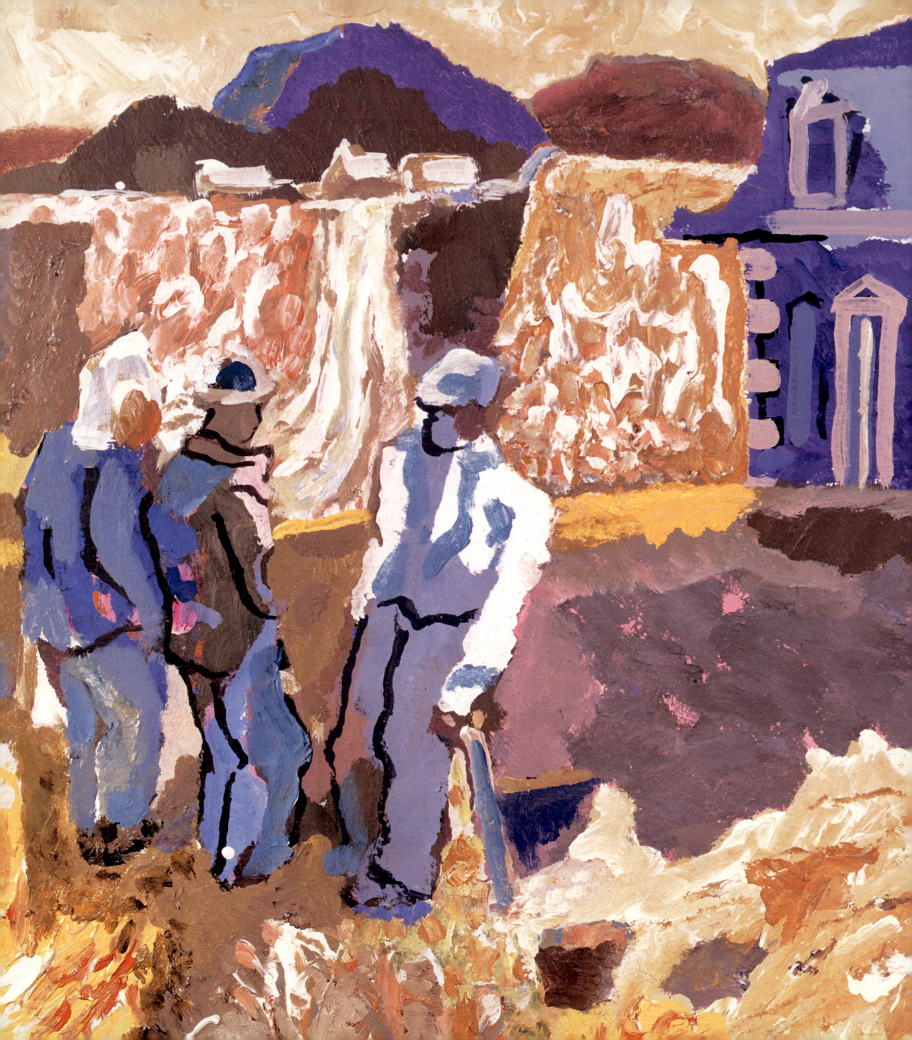

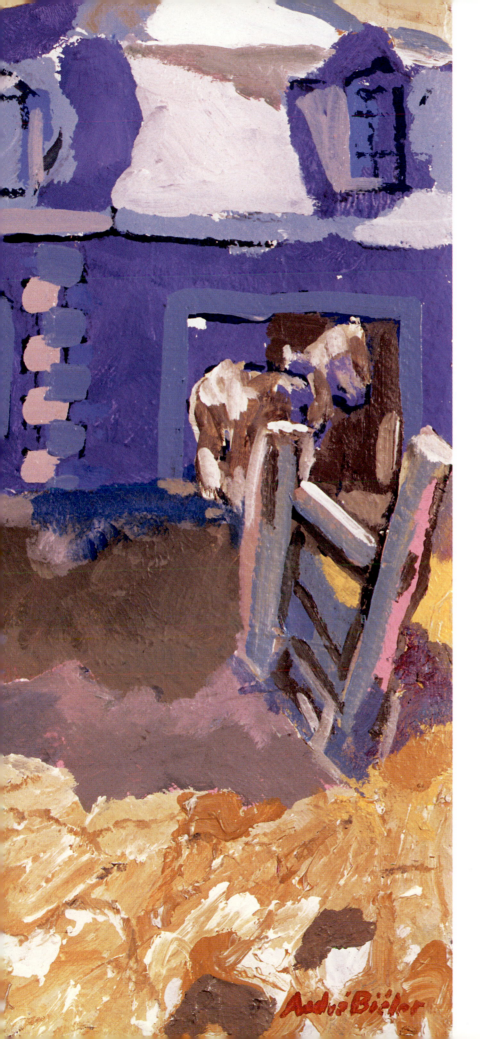

The aluminum sculptures and reliefs can be seen as a joyous excursion for André, set in motion by his sensitivity to the baroque in Mexican art combined with his ability to exploit new materials. It was not, however, the aspect of his creative work that gave him the deepest satisfaction in the late 1960s. The affinity between Mexico and rural Québec had offered him the sort of subject matter in which he delighted: an environment scaled to man and not to the jet age. Mexico, however, could never replace his deeply rooted affection for rural Québec, its people and their way of life. At this time he began to look through the hundreds of sketches he had done during his stay on Île d'Orléans and his explorations on the north shore of the St. Lawrence. He began to work directly from them in the studio: "There's something in you that makes you turn to what you did when you were young, there's an aspect of youthfulness which has a very tremendous drawing power ... because it was a moment in one's life when everything is fine, when you're full of vigour, of hopes and plans ... and I get a certain amount of that energy that was stored at that time." The result of this very conscious "return" to his roots in Québec was an exhibition at the Klinkhoff Gallery in Montréal in 1969 which was titled "Un homme se penche sur son passé." It could have been called "Québec Revisited" or, in Marcel Proust's words, "A la recherche du temps perdu."

The exhibition consisted of over forty works: oils, acrylics, watercolours and ink drawings. They were almost all painted in 1968 and 1969 in a mood of intense joy, a mood of almost complete recall of the feelings he had experienced about his subject matter many years earlier. There was an element of nostalgia for his youth, and for the simple life on the farm and in the village – a style of life which lent itself, pictorially, to the intimate human qualities which had characterized his sketches and paintings of the 1920s and 1930s. In returning to this subject matter he became conscious that the contemporary techniques with which he had become familiar – a dynamic use of colour and line – tended to overpower the intimacy of the scene. As Robert Ayre commented in a review of the exhibition, "He put aside the sophisticated methods he had cultivated in years of research and experiment and returned to a style in keeping with the simplicity of his subject matter. He returned, the artist said, 'to warm and earthy colours that correspond to the warmth of my feelings for the people and landscapes of Québec at that time.'"[18]

Tout en causant, 1970
(While Chatting)
Acrylic on canvassed panel
45.7 x 61 cm
Private collection

Retour des chasseurs, 1968
(Return of the Hunters)
Ink and acrylic on paper
26.7 x 34.9 cm
Private collection

La Boutique, 1968
(The Shop)
Ink and acrylic on paper
26.7 x 34.9 cm
Private collection

His method was to look over a group of sketches in the evening "because you are more apt to be critical about things, or to be sharper about such things, in the evenings than at nine o'clock in the morning when you are ready to get to work." He made notes, planned the next day's work and sometimes wandered into the studio to try out a preliminary sketch, to recapture the ambience of the original moment before the subject. He recalled that the worst sketch often turned out to be the best:

> I think in this case, it's especially something in my character, in that – and mind you, this occurs in families where there is one weak child which gets all the attention from the mother, it's a little bit like that – I invariably choose the worst sketch, apparently the worst sketch to work from, but I can't answer why, I don't know – it's my own child, and I like to see if I can bring this child up to something – it might be simply that it suggests more because of its unfinished state, that might be so...

Bringing up "this child" of his, reanimating the scene, was the sort of challenge to which André responded with full enthusiasm. In spite of his statement of a conscious "switch to warm and earthy colours," he had too much integrity as an artist to deny completely his mature development in the use of high-key colour, and his propensity towards a glowing pink was not missing. Nor did he overly subdue the dynamic line of the works in ink and acrylic wash. The quality of this line animates *Retour des chasseurs* and *La Boutique,* but without negating the essential humanity and intimacy of the scenes.

The works in oil were painted with a mature freedom and relaxation that came from the affection he felt for the subject. The harrowing of the soil, the early morning milking, the children going to the schoolhouse, the evening meal, the gathering after mass, the dyeing of the wool, the catalogne on the market, the wayside cross – all these familiar scenes were there. Robert Ayre said: "There is much of sungold in the exhibition. *La Petite École* is bathed in it. It comes in the sheaves in the field, in the straw the women are about to plait into straw hats."[19] Undoubtedly the painter took liberties in his use of colour; shapes in the landscape dissolved in an overwhelming sun; details were heightened with a blue or a pink of an intensity "that never was"; but these works retained a tender and sensitive naturalism without a touch of sentimentality.

Sortie de la messe à Saint-Placide was painted in the warm and earthy colours André spoke about; its orange and brown tonality, in a fairly high key, is set off by the cool blue-white of the church and by the light-coloured clothes of the people. Compare his treatment of the same subject in the 1939 watercolour *Après la messe, Saint-Placide* (repr. p. 128-129), in the collection of the Musée national des beaux-arts du Québec. In the earlier work, the trees, building, figures and carriages are precisely rendered in rather low-key colours and the repetition of the slow curves of the shoulders of the people gives rhythm and unity to the composition. In the 1969 work, the whole scene is painted in an impressionist manner; colour rather than a precise line provides the rhythm and pattern which gives balance to the composition. Yet both works had their origin in the same early sketches, such as this one of the church at Saint-Placide, and others reproduced here and in chapter 4. The changing vision of the artist and the greater freedom of expression as a result of long experience is well demonstrated.

La Petite École and *La herse* convey their own sense of place and time. All are recreations from early sketches of familiar scenes recalled with a fresh vision and brought to life with a sure hand.

Interior genre subjects were infrequent in André's early work. *Le repas du soir* of 1969 seems to owe something to the influence of the French school, particularly Bonnard and Renoir, in the masterful naturalism with which light in an interior has been handled. It is a painting done against the light, but with a vibrancy of colouring which pervades even the faces in shadow and touches on objects and figure with an expressive freedom. Colour is alive with light.

There was no sense of retirement in the years at Glenburnie. André is indeed the "Ulyssean adult" of Dr. John McLeish's book of that title,[20] the man whose life is a process of continuous growth as much through the later years as in any early period. André had found rejuvenation in the Mexican environment, among people living close to the earth; he had found it in "revisiting" rural Québec; but above all he had found creative expression in new adventures and inventions, with a mind open to the unexpected and a readiness of hand to go along with it. His Ulyssean journey was not over.

Study of Figures at Saint-Placide, 1938
Lead pencil on paper with watercolour
19.7 x 25.4 cm
Private collection

La Petite École, 1969
(The Little School)
Oil on panel
45.7 x 61 cm
Private collection

*Sortie de la messe à
Saint-Placide,* 1938
(Leaving Mass at Saint-Placide)
Ink and pencil sketch on paper
11 x 15 cm
Collection of the Musée national
des beaux-arts du Québec
Gift of the estate of André and
Jeannette Biéler

NOTES FOR CHAPTER 8

1. "Man of the Year: Jaycees Honor André Biéler," *Kingston Whig-Standard*, 16 January 1963.
2. Ralph Allen, "Introduction" to exhibition catalogue *André Biéler: 50 Years* (Kingston: Agnes Etherington Art Centre, 1970).
3. Ralph Allen, "Allen on Biéler," *Queen's Journal*, 29 October 1963.
4. Elizabeth Rynasko, "Four Phases of Painting Reflect Artist's Life," *Kingston Whig-Standard*, 9 October 1963.
5. "Biéler Exhibition to Honor Retired Queen's Artist," *Kingston Whig-Standard*, 24 September 1964.
6. "Prof. Retires with 'Retrospect,'" *Queen's Journal*, 8 October 1963.
7. "Biéler Retrospective," *The Gazette* (Montreal), 12 October 1963.
8. Paul H. Walton to André Biéler, 6 December 1968.
9. André Biéler, "Twelve Pines Press," *Occasional Paper No. 1* (Kingston: Agnes Etherington Art Centre, 1972), p. 3.
10. Barry Thorne, "A Totally New Conception," *Kingston Whig-Standard*, 18 May 1968.
11. André Biéler, "Twelve Pines Press," p. 3.
12. Barry Thorne, "Commentary: André Biéler's Deep Relief Prints," *Journal of Canadian Studies*, IV, no. 4, pp. 43-45.
13. André Biéler and Elizabeth Harrison, eds., *The Kingston Conference: Proceedings* (Kingston: Queen's University, 1941), p. 104.
14. André Biéler, "Twelve Pines Press," p. 3.
15. André Biéler to Robert Ayre, December 1963.
16. "Let us Now Praise Famous Men," *Alumni Review* (Queen's University), 43, no. 3 (May-June 1969): 65.
17. Graham George to André Biéler, 27 May 1969.
18. Robert Ayre, "A Fond Glance Back to Yesterday," *The Montreal Star*, 4 October 1969.
19. Ibid.
20. John A B. McLeish, *The Ulyssean Adult: Creativity in the Middle and Later Years,* (Toronto: McGraw-Hill Ryerson Limited, 1976).

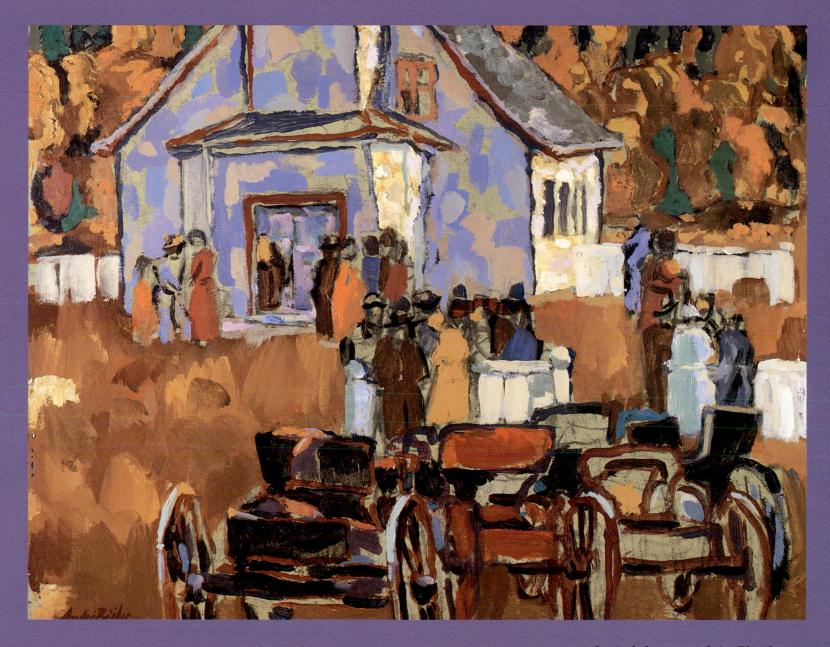

Sortie de la messe à Saint-Placide, 1969
(Leaving Mass at Saint-Placide)
Oil and acrylic on canvas
50.8 x 61 cm
Private collection

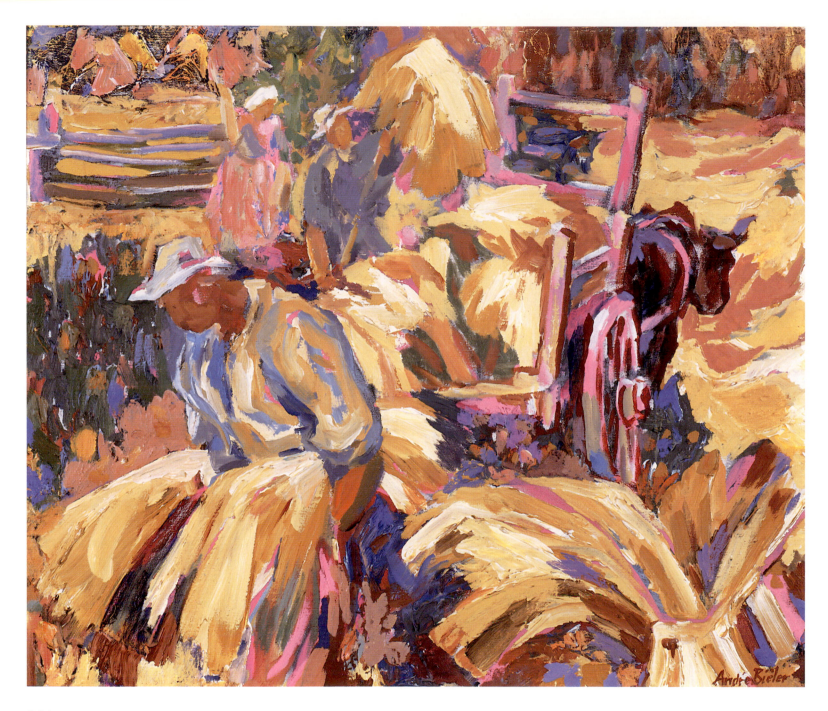

Moisson rose, 1970
(Pink Harvest)
Oil on panel
50 x 60 cm
Private collection

Pages 300-301
André Biéler painting on a river boat on the Rideau Canal, between Ottawa and Kingston, June 1979.
A.B. Archives

THE CELEBRATION OF LIFE

The momentum in painting that André had rediscovered in the 1960s in Mexico and in his nostalgic return to his early sketches of rural Québec continued in full force in the next decade. He also continued to receive honours and recognition, and a retrospective exhibition, spanning fifty years of his work, was planned as a tribute to his very considerable contribution to art in Canada.

The exhibition was organized by the Agnes Etherington Art Centre and opened in Charlottetown, Prince Edward Island, in September 1970 and then circulated to Montréal in Québec and to Windsor, London, Hamilton, Saint Catharines, Oshawa and Stratford in Ontario. It opened in Kingston on Dominion Day, 1 July 1971. A Mexican fiesta, planned by the Gallery Association of the Art Centre in honour of the artist and involving the whole community, marked the occasion. Outside, in the early afternoon, there were Mexican games for children and adults; stalls as in a Mexican market, with exotic fruits and flowers, tacos and tortillas, sombreros, ceramics and crafts of all sorts; strolling Mexican musicians, dancers and donkey rides for the children. A procession into the exhibition was led by a giant "mono" (monkey) André made for the occasion based on a 1964 sketch (repr. p. VII); it was followed by the artist and his family and, it seemed, by half the population of Kingston ringing bells. It was totally in character with the artist and his work; his fascination with festivities and ceremony, people grouped together and the sheer joy and richness of colour in the marketplaces of the world, all this was the keynote of his paintings and of the event. In the evening, a Mexican-style dinner on the lawn was followed by dancing under the stars, topped off by a magnificent firework display. The melding of generations and the spontaneous reaction of people to the occasion was indeed a celebration of Canada's birthday that only an artist with the vitality, enthusiasm and love of humanity such as André Biéler could spark. Kingston honoured its "grand old man" with warmth and affection.

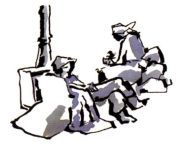

At the Market, 1981
Against a Post, 1981
Seated Man at the Market, 1981
The Harvesters, 1981
Acrylic and ink on paper
Each measuring 15 x 17 cm
Private collection

Part of the footage of *Biéler*, a film directed by Peter Harcourt, was shot on this occasion; it was completed in the home environment at Glenburnie, revealing much of the artist's way of working and of his mature philosophy of life. It was released in 1973; thirty years earlier André was one of the *Seven Painters of Québec* in the documentary film of that title, by Graham McInnes and Marius Barbeau, produced by the National Film Board of Canada in 1944.

"In the art of André Biéler, spread over fifty years but telescoped into a single exhibition, it is fascinating to observe the inability of constant change to deflect the basic personality of the artist," wrote Ralph Allen in the introduction to the exhibition catalogue. Change had indeed been a way of life – or of art – to Biéler, but whatever major influences of style or idea appeared, they were continuously absorbed by him and transposed into his own strong sense of vision and design. One of the latest paintings in the exhibition, *Tout en causant* from 1970 (repr. p. 294-295), was made after André had refreshed himself at the source in a sketching trip to rural Québec in 1969. His work began to develop stronger expressive qualities of both colour and form in this period. No house was really as blue as this one – but the joie de vivre of the composition demanded colour. As in many of his sketches, the spectator is drawn to participate; such is the universal quality and sensory effect in the stance of the group of men talking. Consider the contrast, for example, with *Catskill Landscape* of 1920 (repr. p. 51), a product of the Woodstock experience in which Cézanne had dominated the teaching theories. The more recent painting has the emotional form and colour of the post-impressionists.

Perhaps stimulated by the enjoyment of the children at the Mexican fiesta and remembering his children's classes in the early days in Kingston, André visited the Warehouse, a community recreation centre that summer by the Kingston waterfront. Always observant of what was going on in any community in which he lived, he saw a group of children involved in an art and drama workshop – but there did not seem to him to be much excitement. Would they like him to do a project with the children one day? He requested newspapers, scissors and glue. The day came and about twenty children cut and curled newsprint and, under his lively inspiration, transformed themselves into sheep. André the shepherd, in sandals, cloak and staff, and a student

instructor with a recorder, like the proverbial Pied Piper, led the children along the waterfront, around the market and back to the warehouse where, of course, the wolf lay in wait. A dancer, in a wolf mask that André made, acted out the scene in ballet form: the wolf was slain by the good shepherd. The artist returned again to show the children how to make papier-mâché masks. At seventy-five, he was as young at heart as his small friends.

Finding his subject matter in the community, he painted *Jean Vanier at Bell Island* in 1973. André made the painting while Vanier spoke to a large group of people in the Kingston island park. André's delight in the colour patterns formed by the clothes of people grouped together is expressed here in a manner completely different from his Québec paintings of groups of people; it is pure expressionism in its strong, fauvist colour patterns.

In 1974, Jeannette and André decided to leave the Glenburnie environment that, together, they had created and where they had passed fourteen wonderful years. It was a difficult decision to make but the time had come for them to seek less demanding physical responsibilities and less reliance on car transport. They moved to an apartment overlooking the waterfront in Kingston. André's studio in the apartment could not accommodate the Twelve Pines Press, so it was removed to his son Ted's studio near Toronto. With perennial optimism, André did not look backwards but rather, with excitement, at the new environment he found on his doorstep. He could walk along the waterfront and watch the sailing activities in summer and ice-boating in winter; the open market was a ten-minute walk away, as was the Art Centre. His sketchbook was ready. In this transition, as in all the many changes in his life, he had the warm support of his wife Jeannette. The move also made it easier for them to travel, and in this decade they made two visits to Europe: to Italy, Switzerland, Greece and France. The winter months included several return visits to Mexico and a visit to their son Peter in California. New impressions along the way were captured by André in sketches and paintings and provided rich material for the raconteur in his personality.

The decade became a remarkable period of creativity in terms of his painting. In Toronto in 1977 for the opening of the exhibition "The Laurentians: Painters in a Landscape" at the Art Gallery of Ontario, James Purdie reported a conversation with Biéler:

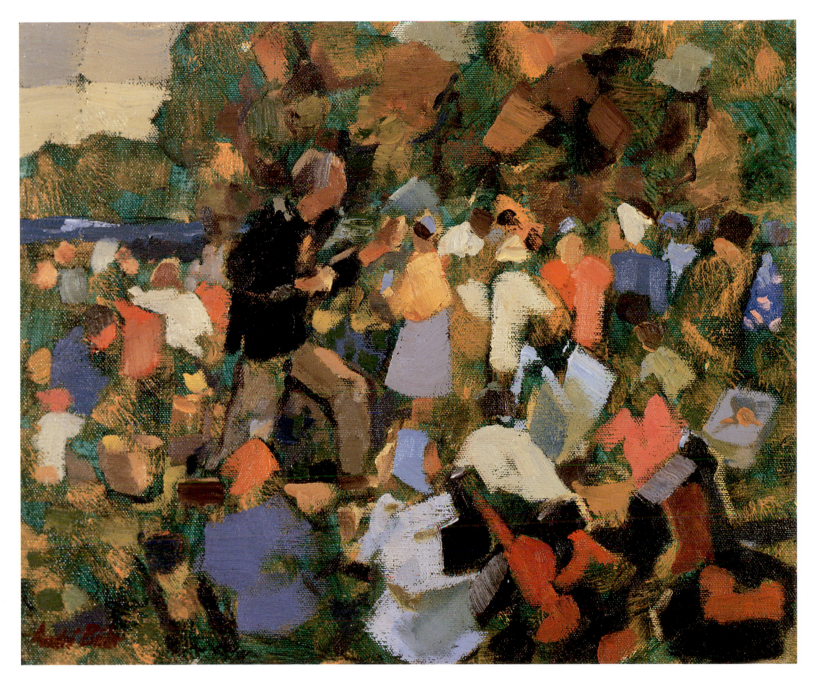

Jean Vanier at Bell Island, 1973
Oil on canvas
30.5 x 36.8 cm
Private collection

The Sap is Running, 1979
Acrylic and ink on paper
35 x 52 cm
Private collection

So Much Sun, Aegean, 1974
Watercolour on paper
35.6 x 53.2 cm
Private collection

The artists of this generation have "flown to the moon" with abstraction, leaving the public behind and skimping more than a little on basic training. So claims André Biéler who, at eighty-one, isn't paying very much attention any more to the public arguments about art, artists and their various theories. His days on the front lines were in the Forties. He's retired now from all the old wars and devoting his slower but still vital energies to painting. But from the sidelines, and only when pressed, he'll deplore the way they're teaching art in the schools these days. He also reminds governments that the way they're spending money on culture these days is not at all what he had in mind when he brought artists together to call for a new deal in the Forties. "But that was yesterday," he says. "Artists and governments are going to do what they do, anyway. I have no advice at all to offer. I'm too busy painting what I think remains to be said about Québec and the north shore of the St. Lawrence."[1]

He continued to paint in a strong postimpressionist manner. *The Sap is Running* of 1979 presents a subject he has treated many times, both in Québec and Ontario. The marketplace still occupied his thoughts, as can be seen in the strong painting *Ceux de Sainte-Famille au marché de Québec* (repr. p. 309). It still relates in mood to his early Québec sketches but in form and colour it is in his mature style of the 1970s. *The Green Tug* was painted at the docks in Kingston (repr. p. 308). The green tugboat, he said, just came into the picture as he was busy painting the scene and "it was just what I needed." This work could well have been included in an exhibition of the fauve school.

From his visit to Greece, the watercolour and wax-resist painting *So Much Sun, Aegean,* 1974, relates closely to the style in which he painted many of his impressions of the Mexican scene. There is confidence in the way he relates the jumble of chairs, tables, flowers and stalls, with a baroque exuberance, to the backdrop of Mediterranean architecture. Yet he does not negate the flat surface of the painting, demonstrating an ability and vision that could only have been attained after years of drawing, drawing, drawing.

In about 1978, another subtle change began to emerge in Bieler's paintings. He had always been fascinated with what the impressionists had discovered about light: "I'm now at an age when I can enjoy reducing the Canadian landscape to pure light and colour." A fragmentation of the subject in terms of colour began. Paintings were no longer based on naturalistic ideas or values but on a new harmony, a melding of sensations of colour and form, a transformation of plastic expression. The metamorphosis enriched the reality that was still present in his subject matter.

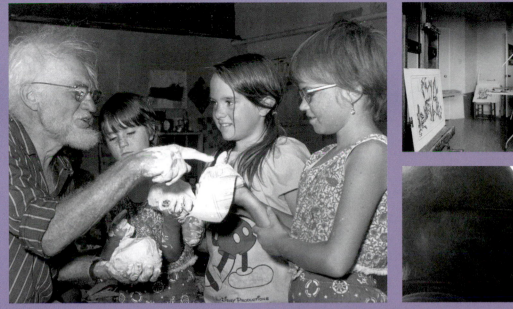

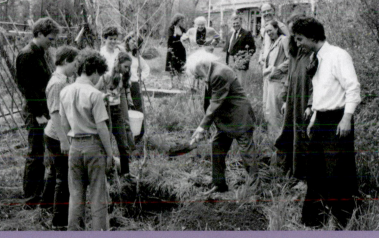

1

2 et 3

4

5

6

7

8

All images from A.B. Archives.
1. Modelling session with André Biéler, 1983.
2. André Biéler painting in his studio at Harbour Place, Kingston.
3. André Biéler reading.
4. André Biéler wearing his war medals on Remembrance Day (November 11) during the early 1980s.
5. *Peter and the Wolf*, children's project at Harbour Front, in Kingston.
6. André Biéler, surrounded by his grandchildren, plants a tree to celebrate his 50th wedding anniversary in 1981.
7. André Biéler sketching next to one of Kingston's Martello towers. (video image source)
8. André Biéler, listening. (video image source)

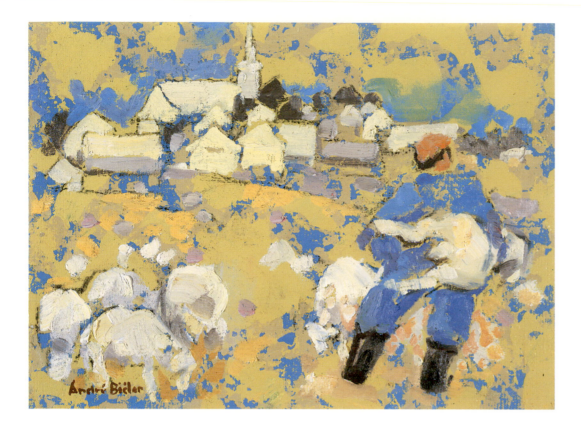

Les Moutons, les Éboulements, 1979
(Sheep, les Éboulements)
Oil on canvassed panel
31 x 41 cm
Private collection

The Green Tug, 1979
Oil on canvassed panel
31 x 41 cm
Private collection

In achieving these aims after his "private journey of the mind back to impressionism," he adopted a new technique. Canvases were prepared ahead of time, surfaced with usually a warm and a cool colour splattered over the base colour, or with one dominating colour alone. The mood of the final painting was determined by the selected ground. The ground itself, and there was considerable variety, had no interest of form but, as he said, "a great quality of light, of potential, a vibrant quality you don't get with white – why start with a white canvas?" The colour range of the selected canvas came through in the final harmony as he let the painting determine its own development – a sort of partnership as he created form on the canvas. The resulting impression is of luminosity, of colour of an amazing order – sometimes just a shimmer of light and at other times the domination of a mood. About one-third of a work could consist of the basic ground colour. Like the works of the impressionists, these paintings need to be seen at a distance, when the forms come together in light and space.

In one painting, *Derniers Rayons* (repr. p. 315), his well-known propensity for pink creates the mood; the ground was basically a luminous red which he allowed to come through to accentuate the unity of effect. *Les Moutons, Les Éboulements,* in contrast, was painted over a blue ground which is allowed to speak for itself in establishing a mood, a cool but luminous quality. *Swing Bridge, Jones Falls* is a work made in the fall of 1979 along the Rideau system in the hinterland of Kingston (repr. p. 311). The effect created by the dark red ground can be clearly seen as establishing the mood of the painting.

The one-man exhibition of André's works at the Roberts Gallery in Toronto in February 1979 consisted of forty-two works, almost all painted in Kingston in the summer of 1978. "Of course what we have here is the energy of nature expressed through colour," the artist said to a group of students on the opening day. "There are two things, actually, first, the subject matter, the inspiration – what I've found in nature. The second is the personal side – the fact that more and more I realize the tremendous dynamic quality in nature, especially in the summertime."[2] He went on to urge the students to camp anywhere and the subjects would come; if the sketch is no good, he said, just throw it away, like Cézanne, and start again. The exhibition was a revelation on the Toronto scene where his recent work had seldom been seen. An artist colleague paid him a warm compliment when he said he would have been proud to have painted the show. One work from the exhibition, *The Ruin, Wolfe Island,* is rather more subtle in its colour harmony. A nostalgic mood, redolent of the feeling experienced in contemplating the subject, a ruin among the summer trees, is fully realized.

Ceux de Sainte-Famille au marché de Québec, circa 1975
(Those from Sainte-Famille at the Québec Market)
Oil on canvassed panel
35.6 x 50.8 cm
Private collection

The Ruin, Wolfe Island, 1978
Oil on canvassed panel
21.6 x 26.7 cm
Private collection

Crisp Day, circa 1979
Oil on canvassed panel
23 x 31 cm
Private collection

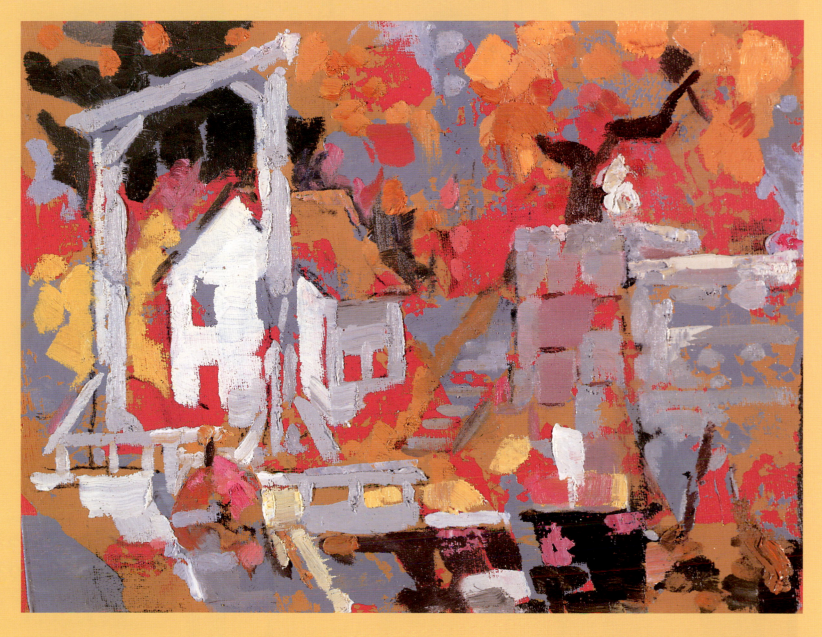

Swing Bridge, Jones Falls, circa 1979
Oil on canvassed panel
23 x 30.5 cm
Private collection

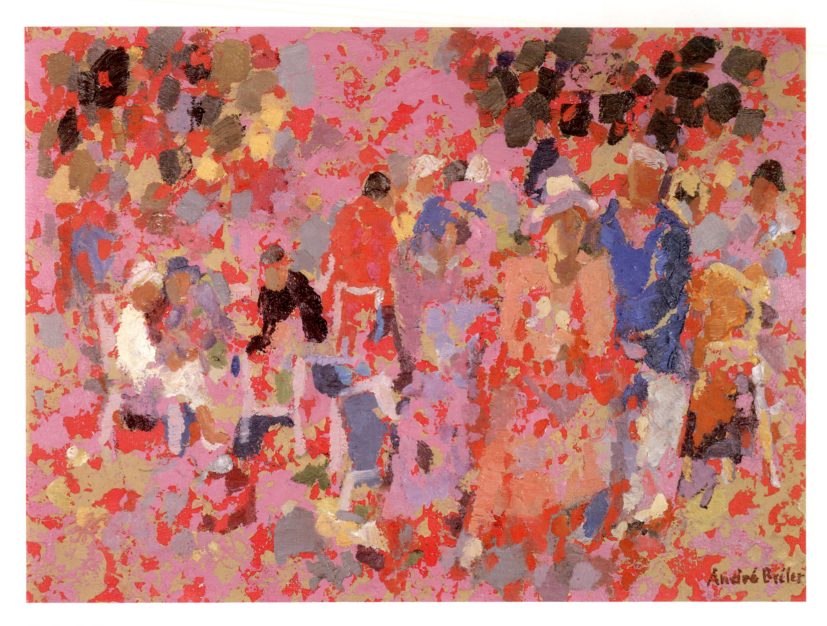

The Garden Party, 1979
Oil on panel
30.5 x 40.6 cm
Private collection

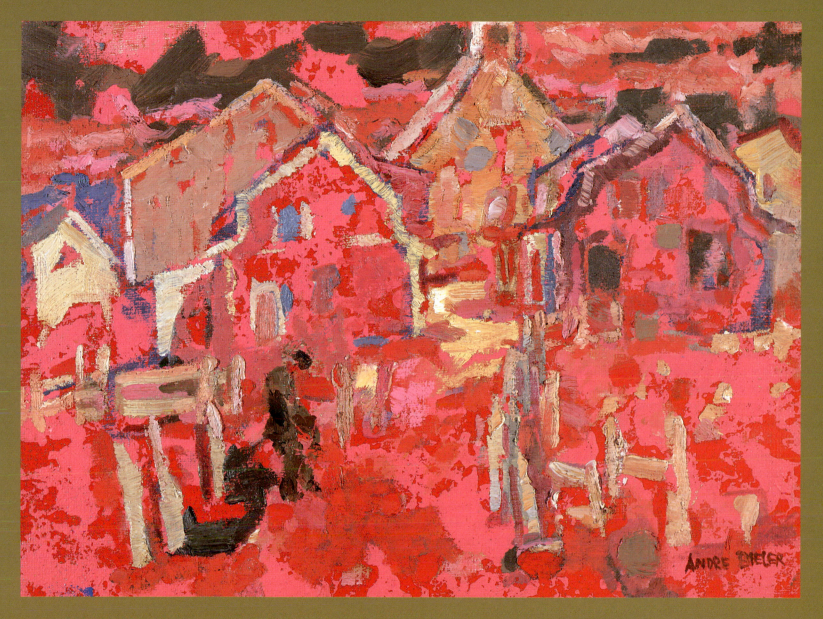

Derniers rayons, 1979
(Last Rays of the Sun)
Oil on canvassed panel
30.5 x 40.6 cm
Private collection

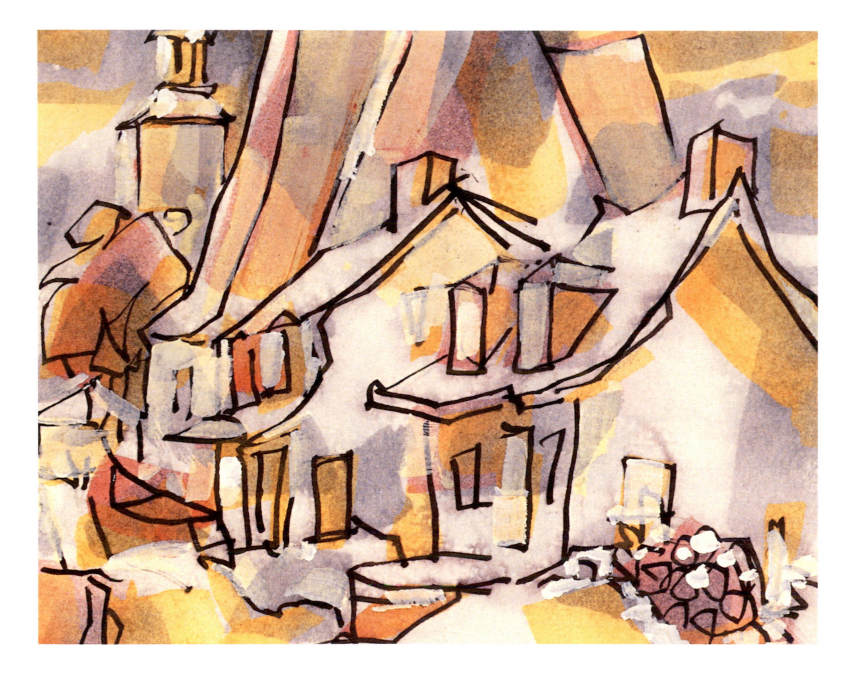

Maisons et clochers, 1980
(Houses and church steeples)
Acrylic pen and ink
19 x 28 cm
Private collection

DRAWING POWER FROM RECOLLECTION

BY TED BIÉLER

Early in 1990 after my father's death, but with Jeannette still firmly in control, members of the family gathered to open the "magic box" that was the closet in André Biéler's studio. We knew that he had retained early works, going back to at least the Île d'Orléans period but none of us, not even Jeannette, really knew the abundant visions it contained. Secreted away inside this cupboard were his creative seeds, his sketches. André Biéler had continued to select from this trove and cultivate them in new works through the 1980s. We found bound sketchbooks full of exquisite colored pencil drawings of Italian hill towns and churches in the 1920s, lovely sensual nudes in conté or charcoal in a kaleidoscope of styles, also going back to the 1920s, watercolour sketches to illustrate a whole anthropological study of the seasonal tasks on the Île d'Orléans, and much more.

Early in 1982 Jeannette had effectively gone blind, and the abundant years of traveling, to Europe and to Mexico to freshen the palette with new drawings and paintings was past. André turned more and more to his early sketches for fresh stimulus. As he said,

> When I look at them, I feel the youthful decision, the decision of making the sketch in a certain way. It brings out the vigor one had in early life, the decision of making it with such coloring at that time. The sketch's vigor comes first, then all the rest comes into shape.[1]

André and Ted Biéler in André's studio at Harbourfront Apartments, Kingston, 6 October 1986.
Photo by Ian MacAlpine
Kingston Whig-Standard Archives

The creative spark that those sketches provided my father in late life was echoed by the energy the images inspired in family members as they began to sort through the hundreds of works he'd left behind. Starting in Kingston and then in Montréal, Sylvie Biéler Baylaucq, her husband Jacques and son Philippe undertook the large job of cataloguing, photographing and properly storing all the works.[2] This intense exposure to the rich heritage of André Biéler's work accelerated Philippe Baylaucq's determination to make the film on his grandfather, *The Art of Time*, which has been widely broadcast.

1. Interview with Jennie Punter, *The Kingston Whig-Standard*, 13 August 1988.
2. The entire collection was photographed by Bertrand Carrière.

Joy of Summer, 1986
Oil on board
38 x 48 cm
Private collection

Asked about this much bolder use of color, Biéler responds:

I think definitely this is a rather new aspect in my work...

Now, in my case, I've evolved a system, where I start from the abstract. That is, I take a board – canvas I should say – that has been previously prepared in a number of harmonious colors, a number of interesting harmonies, or whatever, painted on the canvas. These are painted in an abstract manner: areas, lines, anything at all; it doesn't matter. And I paint many of these. I could have maybe ten of them at one time.

I take these (*prepared boards or canvases*), look at them one after another, and suddenly that color combination seems to bring to my mind a sketch that I have in my files. I've kept my sketches from the very beginning – I must have two or three or four hundred of them – and so I look through the file, find the sketch and see if it goes. It may go; my memory may be wrong, it doesn't go quite well; I take either another canvas or another sketch. And in that way, then, having the canvas on my easel, the sketch in my hand, strangely enough the abstract shapes in that canvas somehow fit the main line of my sketch. Very little change has to be done, except the value in some color changes; and from there on I go from the abstract that was the original to the expression of – I'm not going to say "to the realism"; it's not realism, ever. It's to the expression I want to give to that canvas, be it joyful, be it deeply religious – my next canvas is one of the procession at the le d'Orléans – or be it some other aspect of our lives.

Sometimes strangely, the picture, after all that preparation, of color, values, having found the sketch, will go immediately: a few lines here, and then, bang!, it seems to be. I leave it then for a while, six weeks or four weeks, a month or so, take it up again, see the glaring changes that have to be made, and it is done.

Other times it is not so easy. You start to change a balance that you have produced on the canvas in an abstract way, and I look at it and I say, "By God, why should I destroy that? It is so lovely the way it is." But I know very well, from long experience, that a person will look at an abstract, a non-objective painting, for a few minutes, just a few minutes, feel exalted by it, feel happy about it, in some cases, and leave it in no time at all. But just as soon as they recognize the human being – a person has been in that place, been in that circumstance, been in the cold of that winter and so on – he is attracted by it. He delves in it longer. And the longer he is kept looking at it, the more he discovers in the relationship of colors that have been put on the canvas. And that is really the essence of my system.[12]

12. Ibid.

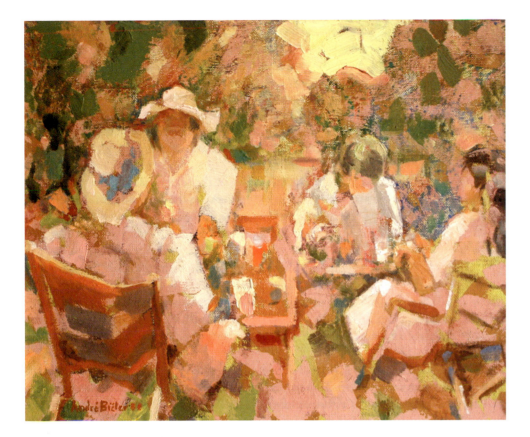

On the Salmon River, 1986
Oil on board
39 x 51 cm
Private collection

Describing a specific example:

Now, you take that little one of the ladies having tea at the Salmon River. The canvas was pink, rather lemonish yellow and bits of green here and there.

Probably the pinkish color dominated. Now that was so abstract it didn't show light or dark or anything; it just showed color. When I looked at it I decided on light by the hats, the blouses or skirts in white and the background sky. And immediately that changed from a non-objective to a very glowing representation. So the figures, the people in the painting are revealed by the light, the light is used to define them. And I generally reserve the darks until I've established the arrangement of the composition, so as to be able to put the darks here and there according to my scheme of composition.

Painting the figures on top only enhances the fact that they were separated and connected by some kind of scheme of composition that generally starts at the front, in the fore-

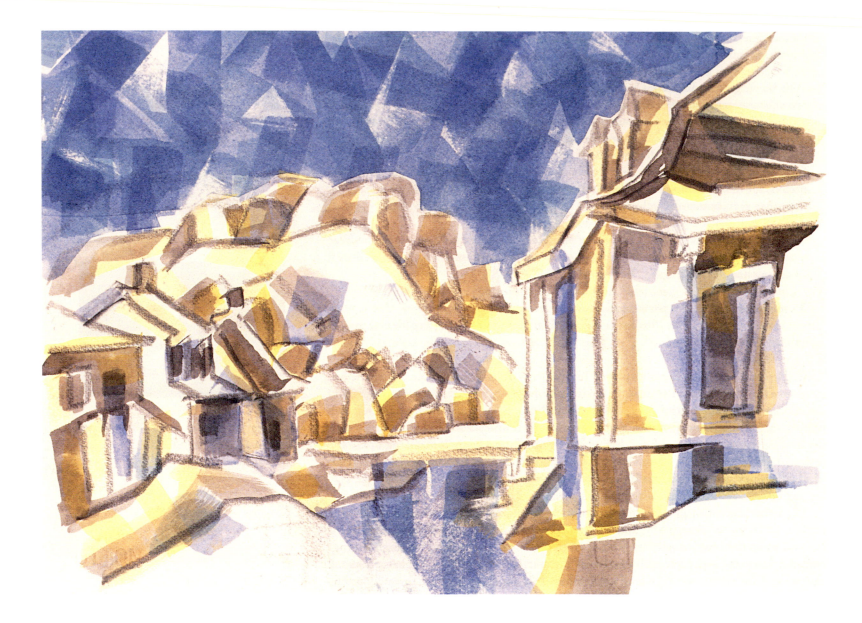

Le Dégel, 1982
28 x 38 cm
Acrylic pen and ink
Private collection

The horrors of the First World War and the trenches knocked religion right out of him; after that he was never overtly religious. He survived the dislocation and horrors of the conflict, essentially through comradeship with his fellow soldiers, as he himself stated. Sheer survival took the form of employing his hands and eyes in drawing and making, talents that eventually led to his being assigned to the topographical section of the army. Still, brought up in a family with deep Protestant roots and an evangelical Christian disposition on both his father and mother's side, he clearly absorbed a foundation and a practice in the spiritual dimensions. In the creative pursuits that shaped his own life these took the form of a capacity for absorption, interest and sympathy for others and a genuinely inquisitive mind, all of these nourished his inner life.

On his extended stays in Europe after the war learning his craft, Biéler traveled and explored in depth the churches and religious iconography of Christendom and made many sketches incorporating these monuments. At the Île d'Orléans in the late 1920s he was drawn to the many Catholic ceremonies that engaged the whole community in processions and rituals, with the Church at the centre. There are many fine sketches and finished paintings of these, including unusual ones, such as the *Benediction des Barques*. I recall attending, when I was a high school student, a public lecture he gave to a capacity audience at Queen's University on the *Last Supper* by Leonardo da Vinci. It is vivid in my memory for the passion he conveyed, not just for the formal and narrative ambition of the mural, but for its Christian and spiritual meaning. His teaching of art history was an ongoing opportunity to explore and articulate Christian iconography, which he did with eloquence. Liberated from 'religion' and the conventions of denominational orthodoxies he was free to delve into the essential sources of that imagery.

Fundamentally Biéler was a humanist and a modernist. When he returned to live in Montreal in 1929 he became more intensely involved with a group of Montreal artists and intellectuals he had exhibited with and met on previous visits. A recent PhD thesis, *The Last Ulysseans: Culture and Modernism in Montreal, 1930-1939* by author Molly Pulver Unger describes in compelling detail the importance of this informal but cohesive group, which at its core included eight couples, Jeannette and André Biéler, Florence and John Bird, Maize and Fritz Brandtner, Corinne and John Lyman, Marion and Goodridge Roberts, Marian and Frank Scott, Jori Smith and Jean Palardy, Margaret and Philip Surrey; on its periphery there were another eight women and twenty five men. To quote:

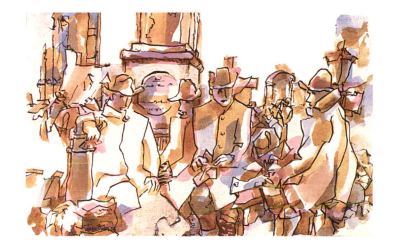

> ...What drew these individuals together was the shared perception that they should and could embark on a journey of questioning, creativity and renewal in defiance of and in opposition to their lived experiences of the Great War and the Great Depression.

The Lymans, the Scotts, the Birds *(the Biélers)* and their friends rejected what they identified as the world of their parents – the religious, romantic, capitalist and bourgeois values, which they believed had been responsible for the Great War. What is important is that they were not satisfied simply to reject. On the contrary, they wanted to effect change, to create a new social order and to achieve personal significance in so doing. Because they consciously described their way of thinking and living as modern, and because they did not associate the Great War with modernism, these individuals exemplified a thematically more inclusive and chronologically more exclusive definition of modernity than is conventionally understood: modernism can be observed in all aspects of their lives, and the critical moment of their intellectual change occurred in 1936 with the outbreak of the civil war in Spain. I argue that the Montreal group did indeed achieve their goals that they developed a model of heroism not

Tobacco Stall, Montreal, 1984
Watercolor and ink
36 x 53 cm
Private collection

1896
André Biéler is born on 8 October, at the Collège Galliard, in Lausanne, Switzerland, the son of Charles Biéler and Blanche Biéler (née Merle d'Aubigné).

1898
The family moves from Lausanne to Paris. He attends kindergarten in Neuilly-sur-Seine.

1905
Enters Lycée Carnot, in Paris. Receives marks in drawing.

1908
Charles Biéler accepts a position as professor of theology at the Montreal Presbyterian College in Montréal, Canada.

The family arrives in Quebec City on 14 September.

1913
Starts architectural studies at the Montreal Technical Institute.

1896-1914 **1**

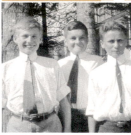

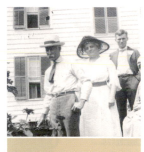

1915
Enrols as a volunteer in the Canadian Army. He joins his brothers Jean and Etienne in the Princess Patricia's Canadian Light Infantry. His younger brother Philippe will join them later. (Four brothers enrolled in the same army corps is considered as an exceptional event.)

André will fight at Vimy Ridge, Sanctuary Wood and Passchendaele.

1916
His brother Philippe dies in France and Etienne is seriously wounded in one leg.

1919
Arrives in Montreal on 11 April, as a war invalid, wounded and gassed.

Starts a long convalescence.

1914-1921 **2**

1920
Awakening of his vocation as a painter during a stay with his mother in Florida. Studies briefly at Stetson University, at De Land in Florida, in the Fine Arts Department with the artist Harry Davis Fluhart.

In Asheville, North Carolina, he meets and is influenced by Bertha Thompson, who will encourage him to attend the Art Students' League, at Woodstock, in the State of New York.

Goes to Woodstock for the summer and studies with Charles Rosen and Eugene Speicher. He will also meet the artist George Bellows.

1921
While at Woodstock visits the Impressionists and Post-Impressionists Exhibition in New York.

Sails for Italy and France.

To improve his health he stays in a sanatorium at Les Courmettes, in the French Maritime Alps.

1922
Under the direction of his uncle Ernest Biéler, a well-established Swiss artist, he takes part in the creation of a large fresco on the facade of the new City Hall Building at Le Locle in Switzerland.

1923
On the advice of his uncle he decides to pursue his studies in Paris, where he lives in an attic room, in the Latin Quarter, overlooking the Senate and the "Jardins du Luxembourg."

Maurice Denis and Paul Sérusier are among his teachers.

1924
On account of his poor health, he is forced to leave Paris and returns to Switzerland, where he continues his studies with his uncle Ernest.

1921-1926 **3**

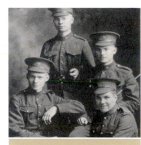

1924
First one-man show at the Montreal Art Association (now the Montreal Museum of Fine Arts), from 1 to 16 March.

Participates in the MAA Spring Exhibition from 27 March to 20 April.

1925 to 1926
With his uncle, he paints many subjects during his travels in Italy, France and Switzerland.

One man show in Geneva from 1 to 4 May.

He sojourns alone in Sion in the spring, and his parents, travelling in Europe, visit him in June.

Stops off in Paris on his way back to Canada, where he arrives on 26 September.

Travels to the Gaspé, (Québec); visits Rivière-aux-Renards.

One-man show in November at the Ritz-Carlton Hotel, where he meets Edwin Holgate, who will become a life-long friend.

1927

In the spring takes a trip to Tourville (Québec), then settles in an old house at Sainte-Famille on Île d'Orléans.

Both the sculptor Alfred Laliberté and the anthropologist Marius Barbeau call in to visit him at Sainte-Famille.

From Paris his father sends him a technical book entitled "Traité d'enluminure d'art du pochoir" by J. Saudé (1925).

1928

Produces "La Chapelle de Sainte-Famille," combining woodblock printing and pochoir technique.

1929

Travels through the Charlevoix region on the North shore of the Saint Lawrence river.

Receives the news of his older brother Etienne's tragic death in Australia.

Decides to close his atelier in Sainte-Famille, and returns to Montreal.

1926-1929 · 4

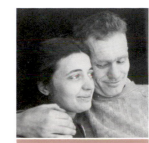

1930

Lives in a studio on Sainte-Famille Street, subsequently moves to 1100 Beaver Hall Hill.

1931

On 27 April marries Jeannette Meunier, interior decorator and designer of contemporary furniture.

The couple lives in Montreal, and Saint-Sauveur in the Laurentians.

On the facade of a house ("la maison rose") belonging to his younger brother Jacques Biéler, and situated in the heart of Saint-Sauveur-des-Monts, he paints a fresco of Saint Christopher and the Christ child.

Meets John Lyman; with others they found the Atelier School of Art. Teaches there until 1933.

1934

Birth of his first daughter, Nathalie, in Montréal.

1930-1939 · 5

1935

Moves to Saint-Adèle.

1936

Accepts a position as resident artist to teach fine arts at Queen's University, Kingston, Ontario.

1937

Birth of his second daughter, Sylvie.

1938

Birth of his first son, Theodore (Ted).

1939

As a staunch anti-sectarian, he declines the offer to join the Society of Contemporary Arts created by John Lyman. The objective of the society was to counter the academism that was predominant at that time.

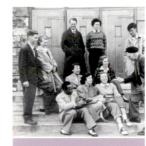

1940

In Kingston, the Biélers build a home for their family at 33 Hill Street.

Teaches for the first time at the Banff Summer School.

1941

Represents Canada at the opening of the National Gallery in Washington.

At Queen's University in Kingston, he organizes the first conference of Canadian artists, known as "The Kingston Conference." One hundred and fifty artists (men and women), Canadians and Americans attend.

From this event emerged the creation of the Federation of Canadian Artists, with André Biéler as its first elected President. The federation will contribute to the creation of the Royal Commission (Massey-Lévesque) on the development of arts in Canada, in 1949, that, in turn, will spawn the Canada Council in 1959.

1940-1949 · 6

1942 to 1944

During the war, teaches at the University, and participates in several exhibitions.

Birth of his second son, Peter, in 1943.

Travels across Canada on behalf of the Federation of Canadian Artists.

Health problems and a desire to return to his artistic production force him to resign his position as President in 1944.

1945

Starts a large mural commission for the Aluminium Company of Canada, to be housed in their hydroelectric dam at Shipshaw (Québec).

1947

Finishes and installs the mural at Shipshaw.

Teaches at the Banff Summer School.

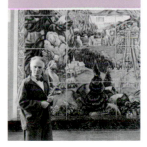

INDEX

A

Abell, Walter, 180, 183, 191, 193, 197

Académie Ranson (Paris), XIX, 64, 65, 94

Agnes Etherington Art Centre, XI, 2, 3, 4, 242, 245-247, 249, 252, 254, 256, 261, 262, 277, 303

Alford, John, 180

Alfsen, John, 185

Allen, Ralph, 67, 261, 262, 293, 304

Allen, Rita Greer, 279

Alma-Tadema, Sir Lawrence, 145

American Academy of the Fine Arts, 44

Amis des Beaux Arts (Les), 39

Armory Show, 1913, 43, 44, 47, 49, 152, 171, 198

Arras, 30

Art Association (of Montreal), 47, 72

Art Gallery of Hamilton, 106

Art Gallery of Ontario, 222

Art Gallery of Toronto, 88

Art Students' League (Woodstock, NY), 38, 41, 43, 44, 45, 47, 48, 49

Association of American Painters and Sculptors, 43, 44

Atelier (The), XXIII, 152, 153, 155, 163

Atelier de l'Art Sacré, 94

Ayre, Robert, 136, 187, 225, 243, 253, 279, 295, 296

B

Banff Summer School, 179, 200

Barbeau, Marius, XXII, XXV, XXVII, XXVIII, 71, 90, 91, 96, 98, 104, 109, 127, 133, 148, 171, 208, 243, 245, 304

Barbizon (school of), 106, 109, 135

Bawden, Edward, 201, 235

Beach, Sylvia, 66

Beavergroup Art Gallery (Fredericton), XI

Beaver Hall Group, 141

Bell, Clive, XXIV

Bellows, George, 43, 44, 45

Benton, Thomas Hart, 135, 180, 185, 187, 198, 264

Bergman, Eric, 160

Biéler, Blanche, XXVIII, 9, 16, 20, 21, 24, 39, 48, 90

Biéler, Charles, 9, 11, 16, 19, 90

Biéler, Ernest, XXIV, XXV, 40, 49, 60, 61, 62, 64, 66, 67, 71, 76, 80

Biéler, Jeannette, XXVIII, 144, 145, 147, 150, 155

Bird, Florence and John, 148, 331

Blackfoot Indians, 200

Bonnard, Pierre, 48, 228, 249, 297

Borduas, Paul-Émile, XVIII, 94, 254

Bovey, William, 153

Brandtner, Fritz, 173, 191, 331

Braque, Georges, 230, 264

Breton, André, 196

Brinley, Daniel, 48

Brittain, Miller, 185

Brown, Eric, 145

Brymner, William, 47

Bush, Jack, 254

Byrdcliffe (Woodstock, NY), 41, 43

C

Canada Council for the Arts, XV, 194, 240, 252, 256

Canadian Arts Council, 2, 194

Canadian Celanese, 155

Canadian Group of Painters, 193

Carnegie Corporation (New York), 2, 4, 163, 165, 179, 180, 219, 246

Carr, Emily, 243

Cézanne, Paul, 44, 48, 58, 64, 145, 198, 228, 304, 309

Charlevoix, 126, 127, 133, 135, 157

Chauvin, Jean, 142, 148

Clairière (La), Laurentians, 30, 38

Clark, Paraskeva, 185

Claxton, Brooke, 249

Cloutier, Albert, 148, 185

Cocteau, Jean, 64

Comfort, Charles, 192, 237, 240

Conference of Canadian Artists, XV, 180

Conference on Canadian-American Affairs, 169, 171, 183

Constable, W.G., 166, 252

Coonan, Emily, 141

Corry, J.A., 253, 254, 264

Cosgrove, Stanley, XXVIII, 133

Coué, Dr. Emile, 58, 279

Coughtry, Graham, 254

Courtenay, Lysle, 160

Couturier, Marie-Alain, XXIV

Crowe, Kenneth, 152

Cullen, Maurice, 35, 142, 144

Currie, Sir Arthur, 153

D

De Butzow (family), 12

Denis, Maurice, XIX, XXIV, 64, 65, 94, 239, 288

Degas, Edgar, 48, 64

Derain, André, 249

Dewey, John, 179

Doré, Gustave, 35

Dreyfus (affair), 19

Duchamp, Marcel, 194, 196

Dufy, Raoul, 225, 237, 249

E

École des Beaux-arts de Montréal, 144

Eliot, T.S., 66

Etherington, Agnes McCausland, 2, 165, 166, 168, 246, 247

Etherington, Dr. Frederick, 246

F

Federation of Canadian Artists, XVI, 3, 191, 192, 193, 194, 197, 200, 220

Ferraton, 229

Finnie, Richard, 71, 90, 133

First Nations, XXVII, XXXII

Fluhart, Harry Davis, 39, 41, 44

Fogg Museum, 152

Forester, Michael, 185

Fortin, Marc-Aurèle, 47

Freifeld, Eric, 180

Frost, Elizabeth, 152

Fry, Roger, XXIV, 44, 47, 49, 58, 59, 70, 145

Frye, Northrop, 117

Fyfe, Dr. Hamilton, 163, 165, 166

G

Gagnon, Clarence, XXVIII, 122, 133

Gaudreault, Charles Edouard, 267

Gauguin, Paul, XIX, 44, 48, 49, 64, 239

Gettens, R.J., 191

Procession, Mexico, 1978
14 x 20 cm
Pencil on paper
Private collection

ACKNOWLEDGEMENTS

Canada Council for the Arts
Dr. Albert and Mrs. Christa Fell
The estate of André and Jeannette Biéler
Alcan Inc. of Canada
Power Corporation of Canada
Phil and Sue Cowperthwaite
Baylaucq & Co.
Canneberges Atocas Cranberries
Peter Biéler
Le Groupe CGI
Zeller Family Foundation
Jacqueline Biéler (In memoriam Guy Biéler)
Passerelle Production
The Davies Foundation
Pacart
Musée national des beaux-arts du Québec
Agnes Etherington Art Centre
Rick and Carol Brettell (In memoriam Jacques Biéler)
Galerie Valentin
Alexandre Taillefer
Louis-Marie Gagné
Les Encadrements Marcel Pelletier
Anne Baxter
Françoise Montgomery
Nicholas Kasirer
Hélène et Jean-Marie Roy

Artist André Biéler's grandson explores the places and seasons that shaped his grandfather's life and work. The story focuses on the meeting of two generations, two continents, two languages. By underscoring emotional and artistic connections, the film travels through time and space to celebrate the world of a major artist. A journey through the century that will uncover the hidden sources of Biéler's remarkable humanism.

Researched, Written and Directed by: Philippe Baylaucq
Editing: Dominique Sicotte
Photography: Philippe Baylaucq & André-Paul Therrien
Music: Eric Longsworth
Sound Recording: Paul Castro-Lopez, Louis Léger & Catherine Van Der Donckt
Sound Design and Editing: Benoît Dame & Catherine Van Der Donckt
Sound Mix: Jean-Pierre Bissonnette
Graphic production: Guillaume Millet
Special collaboration: Iolande Cadrin-Rossignol
Production director: Thomas Ramoisy
Produced by: Nathalie Barton

Produced by
InformAction

in association with
Passerelle Production

with the participation of
• Canadian Television Fund created by the Government of Canada
 and the Canadian Cable Industry
 Telefilm Canada: Equity Investment Program
 CTF: Licence Fee Program
• QUÉBEC: Film and Television Tax Credit – Gestion SODEC

 Government of Canada: The Canadian Film or Video Production Tax Credit

and with the collaboration of
Radio-Canada

InformAction films Inc.
(514) 284-0441
www.informactionfilms.com